The Spanish Arts
of Latin America

The Spanish Arts
of Latin America

By FRANÇOIS CALI

Photographs by CLAUDE ARTHAUD and

FRANÇOIS HÉBERT-STEVENS

A STUDIO BOOK

THE VIKING PRESS · NEW YORK

L'ART DES CONQUISTADORS © 1960 B. ARTHAUD, PARIS

THE SPANISH ARTS OF LATIN AMERICA © 1961 THAMES AND HUDSON, LONDON

TRANSLATED BY BRYAN RHYS

PUBLISHED IN 1961 BY THE VIKING PRESS, INC.
625 MADISON AVENUE, NEW YORK 22, N.Y.

LIBRARY OF CONGRESS CATALOG CARD NUMBER 61-8357

TEXT PRINTED IN HOLLAND BY N.V. DRUKKERIJ BOSCH, UTRECHT

PHOTOGRAVURE PLATES PRINTED IN FRANCE BY ETS BRAUN ET CIE, MULHOUSE

BOUND BY VAN RIJMENAM N.V. THE HAGUE HOLLAND

10163

CONTENTS

*Asterisks(*) refer the reader to the glossary on page 275*

*May the Lord in His Mercy guide me and
make me find this gold... For gold is excellent,
the treasure is of gold; he who has gold
may do what he wills in this world and
even send souls to Paradise*

CHRISTOPHER COLUMBUS
Admiral of the South Seas, Duke of Jamaica, 1503

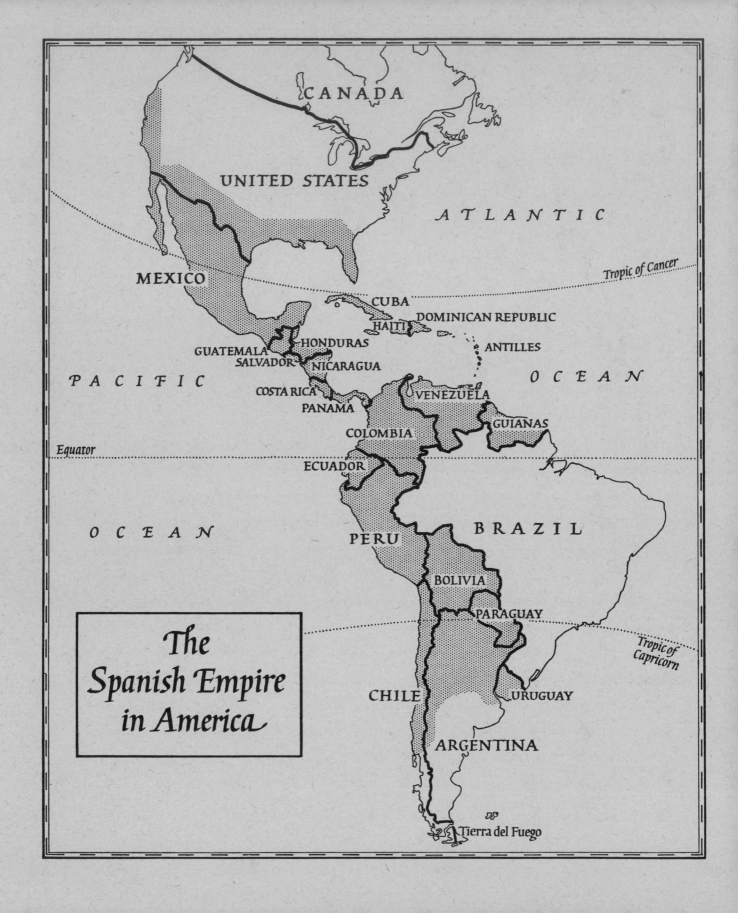

The
Spanish Empire
in America

FOREWORD

IN THE TROPICS of the West, between Cancer and Capricorn, there are a hundred and sixty million Catholics; the churches number seventy thousand, and their Christs and Madonnas are beyond number. Such, briefly, is the sum of the Spanish Empire in the New World, which can only be explained by reference to the mysteries of the Catholic faith, rather than the riddles of history, to the secrets of the art of the Conquistadors*, rather than to the secrets of the rulers who used it to help them in this conquest.

The achievement of these mere handfuls of men, soldiers and priests, who carved out an empire, is without parallel in world history. Islam alone, whose mosques extended from the Atlas Mountains to the Himalayas, could boast another such enterprise, but Islam was faithful to a prophet, while Spain bowed before the living presence of a king. It was the name of an impersonal god, without face or colour, that the muezzins cried upon the sunlit air, but in their dark churches the *conquistadores a lo divino* gathered together a whole continent of 'red' peoples, to commune in this the passion of a Christ that was white.

The field in which this dream of the Conquistadors was achieved challenges the imagination: a welter of nations with ten thousand languages and dialects and different gods, scattered over an area of ten million square miles, and grouped more or less under the sway of the Mayas*, Aztecs*, Chibchas* and Incas*. Yet the miracle was that the Spanish Empire of the Americas lasted for three centuries. Army and navy in the proper sense it had none, scarcely even a common language, though

Castilian came nearest to fulfilling that function; and the head of government sat upon a throne so distant that he was powerless to control the impulses and instincts of his servants. Yet conquest went on and on, reaching into lands then still uncharted, California, Yucatan* and the marches of the Amazon. What was the unifying principle, what the mortar that bound so many various, multi-coloured, shifting stones in the white amalgam of a country church, from Terra del Fuego to Florida? Gold, it has been said, as if gold was an all-sufficient answer, explaining the heroic rage of the conquerors, and the extreme despotism of the King in his racial and commercial policies. Can gold explain why an Indian should carve from the substance of his ancient idols a Christ or a Madonna of Spain, and cherish in them his hope of eternal salvation in a white paradise?

For an explanation of this mystery we turn in vain to the historic records with all their contradictions. Neither the methods of Plutarch with his heroes, nor those of the tidier-minded historians of the last century can help us very much here. For indeed every fact we find is at once contradicted by another: the cruelty of the soldiery by the charity of the monks, and their charity itself by their wealth; a church militant in matters spiritual contrasting with the harsh hand kept upon souls by the secular clergy; a racial consciousness among the colonists flouting the King's policy of integration. There was paternalism among the Creoles*, but enslavement of the natives by the Spaniards; there was the strictest official control of trade in precious metals, yet clandestine dealing in spices went on freely; and the despotism of the crown was countered by the anarchy of its officers. We seek a common denominator but in the end have to admit that there was none other than the Catholic faith, both in its magnificent and in its humble, everyday forms: the Catholicism which builds cathedrals (*plate 6*) as well as the Catholicism which daily brings members of all races, without distinction of rank or fortune or colour, to their knees before the Madonna. And when the break-up of the Catholic Empire had already begun,

Bolivar himself, the leader of insurrection, wrote these words: 'America is ungovernable. Those who promoted the cause of independence have only ploughed the sea.'

If art were not there to speak, this integrating faith would seem incomprehensible to us, as puzzling as the layman finds the atomic formulae creating man's most spectacular explosion. The art of the Conquistadors is the fall-out of a Catholic explosion, caused by the enormous clash between Spain and America*. Any explosion has its scissions and contradictions, and not least when the agents are as dynamic as the despotism of the most religious prince in Europe, the zeal of the most enterprising monks in Christendom, and the legendary attraction of a metal which for three centuries dazzled all kinds of adventurers.

The art of the Conquistadors and their descendants is the art of the peoples they conquered, and their history is one and indivisible. As it extends over three centuries and an entire continent, the following pages do not claim to be more than an essay on an event perhaps without parallel in the annals of men: an enterprise in colonisation which used the arts to subdue nations possessing their own.

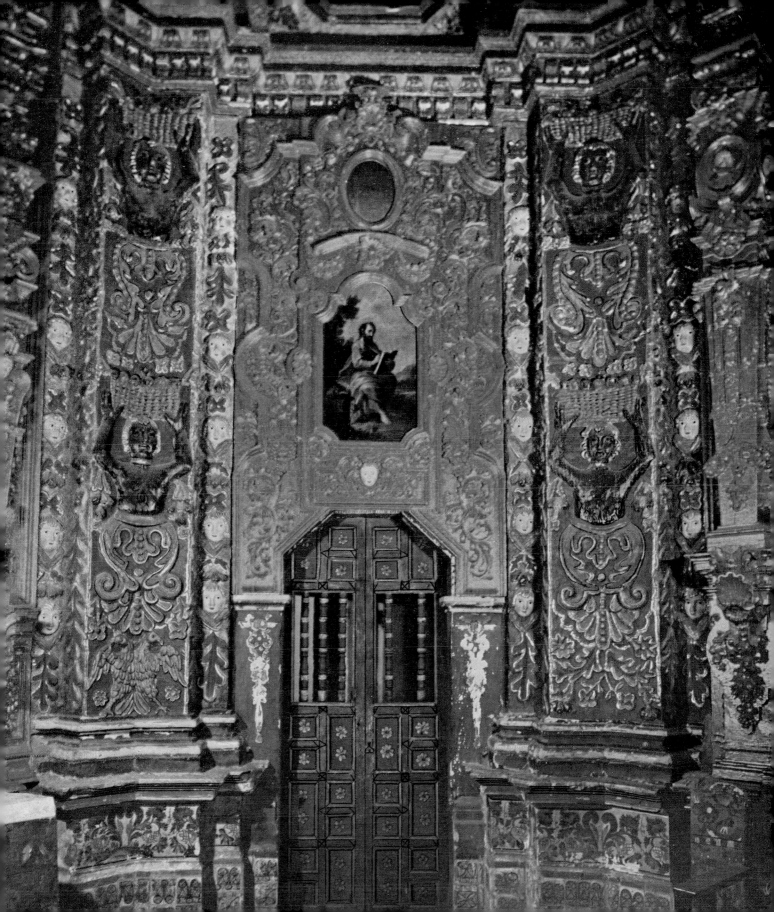

I

I Architecture and Sculpture

Now all these new kingdoms – New Spain*, New Galicia, New Granada, New Toledo, New Andalusia – belonged by right to His Most Catholic Majesty the King of Spain; and these kingdoms were conquered because, just as Luther was about to draw half Europe away from Rome, and twenty-seven years after Christopher Columbus had discovered America, an adventurer (for his faith no less than for gold) landed one Good Friday in Mexico (1519). On the banner which he waved towered a cross in red velvet, with these words below: *Amici sequamur et si fidem habemus vere in hoc signo vincemus.* And Cortés said: 'My Lords, let us follow this banner which is the Holy Cross, for by this shall we conquer.'

Machiavelli had just been writing: 'The desire for conquest is natural and a very common thing, and each and every time that it is undertaken by those who are able, they will be praised for it or at least they will not be blamed. For indeed there is nothing more arduous to undertake, more uncertain of success or more perilous in the execution than to seek to impose new institutions upon others... The institutions of Religion are so powerful and of such kind that their princes cannot be moved, no matter what their behaviour and manner of life...' Half a century later, the Indies of Castile* had a patriarch, six archbishops, thirty-two bishops, three hundred and forty-six canons, and a thousand regular priests. Machiavelli was the theorist of an art of conquest, Cortés its engineer, and the Roman Catholic Church its beneficiary. Never since the reign of Constantine had soldiers rendered her such service, never, not even in the times of the Crusades, had swordsmen and churchmen collaborated so closely to build an Empire of the Faith so speedily and so well.

Historians of the religious orders have indulged in much discussion to decide who was the greatest apostle in the New World. Claims have been put forward for the Benedictine Bernard Buil, almoner to Columbus, Friar Olonedo of the Order of Mercy, almoner to Cortés, Martín of Valencia, the Franciscan, and Betanzos the Dominican *(fig. XVI)*. All these wrought miracles, but the first apostle was undoubtly the knight Cortés de Monroy, and it is surprising that his statue does not stand at St Peter's beside that of another Spanish knight, who, after his thigh had been broken

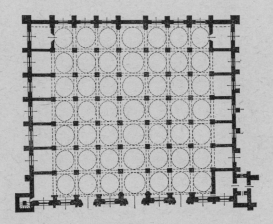

II CHOLULA; PLAN OF THE ROYAL CHAPEL OF THE FRANCISCAN CONVENT

by a cannon-ball at the siege of Pampeluna, decided to limp thereafter in God's service, and founded the Society of Jesus – Ignatius Loyala *(plate 32)*. Cortés, the future Marquis of Oaxaca* *(plates 1,9)*, was not simply a soldier who left the field to the friars when the fighting was done. He himself preached to the survivors of the fray and for that reason they held him to be a god. At every stage on his march into Mexico he seized a temple, turned it into a church *(plate 4 and fig. II)* and celebrated a mass. After which he himself preached the sermon, seeking to convince the natives that the religion which justified his enterprise was the true religion. But did he also manage to justify it to himself? Was he really convinced of the absolute truth of his

message, or only using his creed to further his conquest? Therein lies his secret.

'To govern is to make others believe.' These words, a Machiavellian motto for the art of conquest, should have been inscribed by Catholic monarchs under their coats of arms, ringed by the heavy necklace of the Golden Fleece, and with a lamb with drooping back *(fig. III)*. Machiavelli had also said: 'Men must either cherish or ruin one another utterly: in truth there is no surer manner of enjoying a province than to lay it in ruins.' With the velvet hand of the friar inside the soldier's iron gauntlet, the

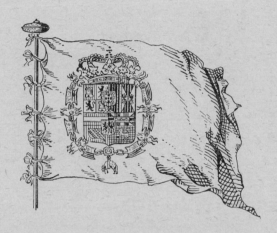

III ROYAL FLAG OF SPAIN

Conquistadors spread ruin through pre-Columbian America; but on the ruins something had to be built, some dream given to these peoples to cherish, to keep them all orderly within the Spanish fold – God's own fold also as it appeared. On the third of May 1493, Pope Alexander VI, 'having ascertained that being truly Catholic Kings and Princes, they had given outstanding proofs in almost every part of the world of their religious sentiments,' ceded to the Kings of Spain and Portugal ecclesiastical domain in the New World, and assigned to them the responsibility of building churches and maintaining the clergy. Julius II confirmed this bull* by another in 1503, and the Kings of Spain* by schedules in 1501 and 1541; church tithes were to

be collected in the colonies by the royal treasury and distributed between the bishop, his chapter and the churches, for their building and maintenance and for the priests in charge. Bishops in the West Indies were high officials, like viceroys and captains-general, and their first duty was to take oath to honour the King's patronage and in no way hinder the full exercise of his powers. They were high stewards or farmers-general of a faith entrusted by express declaration of God's Vicar to the care of the King of Spain, and it was incumbent upon him to see that it fructified in his fatherly care. The friars themselves were the agents of royal power: Franciscans, Dominicans, Brothers of Mercy, Augustinians or Jesuits sailed West on a royal mission and were under the control of the Council of Indies.

Sacred art – the art of the Conquistadors – can only be understood in the light of these royal laws, which allowed the Catholic faith to unfurl *(explicare* is the word in Church Latin) like a banner, to awe, to convince and so to hold dominion.

This phenomenon of conquest is often interpreted simply as an explosive eruption of greed; but, being Spanish, it was always given legal sanction by an act in writing, and accordingly justified under a seal that was absolute, being sacred. Its forceful purpose was promptly detailed by the royal notaries attached to each expedition and broken up into minutes, reports that travelled back to Seville, despatched with the same fervent care as the cargoes of gold and spices and precious stones, in the same padlocked coffers that returned again to the conquerors, crammed with instructions. And the first concern of these instructions was always the establishment of the Catholic faith.

As early as the third expedition of Columbus, royal directions came to specify that no town should be founded without the presence and blessing of a priest approved by the Council of Indies, and that the first building to be erected must be a church. And the site of this church was fixed at the centre of a strictly ordained plan which Spain owed to the Romans, yet corresponding as it happened with the lay-out

already adopted in ancient Mexico *(fig. IV)*, square-ruled streets in which men were compartmented and quartered, colour by colour, block by block, trade by trade – a human grid *(fig. V)* which reminds one of the Escorial*. And the first expression of the Conquistadors, at the centre of what was to be a great convent, was this building of the church; an act of government, a statement by the prince. It may seem

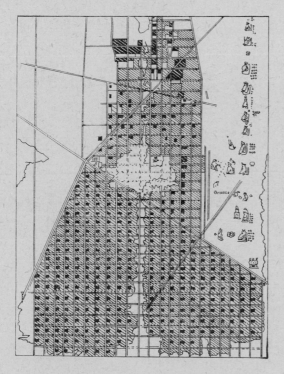

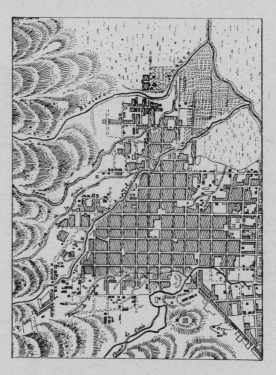

IV PLAN OF TENOCHTITLAN

V PLAN OF CARACAS

extraordinary that an enterprise born in a legal strait-jacket should succeed, but the prince's law was a function of order, and this order in turn became a function of art. From the first brick the building would rise in complete obedience to the monumental lines of a politican document. A church in Latin America was the seal of their most Catholic majesties on an imperious act and deed of conquest, for the plan was decreed and often the architect too.

The earliest churches were flimsy constructions, hurriedly erected by the soldiers or natives, using wood, adobe, or large sun-dried bricks. Their life was short and later they were demolished to be replaced by larger buildings. A church standing on the high Andean plateau *(plate 169)* shows us what they were like. The plan is a simple rectangle, with a single nave in elevation, covered by a thatched pointed roof which from the front is seen as a flattened triangle, like the Greek pediment. We recognise the rectilinear frontage of the Mediterranean temples, but Spanish hands have added the two towers needed for the bells that sound the hours of office and summon the faithful. This early church, an instrument of worship, houses the Holy Sacrament, the vessels and altar napery furnished by the King. When the church stands among the dwellings of 'naked Indians' or scarcely less primitive natives, it remains very simple, unless the danger of uprisings imposes on it the plan of the fortified convents of old Castile, where the church becomes the keep, surrounded by a square crenelated wall and four chapel towers, called *posas* because on procession days the Holy Sacrament was deposited in them *(plates 2,3,5,96)*. But in more civilized regions, where there were pagan sanctuaries decorated with idols and frescoes and bas-reliefs, and the new building often rose from their ruins *(plate 4)*, the church had to be far more imposing; it was not only a means of propagating faith, but substituted the conqueror's art for another. Take for instance the Church of the Dominican Convent at Tepotzotlán 1560-1570; *(plates 57 and 170)*. Domingo de l'Anunciacion evangelised the district between 1551 and 1559, and his early mission church, rising from the *teocalli** of the god Ometochtli, was devised on a very simple plan. This was retained, but the new portal was carved, and divided the front into three: the doorway, framed in short columns and decorated with the seals of the order of St Dominic; a triangular tympanum with the Virgin of Guadeloupe between two saints; on either side of this triangle two kneeling angels, at the edge of the third, bare part, with a single window above. The carvings, which are of the

'Oceanic Gothic' style, a mixture of the Isabelline and the Plateresque*, are in low relief, cut into the stonework, and are entirely in keeping with the extreme architectural simplicity of the frontage.

The work was nearing completion when the Dominicans set about building the church of their convent at Oaxaca *(plates 99, 171 and 177)*. It was to be the largest in New Spain, and Don Antonio de Villaseca allotted them thirteen thousand gold *pesos* towards the cost. This church, completed at the beginning of the seventeenth century, was still on the same plan, and continues the logical evolution begun at Tepotzotlán, but presents quite a different appearance: carving has now invaded the façade and the two belfries; only the two towers are left bare. The ornamentation, no longer Gothic except on the tympanum, is in bolder relief; there are, for example, fully rounded statues set in the niches between Corinthian columns. The columns on the belfries are Doric, with an entablature of triglyphs. The façade, quadripartite, rises to the pediment, to which the belfries are linked ornamentally, whereas architecturally they are separate – a device achieved by carving which cunningly simulates architectural unity, the work of master masons well trained in the classical conventions of their art. Even at Tepotzotlán a Spanish architect is thought to have been called in – Francisco Becerra, a pupil of Herrera who worked at the Escorial*. At Oaxaca there can be no doubt that the classical style of the Counter-Reformation* *(plates 5 and 8)* asserts its influence, and with the approval of the authorities; the Council of Indies at Seville had specified both plan and architect. In 1552 Puebla de Los Angeles obtained a royal *cedula* authorizing him to build a cathedral *(plates 12, 13, 14)*; it took him more than twenty years to reach the building stage, and when work began in 1575, Claudio de Arciniega, the Creole architect, was only a contractor under the direction of the colonial Becerra, who himself came under the control of Herrera, who in his turn, was following the precepts of Vignola*. Vignola himself, the great Italian architect, might have worked on the Escorial if he had not

preferred to succeed Michelangelo at St Peter's in Rome, rather than go Madrid.

It was the Gesù church at Rome *(plates 180, 181, fig. VI)* which brought fame to Giacomo Barozzi di Vignola (1507-1573). Its individual plan – a single nave with shortened transept topped by a dome – is considered to have been the model for Spanish churches in the days of the Catholic Kings, and served as a pattern in Spanish Christendom for more than a century. As there are no aisles the worshipper is compelled to attend to the preacher; he cannot withdraw into darkened aisles for private prayer; and the dome, if he is a simple soul, invites his awe at the majesty of

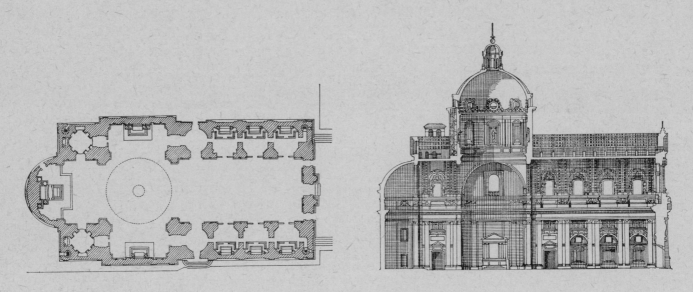

VI ROME, THE GESU CHURCH

the interior. A dome, of course, also allows one's thoughts to wander if the sermon is boring, but only upwards towards the painted over-arching sky. The painted sky in the Gesù instructed the eye in the hierarchy of the saints and angels and archangels grouped around the symbol of the Saviour of men, truly an edifying lesson for a

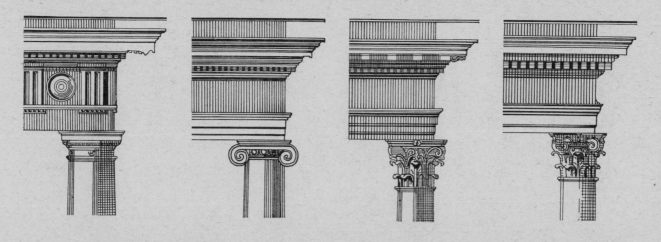

VII ORDERS OF VIGNOLA (EIGHTEENTH CENTURY)

subject people: and colonial churches across the seas vied with one another in copying it *(plates 87 and 89)*.

These merits, combined with great simplicity of construction, made Vignola's church an admirable instrument for the conquest of souls. It had, however, just one defect: the austerity of the façade. So colonial churches in America remedied this by keeping two towers but linking them to the classical scheme by the artifice of sculpture. In the case of Santa Monica at Oaxaca (1682-1695), the architectural separation of the towers had been concealed from the eye by a massive coating of writhing stucco-work *(plate 172)* plastered over the functional design. Yet the façade obeys to the letter those laws which Vignola laid down for ornamental architecture – four parts, four orders, rising from stern simplicity to splendour above: Doric at the base, Ionic for the tympanum, Corinthian aloft, and composite style for the pediment to frame the Virgin, majestically alone, *la Soledad*, in her place of honour. Thus Colonial Baroque gets round the classical formula while yet respecting it, just as the Conquistadors respected the King's laws while they did as they liked. This blend of skill and cunning was countenanced by Cortés, the man who allowed it to develop.

25

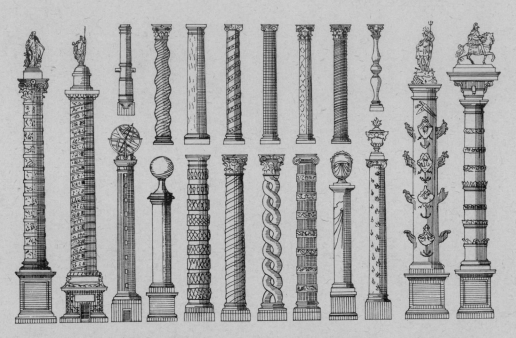

VIII UNORTHODOX COLUMNS (EIGHTEENTH CENTURY)

Church builders were as wily with aesthetic rules as he was himself with laws. Colonial Baroque may be called a Machiavellian architecture, without conscience in its handling of inferior material, practised by a clan obsessed by the laws laid down for it in Madrid – laws which had to be broken before the architecture could come to life.

The lack of hard materials or their danger, the use of stucco and *quincha*, a mixture of clay and reeds, encouraged such architectural devices. 'Earthquake Baroque' was a purely provisional art which, like the Catholic empires of America, lasted miraculously. Fragile and precarious though it may be, it compensates for lack of solidity by mocking up those shapes and designs which were so eagerly studied in illustrated treatises *(figs. VIII and IX)*. Even in the nineteenth century Mollien could express his surprise: 'Of all arts, architecture is the one which has most progressed in Columbia,

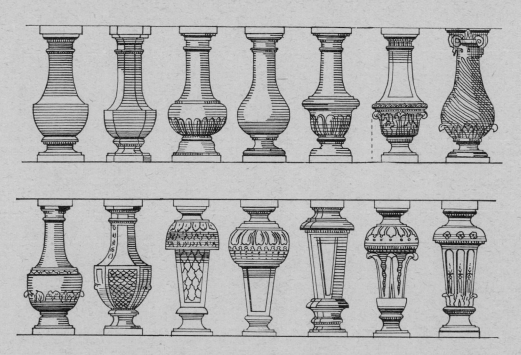

IX BALUSTERS (EIGHTEENTH CENTURY)

and its success is the more surprising because the only masters to guide it were books and engravings.' The mouldings, bosses and columns ordinary and extra-ordinary, the divers pedestals, cornices and balusters illustrating a little 1760 pocket edition of Vignola, were indeed the sacred pictures of a religion of the beautiful, to which the wealthy miners of New Spain made frenzied offerings with the help of their craftsmen, Indian or half-breed. Under their eager hands stones began to rise, obedient to classic forms, at Tasco *(plates 15,16)*, Ocotlán *(plates 17 and 173)* and Tepotzotlán *(plate 62)*. The formal quadripartite façade still remains, but under a swarming mass of carvings. First of these, and one of the most triumphantly success-ful, is the twisted column used by Giovanni Lorenzo Bernini* 1598-1680. It is then supplanted by the irregular column, exuberant and Churrigueresque*, which ignores the proportions of the five orders, and here the carver, working like a

leisured shepherd on his crook, has spent many hours adding flower to flower and volute to volute *(plate 17)*. The work lavished on the interior seems now to have crept outside; the façade has become as rich as the reredos within – only the wrought material has changed. It is as though the ornamental seed cast at the foot of the high altar had germinated, thriven so well that, after sending tendrils up to the arches, it had then pushed through oculi, through the main door, and triumphantly spread its inventions over the belfries. By the eighteenth century the façade of a Mexican church has completely concealed its architectural form; it has become the delicate enrichment without of the ostentatious pomp of the religious celebrations within, also expressed in the dais, the triumphal arches, the tombs, the interior generally *(see plates 178, 179)*. In the sixteenth century Vignola had said that 'mouldings are to architecture what letters are to writing'; Baroque writing is always inventing some new loop, some new flourish. Soon the capitals of those essential columns in their five Classical orders are not enough to dignify the new nobility, whose gold is breeding painters, sculptors and architects.

A host of new forms emerges – the twisted, the heroic, the astronomic, the bellicose and funerary, the rostral, triumphal and pastoral, and genealogical of course; it is the fanciful outgrowth of a new ornamental vegetation, soon to flourish in complete independence. A parish church at the gold mines of New Spain, in Peru* or Brazil*, is a temple to Fortune, and it is unquestionably she who appears *(plate 69)*, blindfolded and holding perhaps letters patent of nobility in her hand, on the main portal of the church at Tasco *(plates 15,16)* beneath the Holy Sacrament. The church was erected in 1751 by José de la Borda, the miner, for his son Manuel, the priest. A church, did we say? A cathedral rather in size, and twin towers would have proclaimed it as one, if the vicar of the next parish, Guanajuato, had not felt jealous at the thought of all this pomp for a petty priest only just ordained! He began proceedings and after five years of argument, won his case: the second tower was not

built. La Borda must have felt as heavy at heart as if the King had taken away an honourable piece from his coat of arms. This lack of proportion – measure, the Greeks would have said – between a social event and the building which records it – is itself essentially Baroque.

In America the gold-washers would build a church at the very mouth of their mines and dedicate it to some saint of Estremadura or Castile to whom they thought they owed their fortunes. This had been a tradition since the day of Columbus. When gold was brought to the explorer, he used to go to his oratory, kneel down with the nugget in his hands and, asking all present to do likewise, he would say: 'Let us give thanks to the Lord who has made us worthy to find all this wealth...' Such reverent communion calls to mind a remark of Las Casas: 'Christians showed in the Indies that gold was their God.' From the façades and arching domes, Baroque angels proclaimed golden oracles to the sound of trumpet and cymbals, violin and lute; gold it was that created the Virtues and the Powers, the Principalities and Dominions, gold swelled the cheeks of Cherubim and made fast the seats of Thrones, the finest gold leaf shone bright upon the hair of Seraphim; gold was truly the metal closest to God and the Sun-Christ who ripened it in the mountains; every step nearer to gold was a step nearer to God.

Thus, in America as in Europe, gold was the leaven in the bread of Baroque. In chemistry a catalyst is said not to mix with the reaction, neither reduce nor increase the molecular weight of the elements concerned: the same is true of West Indian gold; in the long run it did not make Spain any richer, and it certainly did not enrich the Indians, but it helped Catholic architecture to spread across the continent with amazing speed.

There were three great spurts or drives in this colonial art, one in Peru in the sixteenth century, one at the beginning of the eighteenth century in New Spain, and a third in Brazil at the end of the eighteenth century. They coincided with the silver,

gold and diamond rushes in these three countries, centred round Lake Titicaca and Potosí, Tasco and Guanajuato, Minas Geraïs and Ouro Preto. And to each corresponds a European architectural style that underwent change in the New World: *Mudéjar* and Isabelline Plateresque *(plate 167)*, the Roman classicism of the Counter-Reformation *(plate 181)*, and two Baroque styles, the Churrigueresque and Lusitano-Austrian. Colonial art carried yet further what was already ostentation in Europe, as if the gold of America, which played some part in European art, gave it new life and vigour when it reached this land which had helped in its development. And this magnificence, though often meretricious, mere display – how afraid Baroque is of losing face! – could even cast a spell over travellers. In 1823 Bullock exclaims in all seriousness: 'Such is the splendour of the churches and other religious edifices, such the wealth of their endowment, that in this respect Puebla surpasses even the capital of the Christian world.' Puebla was then a town of ninety thousand inhabitants and boasted a cathedral, sixty churches, nine monasteries, thirteen convents and twenty-three colleges; nothing was spared in the townsmen's zeal to tell one and all how great was their good fortune, their success, their faith in the present, the future, in eternity. There was something of every style: ribbons, bells, finials, fillets, ova, chequerings, paternoster beads, roses, traceries, arabesques, *chinoiseries*. Just as the King's designs and plans were smothered by the exuberant vanities of his subjects, so his architectural rulings were flouted by Indian craftsmen using sculpture as their means to conquest. From the seventeenth century onward Puebla was the centre of an Indian craftsmanship closely linked with the pre-Columbian traditions; by the middle of the eighteenth century it reached a nervous pitch that defies description, so strange and urgent was the faith that inspired it.

Architecture in the Latin colonies was rarely in the hands of either half-breeds or Indians. The plan of a church might be called a matter of dogma, the concern of theologians who were pure Europeans, while its ornamentation was a liturgy, open

to as many free interpretations as there were nations, or indeed races among these nations. Native originality, Peruvian or Mexican, is only apparent in the minor themes belonging to ornamentation and this of course explains its unique proliferation in Colonial Baroque. Here only was the native able to give free rein to his decorative ideas, handed down by potters and weavers through long centuries before the arrival of Columbus. In this domain he could re-conquer the art imposed upon him, use his traditional geometric patterns, especially the theme of the serpent or reptile with the overlapping scales and upturned tail. This constantly recurs in the pre-Columbian art of Mexico and Peru *(fig. XXII and plate 123)*. And the altar-piece, a product of local art, lent itself to such native treatment. Theoretically the Spanish reredos is a combination of Italian architecture and Flemish painting, the one serving as frame to the other. (The father of Alonso Berruguete (1486-1561) was a pupil of Van Eyck, and he himself a pupil of Michelangelo* and Raphael, as well as Bramante, the founder of classical architecture). But in fact it was the work of local craftsmen: the flamboyant Flemish reredos, in the hands of the old Moorish or *Mudéjar* craftsmen of Spain became a flourish of stucco, the *plateros en yeso*, and with its arabesques intermingle the scrolls, festoons, volutes, shells and fruits of the Roman mannerists. This profusion of ornament in the earlier colonial altar-pieces does not swamp the pictures, which still stand out, rising in tiers above the high altar, just as the carvings mount on the façade outside. The reredos at Yannuitlán, 1575, *(plates 18 and 175)*, towering up monumentally to an arch that remains Gothic, still allows the pictures to dominate the whole; so also at Huejotzingo where a Flemish artist worked: Simon Pereyns (1586), who founded the school of Mexico*. Both these derive from the *altar mayor* of the Escorial, which served Spanish Christendom as a model for more than a century and has its paintings framed in the Corinthian and Composite orders. Colonial work during this century shows restraint and even a certain severity in its ostentation, which corresponds to some slackening in the yield

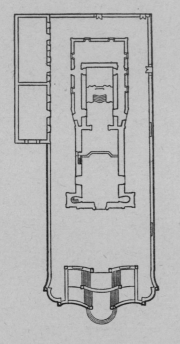
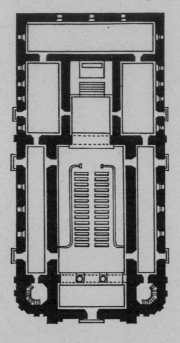
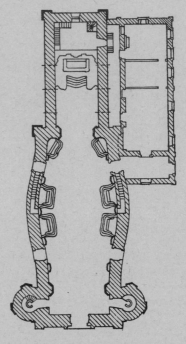

X CONGONHAS DE CAMPO, PLAN OF THE BOM JESUS DE MATOSINHOS

XI SAO JOAO D'EL REI, PLAN OF THE CARMELITE CHURCH

XII SAO JOAO D'EL REI, PLAN OF THE CHURCH OF SAO FRANCISCO

of precious metals from the mines. But a new influx of Mexican gold at the end of the seventeenth century gives sculptors fresh impetus, encourages the inflated ornamentation of Borromini* and José Churriguera, which was taken yet further by his pupil Ribera, and still further again in Mexico by Jeronimo de Balbas in the Altar of the Kings (1718). To what extremes, then, would his son proceed at Tasco, if this orgy of decoration was to continue?

Tasco means, in Nahuatl, Place-where-the-ball-game-is-played. And how this Mexican ball rebounds! Over the façade, over the reredos *(plate 100)*, and at every point of impact yet another volute springs out from volute in a new spiral. One would like to study this activity in slow motion, analyse the detail of this transformation,

32

due in its greater moments to Borromini, Churriguera and a Creole! But it is impossible to dwell on any single detail; one is hurried along as the ball strikes again and again, thrown from the hand of some Indian craftsman, tapping here, there, everywhere, in the dome, on façade and altar-piece, at Ocotlán, Acatepec or Tonantzintlan *(plates 11, 17, 30, 55)*. Bernini's celebrated twisted column at St Peter's *(plate 168)* was still an architectural member, and the decoration added by Francis the Fleming remained discreet. But what can one say of the columns of Mexican Churrigueresque and Andean Baroque *(plates 19 and 123)*? Here all the potential ornamentation which Bernini had unconsciously put into his spirals is given free play. At La Compania de Quito *(plates 120 and 176)* and Oaxaca *(plate 177)* and Tepotzotlán *(plate 70)*, the interior of the colonial church is smothered in carvings, just as a tree coated with ivy and convolvulus soon dies and becomes an invisible skeleton supporting the soft green growth with its bony framework. The full history of this architectural ornament – of all these artichokes, cauliflowers, chicories, urns, balusters and what not – would indeed be revealing for a student with enough patience to follow out its evolution. But it would be an endless task, so fertile is this begetting of ornament from ornament, these off-shoots and divisions endlessly propagated; or perhaps one could compare it to a biologist's enquiry into the lesser mutations of the original stock in countless families. One of these families is American and subdivides in dozens of relationships – with the Aztecs, Olmecs, Chicimecs, Mayas, Chibchas, Quechuas*, Aymaras* – marriages between cousins white and black and red. In a Latin American church all this adds up to an awesome medley of shapes and forms. They are born, they flourish, they decay and take on new life even in their decay; a bewildering world of souls, as Plato would have said.

But even as sculpture in Peru and New Spain, riotous and triumphant, plunges into the further extravagance of the Churrigueresque (complicated also by pre-Columbian reminiscences), far across the continent of America, in the Portuguese

territory of Brazil's mining region, colonial architecture is sobering down. The façades of the churches at Ouro Preto or Sao Joao d'El Rei are bare of superficial ornament concealing the plan; the towers stand well apart, the façade rises between with the grace of a growth that is clearly trimmed and controlled by master hands who know how to keep to essentials *(plates 146,155 and 174)*. Here is the work of master craftsmen who have the secret of that simplicity to which the best designers were reverting in Austria and Portugal. In the early mission churches of Mexico or the Andes this simplicity was of Romanesque or Mediterranean origin, but the church of the Brotherhood of Minas Geraïs is something quite new and also extremely complex, for it conceals a plan that is sometimes very subtle – the elliptical church-plan drawn by Serlio* in his treatise, and by Vignola in 1572 for Santa Anna dei Palfrenieri and by Borromini in 1638 for San Carlo alle Quattro Fontane. By rounding the corners of the classical rectangle, the master-builders achieve a polygon, an oval, an ellipse – witness the Church of St Francis at Sao Joao d'El Rei *(plates 147 and 174)*, or an irregular dodecagon – the Madonna of the Pillar at Pombal – and in 1784 reach the height of subtlety with a plan combining two ellipses in the Rosário at Ouro Preto. Five years later, this mining region rose in rebellion against royal authority and claimed independence. So the great architectural phase of Baroque, which invents a new building instead of masking the old by artifice, comes in Latin America just as the Catholic empires are about to crumble.

NOTES ON THE ILLUSTRATIONS

I Colour plate facing page 12 TEPOTZOTLAN Decoration in the chapel of St Joseph's shrine *(see plates 70,71)*. Example of the use of imitation gold in Baroque decoration *(see page 69)*. Compare the treatment of these black sirens with the stone reliefs of Andean art, *plate 123. For* Tepotzotlán *see plates 60-64.*

II Page 18 CHOLULA, plan of the royal chapel of the Franciscan convent (1549-1552), built over the remains of a native sanctuary *(see plate 4)*. From *Arte Colonial in Mexico* by Manuel Toussaint, fig. 23.

III Page 19 ROYAL FLAG OF SPAIN, white, decorated with the Order of the Golden Fleece; in the first quartering, the arms of Castile and Leon, in the second those of Aragon; also bears the arms of Sicily, Granada, Portugal, Austria, Burgundy, Brabant, Flanders and Tyrol. From *Les Pavillons ou Bannières que la plupart des Nations arborent en mer*, Amsterdam, 1718.

IV Page 20 PLAN OF TENOCHTITLAN, the ancient Mexico, drawn by order of Montezuma; after Bullock, *Six Months' Residence and Travels in Mexico*, London, 1824 and *Les Voyageurs anciens et modernes*, vol. 3, Paris, 1855.

V Page 21 PLAN OF CARACAS, founded in 1567 by Diego Losada, capital of the provinces of Venezuela and Guiana. At the end of the eighteenth century the town was an archdiocese, with a cathedral situated in the centre, nine parish churches, six convents, five hospices. From *Voyage à la partie orientale de la Terre-Ferme dans l'Amérique meridionale* by François Depons, Paris, 1806.

VI Page 24 THE GESU CHURCH IN ROME, plan, section and elevation, from Aviler's *Cours d'Architecture qui comprend les Ordres de Vignole*, Paris, 1760. See also plates *180,181*.

VII Page 25 ORDERS OF VIGNOLA after Aviler, *op. cit.* From left to right, the Doric, Ionic, Corinthian and Composite capitals with their entablatures.

VIII Page 26 UNORTHODOX COLUMNS, after Aviler, *op. cit.* Columns above are the warlike, twisted and fluted, pastoral, hydraulic, trellised, leaved, fluted and baluster; below, the colossal, isolated and hollow columns, also called historic; the astronomic, mile, marine, cabled, open twisted, gnomonic, funereal, rostral, triumphal.

IX Page 27 BALUSTERS, after Aviler, *op. cit.* These are, from left to right: the Tuscan, Doric, Ionic, Corinthian, Composite, pedestalled, fluted, girdled, pannelled, rustic, urn, reverted and vase.

X Page 32 PLAN OF THE BOM JESUS DE MATOSINHOS at Congonhas do Campo, Minas Geraïs, after P.F. Santos and Germain Bazin, *L'Archtecture Baroque Religieuse au Brésil*, Paris, 1956 and 1959. *See plate 155.*

XI Page 32 PLAN OF THE CARMO at Sao Joao d'El Rei, after Juan Ginria and Germain Bazin, op. cit. *See plate 146.*

XII Page 32 PLAN OF SAO FRANCISCO at Sao Joao d'El Rei, after P.F. Santos and Germain Bazin, *op. cit. See plates 147,174.*

1 MERIDA (YUCATAN) Archaeological Museum. Painted wooden panel probably representing Cortés. End of sixteenth century.

2 CALPAN (PUEBLA) Franciscan convent (1540-1550) in the Province of the Holy Gospel. By the end of the century there were twenty-six convents of this fortified type, deriving from Old Castile. At Calpan Cortés received an embassy from Montezuma, offering to pay him annual tribute if he did not enter Mexico (1519). *See plate 96*, showing a cell in this convent.

3 HUEJOTZINGO (PUEBLA) Franciscan Convent of San Miguel (1529-1550), a *posa* in the Isabelline style of Torribio de Alcaraz; there was one *posa* at each angle in the fortified walls, serving as a station on procession days. The native republic of Guaxocingo or Huecingo was in alliance with the Republic of Tlaxcala (Puebla); it submitted at once to Cortés and took part in the capture of Mexico.

4 CHOLULA Cupolas and lanterns of the *capilla real* of the Franciscan convent (1549-1552), combining the Moslem mosque with the Aztec *teocalli: see plan, page 18.* Cholula was a republic in alliance with Montezuma, and the high place of the god Quetzalcoatl, who had a shrine there at the top of a pyramid called Mountain-of-unbaked-brick, Tlachihualtepec, built by the god architect Xelhua; its hieroglyphic paintings were investigated in 1566 by the Dominican Pedro de los Rios. When Cortés seized the town, it had three hundred and sixty *teocallis* and twenty thousand houses. Between three and thirty thousand people were massacred there (1519); Cortés had a temple cleansed to allow Oviedo of the Order of Mercy to celebrate mass inside. The number of these cupolas is the source of the legend that the churches built there by Cortés equalled the number of navite temples.

5 MERIDA (YUCATAN) Nave of the Cathedral of San Ildefonso (1579-1599), by Juan Miguel de Agüero, who also worked on Mexico Cathedral. An example of the severe Counter-Reformation style. See also *(plate 8)* the interior of Puebla Cathedral. It was on the day of San Ildefonso, 21st February 1541, that the Spaniards made peace with the Maya king Mani.

6 OAXACA Dome of the Cathedral. Built in 1535 for Lopez de Zarate, it was the seat of the first Indian bishop, Don Nicolas del Puerto (1679-1681). Destroyed by an earthquake, it was rebuilt in 1733 on the geometric plan of the Spanish architect Simon Garcia (1681). Oaxaca, chosen by Cortés for his title of Marquis, was founded in 1522 by his lieutenant Nuno del Mercado, evangelised in 1535 by Bernardo d'Albuquerque the Dominican, appointed bishop there in 1559. The town was an important centre for native Zapotec and Mixtec sculpture; the names of fifty craftsmen are known between 1680 and 1800.

7, 11 MERIDA (YUCATAN) Caryatids of the *Casa de Montejo*, built in 1549 by order of Montejo the younger in the Plateresque style by a native master-mason. Conquistadors in helmet, morion and cuirass, holding halbards and swords, are flanked by 'hairy men', a common theme in medieval sculpture, found on the arms of the Dukes of the Infantado at Guadalajara. Francisco de Montejo, a Cuban land-owner in a large way, was short of stature, an excellent horseman, high-spirited and very free-spoken, and over-spent his income. He took part in the Grijalva expedition, in the course of which a soldier declared that he felt he was in New Spain, and this became the name of the continent. A friend of Velasquez, the governor of Cuba, he accompanied Cortés to keep watch on him, but Cortés is said to have bought him over with two thousand gold pesos and an appointment as alcade of Vera Cruz. He left for Spain in 1519 to represent his master there and obtained through intrigue the post of *adelantado* of Yucatan where his cruelty made him conspicuous. Deprived of the post in 1553, he returned to Spain. His son took his place until 1565.

8 PUEBLA Interior of the Cathedral; an example of the Classical style of the Counter-Reformation. For the history of this cathedral, *see page 23.*

9 MEXICO, NATIONAL HISTORY MUSEUM Portrait of Cortés, Marquis del Valle d'Oaxaca, as a captain-general with his Commander's scarf and baton. In the right-hand corner, the coat of arms which he was said to have received by letter patent of 2nd July 1529 after undertaking to give two hundred thousand gold pesos. The arms may be described as follows: quarterly, in the first quarter on a golden field a black eagle displayed with a Royal Crown, also of gold, above its head; the second quarter is black and contains three golden antique crowns; the third quarter shows a rampant lion of gold on a red field, and the fourth shows against a blue background a representation of the town of Mexico in silver, above wavy bars alternately blue and silver symbolising water. Over all a gold

escutcheon charged with two red palets (this would seem to be an incorrect version of the family arms of Cortés, namely four red palets on a gold field within a blue border charged with eight silver patronce crosses). The escutcheon is surrounded by a chain enclosing seven crowned heads, representing the seven conquered kings, Montezuma, Tacamatzin, Guatimilin, Tulapa, Coadlava, Taluba and Cojohuacan.

10 TONANTZINTLAN (PUEBLA) Interior of the church of Santa Maria *(see details, plate 30).* Example of native *poblano* art of the eighteenth century.

12,13,14 PUEBLA The Cathedral (1575-1800); views of the buttressing of the central cupola, and ramp leading to the side roofs. *See page 23* for the history of the cathedral.

15,16 TASCO Church of Santa Prisca and San Sebastian (1751-1758), built by Diego Duran and Juan Cabarello for a young priest, son of the miner Jose de la Borda. *See also plates 25,27,28,41,51,69,100 and pages 28-9.*

17 OCOTLAN (TLAXACALA) Church of Santa Maria (1745-1760). Former *teocalli*; the Virgin was said to have appeared here to a Franciscan in 1541. This, the most characteristic façade of Mexican Baroque, was the work of the Indian Francisco Miguel. *See plate 88.*

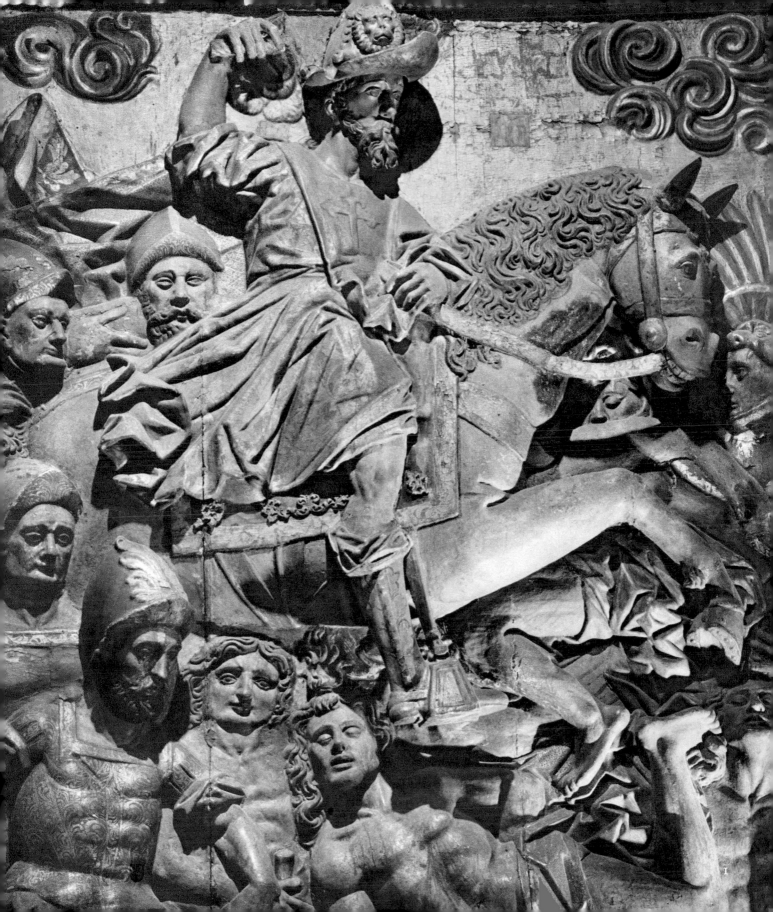

I

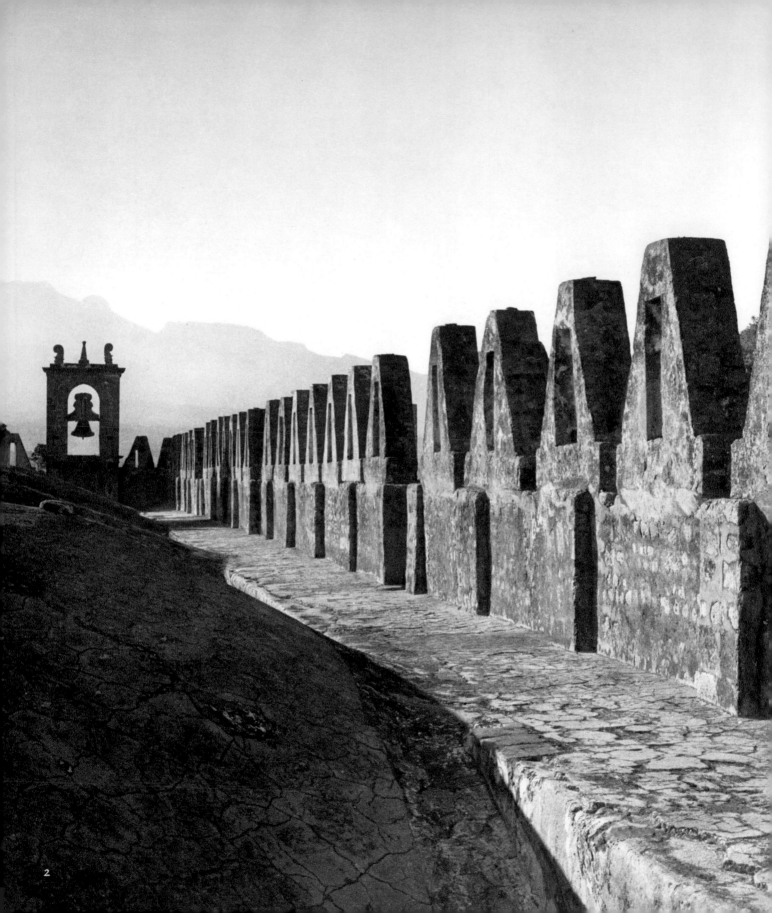

2

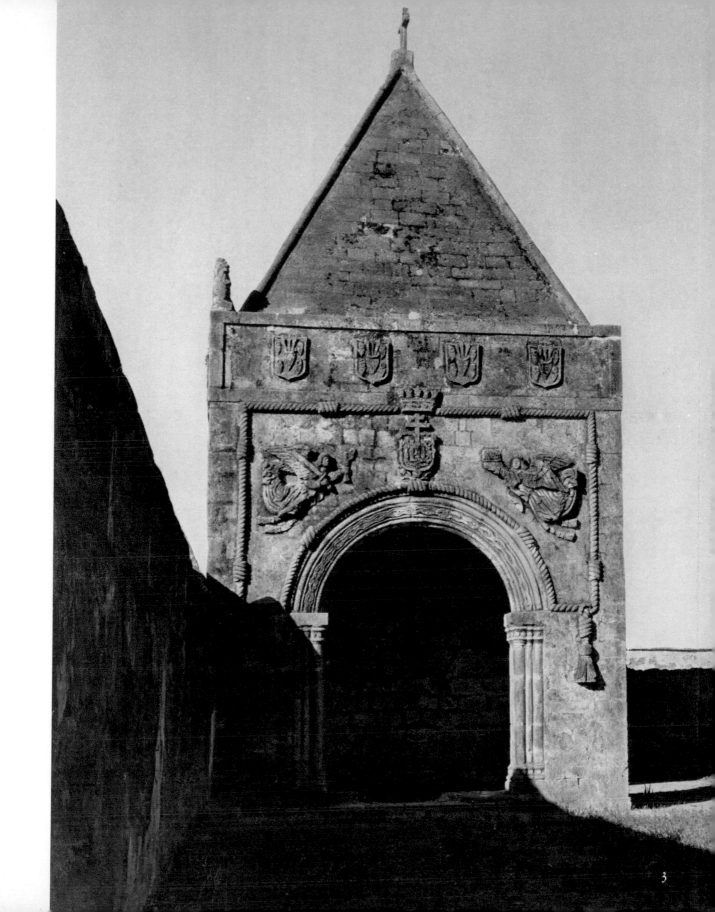

3

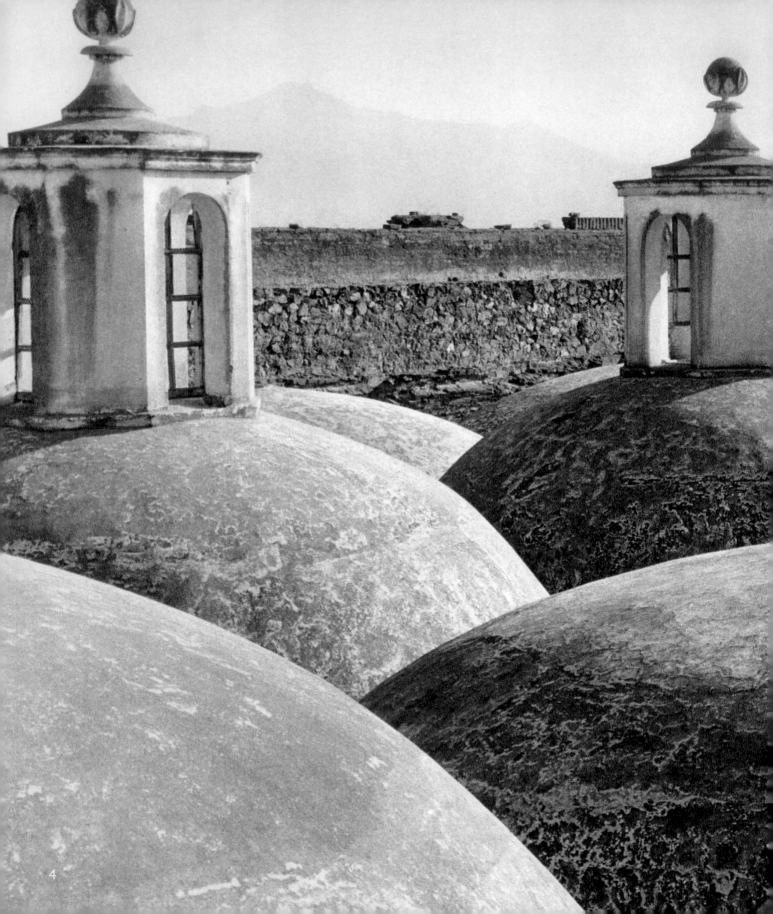

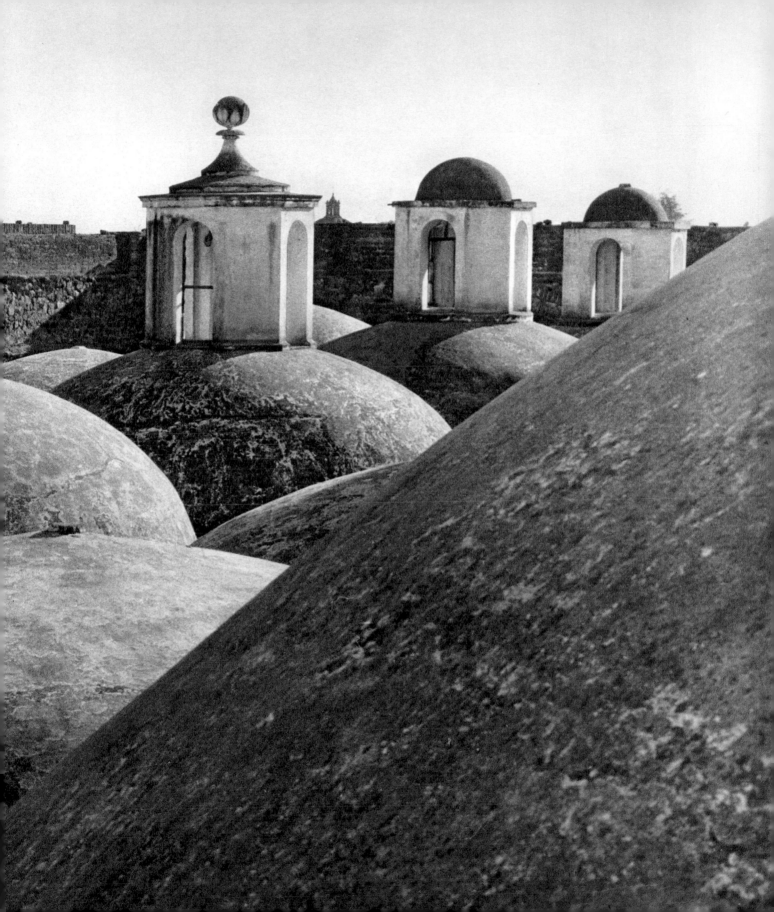

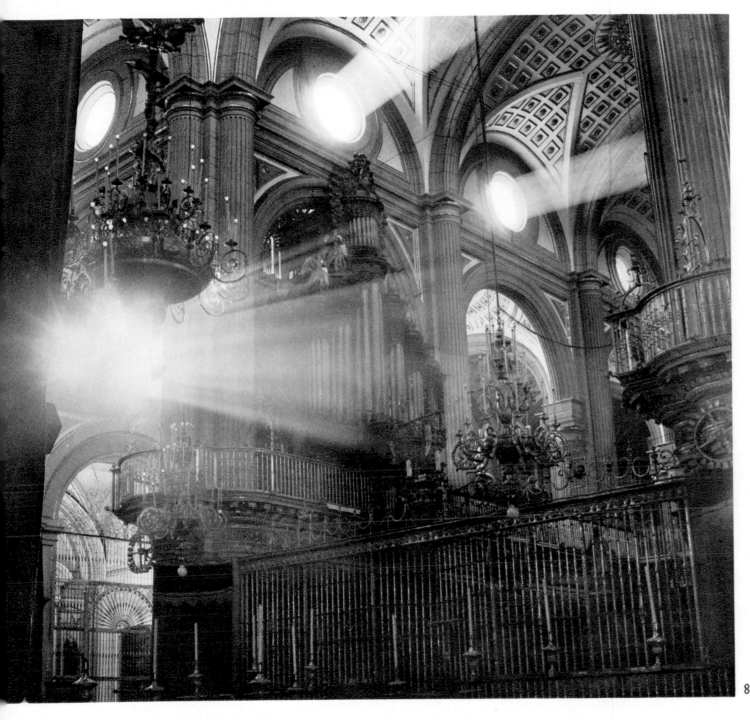

8

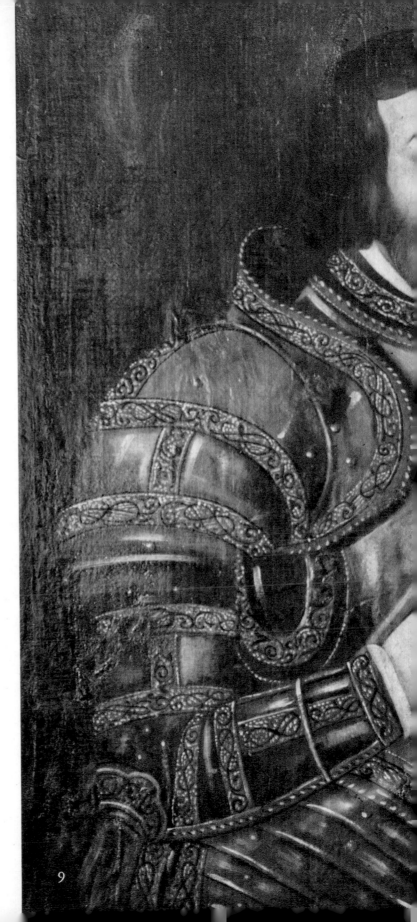

9

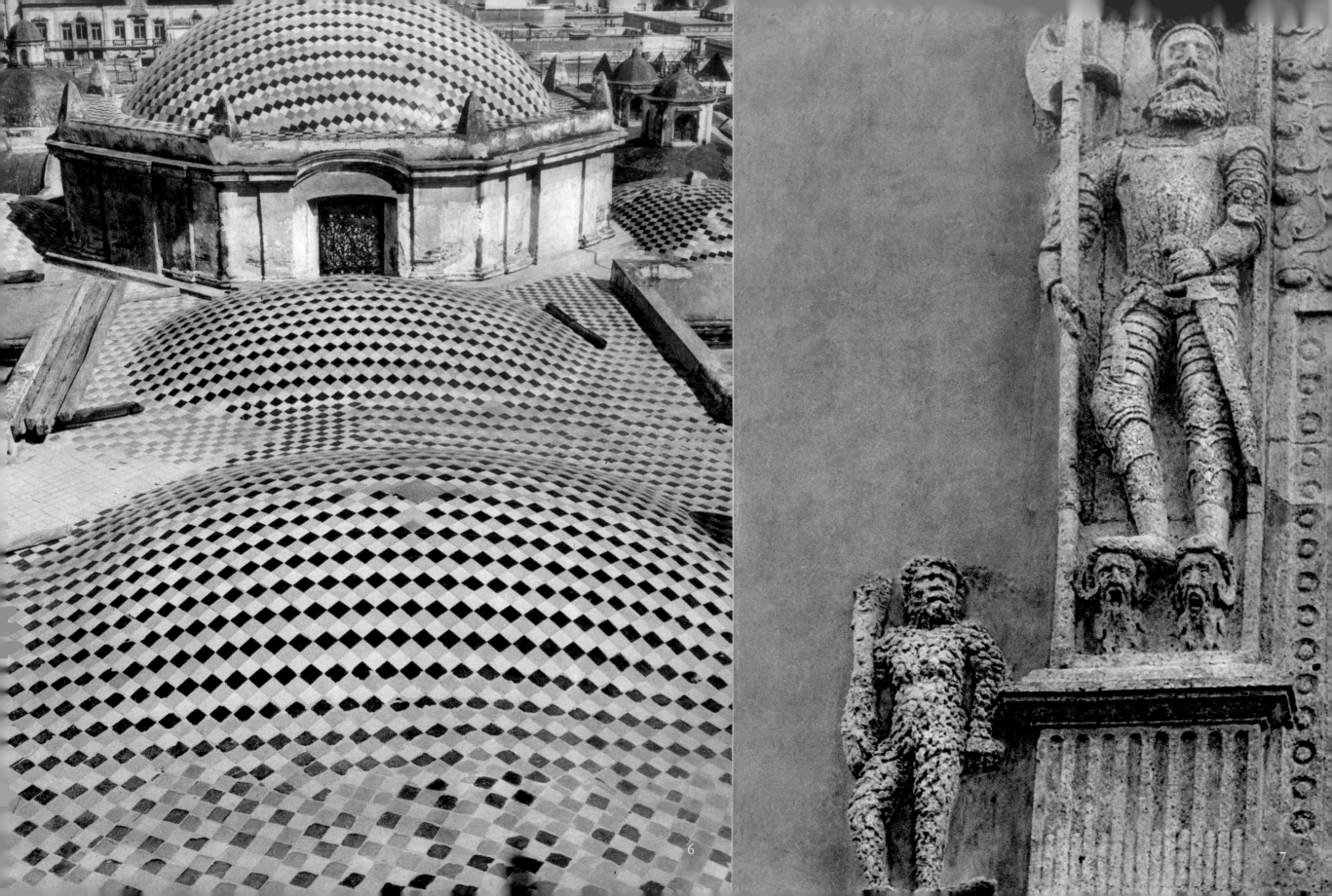

6

7

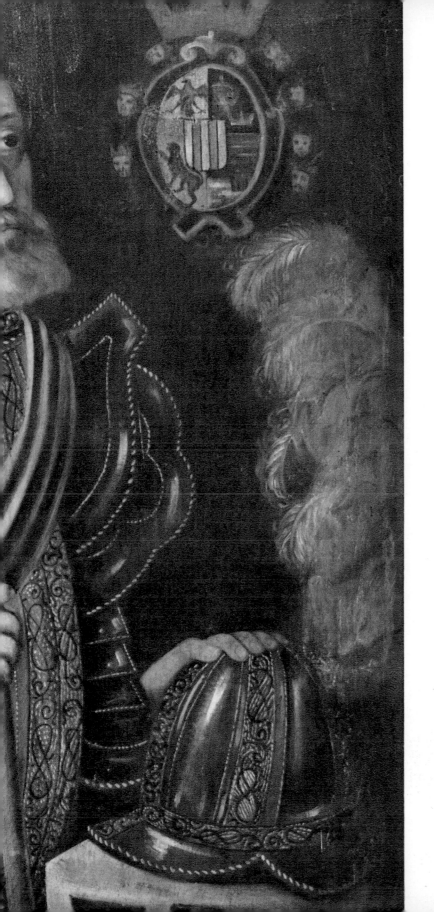

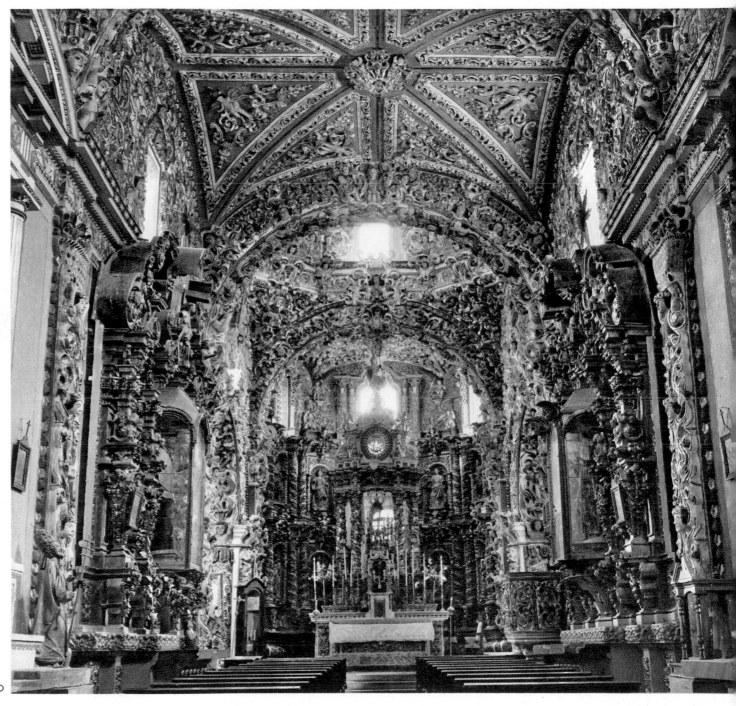

10

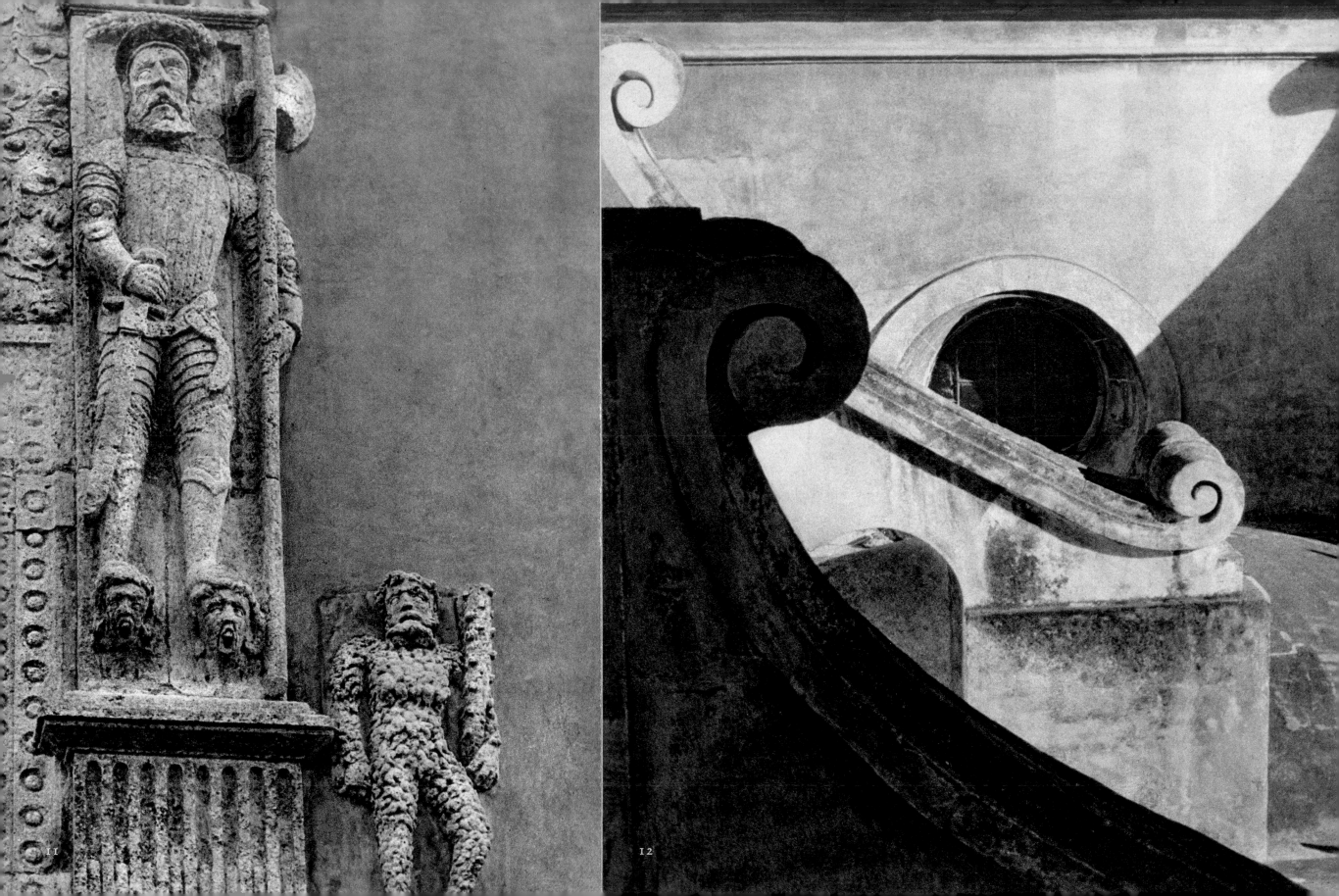

11

12

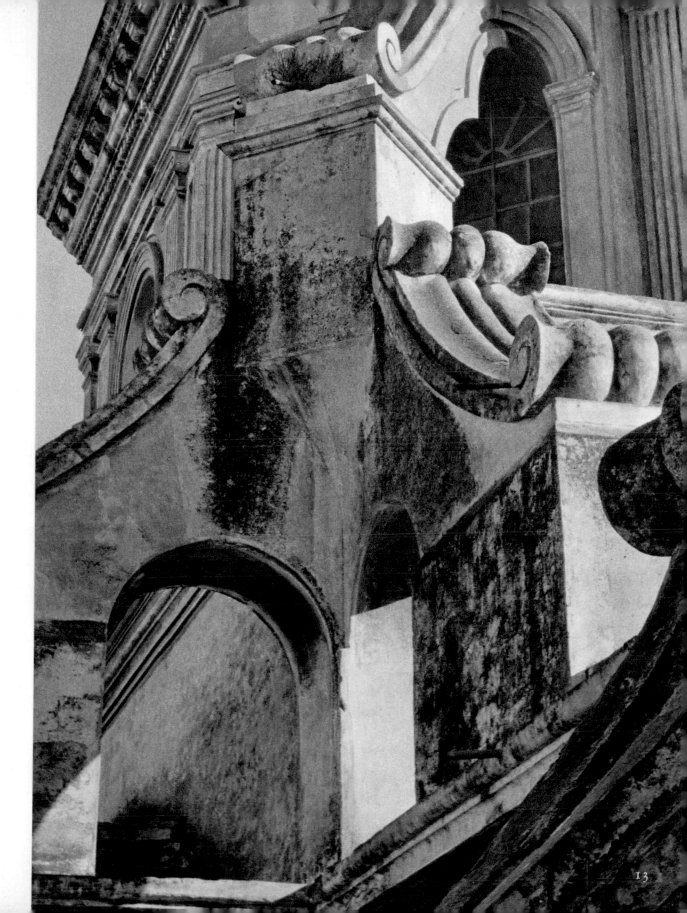

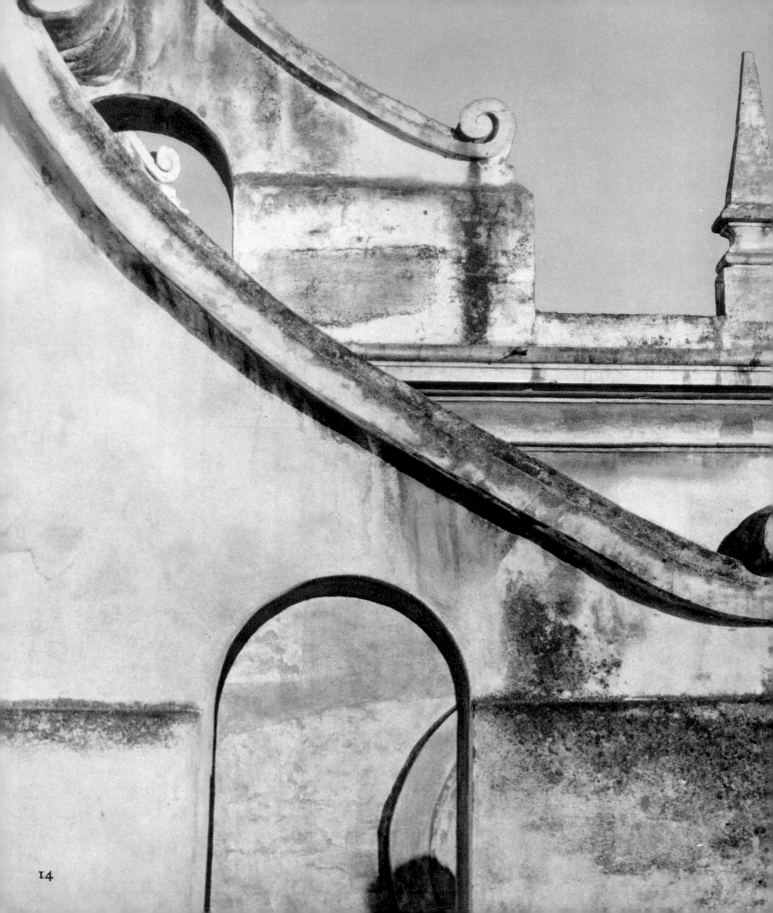

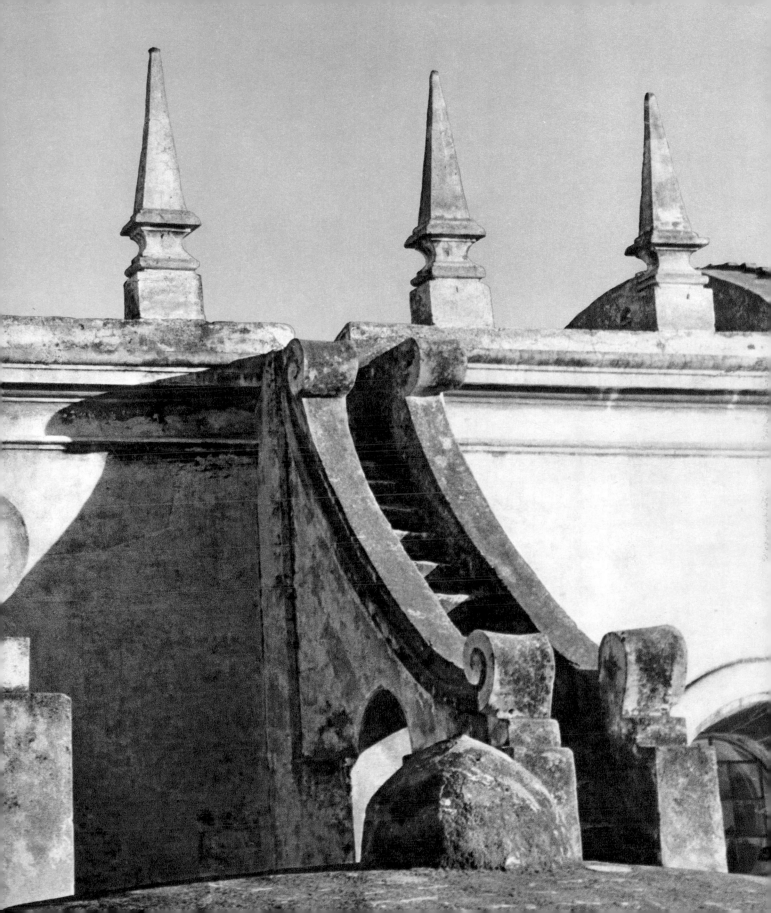

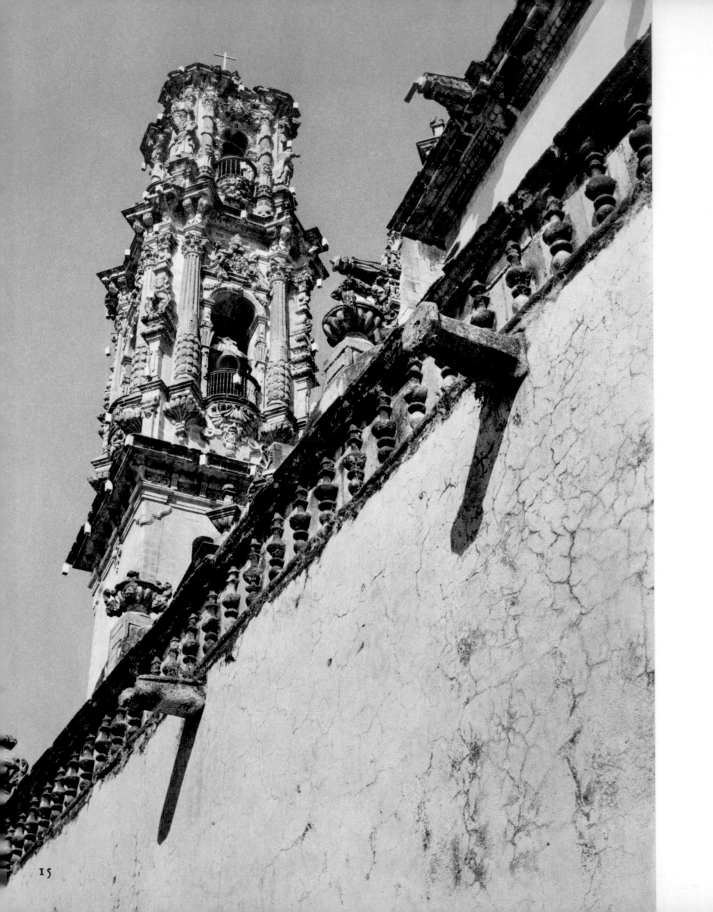

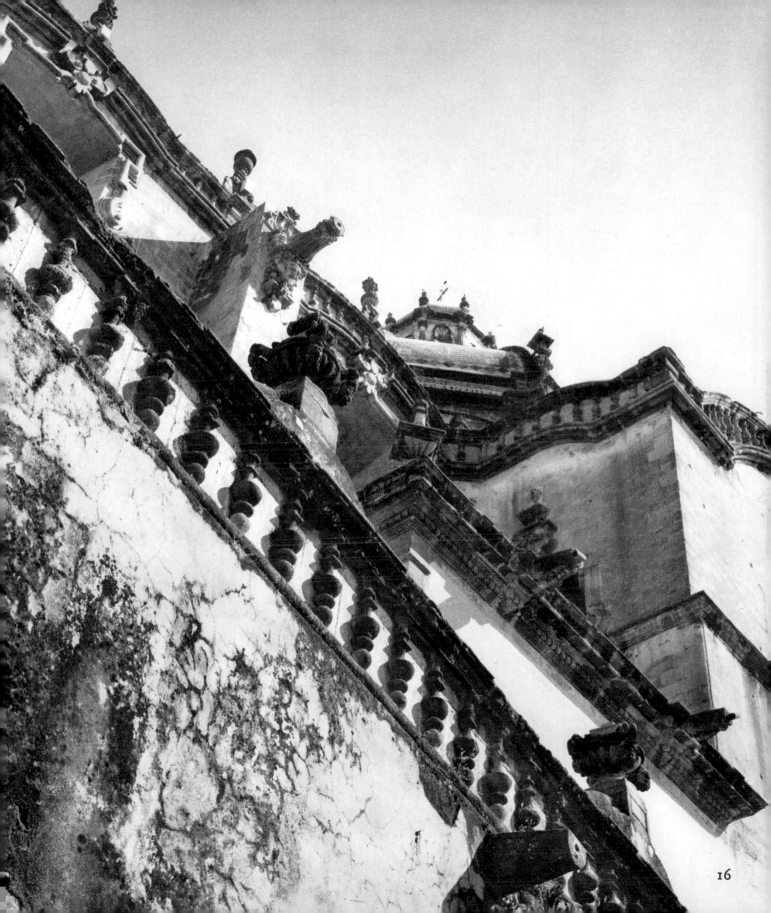

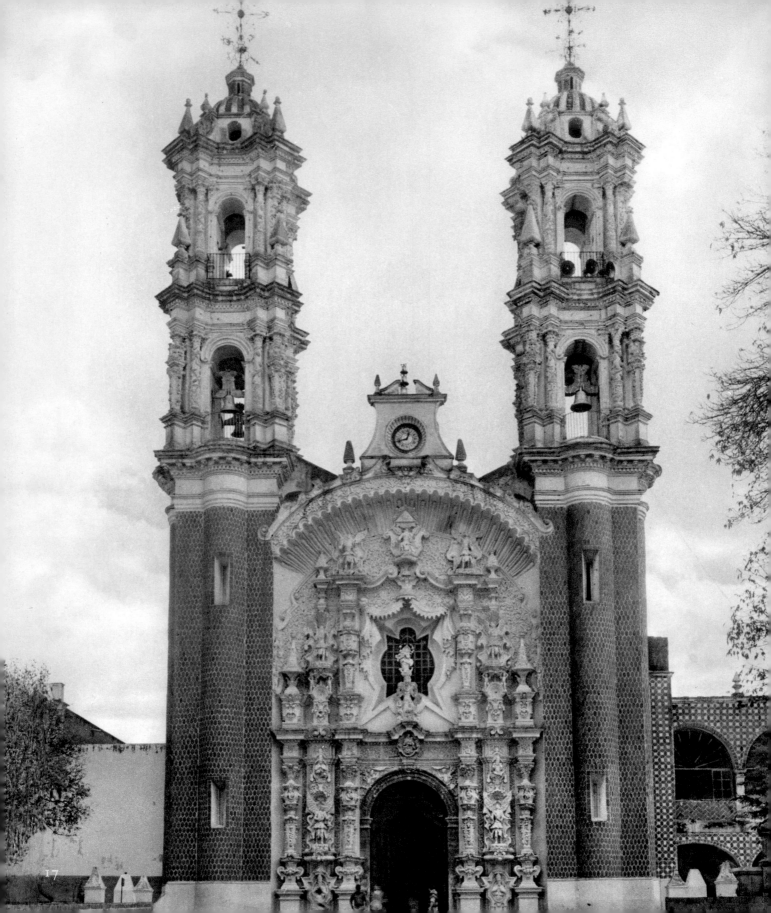

17

II *The Christian Story in New Spain*

THE FUNERALS of the Conquistadors still haunt the fortified churches on the high Mexican plateau *(plate 2)*. Many of them were buried there, with even greater pomp than they had known during their lives. And what is the front or the reredos of a Baroque church but a monumental catafalque?

The art of the funeral, a typically Baroque specialty, first appeared in Europe at the time of the Spanish Conquest; it flourished mightily in the West Indies, where the taste for the spectacular was strong. Four hundred and seventy-seven gun salvoes were fired in salute when the last journey of His Excellency the Viceroy of New Spain began; the body of Juan de Acuna, Marquis of Casa Fuerte, wrapped in the cloak of a Commander of the Order of St James of the Sword, lay under a towering catafalque drawn by twenty-four horses, and the procession of mourners stretched for a mile and more. Four hundred masses were being celebrated at the same time. Every bell tolled, all Mexico was on its knees. It has been said that Death was tricked out in pomp by Baroque to veil its awful presence. No; Death was honoured bravely *(plate 33)*, because men were sure of his defeat, confident that the gates opened at once into everlasting glory; there would be no waiting outside.

A church in Mexico or Peru is a monumental gallery of Christs in death; Christ hanging, Christ sitting, crouching, lying with a sheet drawn up to the chin *(plate 52)*, with a lace cap down to the eyes *(plate 53)*, Christ also resurrected in a robe of silk,

61

amid rejoicing angels and archangels and Christ crucified surrounded by other crucifixions *(plates 35-37,41-43)*. Every landscape lying between the bare Mexican mountains and the forests of the Amazon is a landscape of the Passion, every church that one sees is a cell of agony and death, a labyrinth where every slab is a station of the cross, every storing-place a narrow charnel-house, as it were, so haunting, so pregnant with suffering and death are the statues, effigies and jointed dolls that are kept inside, to be resurrected in broad sunlight on procession days.

Small-pox, vomito-negro, eruptions, cyclones and floods, raids by privateers, Indian bravos, buccaneers or pirates, revolts by the natives, famines: spectacular and familiar, death was always at hand in the Indies, with its usual trail of victims and beggars. In the living-rooms of a Creole there were no flower-paintings, no birth of Venus or pastoral scenes on the walls, only pictures of executions, quarterings, floggings or death-pyres. Every town had a house of retreat where women of *la sociedad* went in Holy Week to be scourged. It was fashionable to belong to a brotherhood of penitents, there was even a subtle distinction made between the orders of Mercy, of St Dominic and St Francis. People went to the great religious festivals as they go to the opera in Europe, booking their seats in advance on account of the crowds. The Indian natives partly came out of obedience, but also because they relished such spectacles, as their harsh cries bore witness, and the hand-claps of the craftsmen who had carved the leading performers in the ritual – the Christs and Madonnas and Saints. The common people formed the red chorus and the vicar was the white hierophant who gave the commentary on each episode of the Passion – Jesus arrested, bound, scourged, bearing the cross, stumbling. And to all these the chorus responded – wailed in earnest, was really frightened, really angry, swooned at the sound of the hammer-blows when a wooden Christ complete with a bladder filled with red liquid, was nailed to the cross. When the cross was set up between the two crucified thieves, one was white and one red so that everyone should be satisfied,

for who could say which was the bad one? Different orders had their own variations in the ritual.

Professional mourners wailed at the foot of the cross, two deacons climbed ladders to loosen the feet and hands of the image, brought it down slowly, dead – ah, see the head drooping! – held the figure out to the sorrowing congregation who began sobbing aloud. And the women became hysterical, longing to feel pain at the pain of this God, fell to slapping themselves vigorously. They were intoxicated with tears and incense, not to speak of maize spirits, like the ten thousand Indians who had been waiting since Saturday on the square in Cuzco in Peru, waiting for the appearance on Easter Monday of the *Señor de Los Temblores*, a block of plain oak with a skirt of English point-lace, and rubies for wounds, diamond-headed nails, thorns of emeralds, and real girl's hair, cut by the lieutenant of police from the head of his dying daughter. A monster puppet jerked by springs, with limbs working convulsively. The crowd at first kept silence when He appeared; then, howling, they rushed upon the thirty bearers carrying the figure, each trying to get a good place, regardless of his neighbour: pleasure enough to last for a year! In the general rush, the Christ of Earthquakes began to sway. Behind, with little steps and slow, walked the mitred bishop. In front, 'like the pistil of some strange flower' went the Madonna, looking down with vacant expression upon the crowd. Her hair was long and fair and wavy, she was sunk deep in a funnel of lace; the panniers of her skirts were six yards round, her robe was of blue and white brocade chequered with gold; her arms, neck, ears and fingers were covered with jewels and in her hand she held a fan. Other figures went before: St Joseph with his plane slung over one shoulder and a peacock's plume in his hat; San Cristobal with his mendicant friar's waxed moustaches; San Benito, black as black, eyes very white and lips purple, loudly insulted by the crowd. First of them all St Blaise went by under a pink parasol, and him they cheered wildly.

Who can tell what the Indian peoples really saw in these images of Christ and his Mother and the Saints, these gifts of Spain? What legends and superstitions of their own did they mingle with those garnered from Judea, the Mediterranean, Castile, Estremadura and Andalusia? The amazing thing about these Christs of Capricorn and Cancer is not so much their fashioning as their numbers *(plates 19,20-29,35-37, 41-43,50-54,141)*. How did the Cross, the tree of faith, manage to root itself so deeply into the souls of these Indians – like those posts hardened in fires on the Equator, on the far borders of virgin forests, which strike root in one night, grow leaves and branches in a week, and teem with resurrected sap? There were no doubts about the success of the Church in imposing its faith on the Spanish West – that was a matter of fifty years – but what prelate or monk could say exactly how the mass of the faithful, the red body of Christ, suffered that faith and lived it? There was more than a whiff of maize spirits about this ceremony of New Spain, this *orgia* in the Greek sense, sacrament and orgy too, that dazed the crowd. Who could say whether all these Christs were not still simply idols, with an ancient earth-dance weaving round them? The very substance of which these Christs were made in mission churches was the substance of the primitive idols which had appalled Cortés. It was a mixture of maize, orchids, cotton, aloe; the only thing lacking was the human blood of sacrifice. A pagan priest had given the secret after his conversion to the Bishop of Michoagan, Vasco de Quiroga (1536-1565), and he started work-shops to produce it. So this unstable blend of the fruits of an unstable earth protected the faithful from the same calamities, in the shape of a lava god or as the Christ of Earthquakes. How would New Spain have answered the celebrated question put by the Inquisition to the Vaudois in the Alps? 'Do you believe that Christ in the Host of the Eucharist is as large and tall as He was on the Cross?' With a *yes* no doubt, but not for reasons of dogma because, in pre-Columbian times, daughters of penitence made rolls in the shape of human bones which were distributed in a kind

of solemn communion – they were the bones of the god Vitziliputzli. And in Inca country the answer would also have been yes, because the Virgins of the Sun made rolls with maize and vicunas' blood which were distributed throughout the Empire; it was the communion of the Inca, the living Sun.

The mystery play of the Passion was acted in Indian America with more talent and perhaps greater fervour than in other lands because the Indies had never ceased to suffer it, had never cast off the horror of human sacrifice, the hell whereby primitive peoples commune with the sacred. America clung to the reality of sanctified murder, and it even happened one Good Friday in Mexico that a penitent volunteered and was actually crucified, with real nails on a real cross, and died of it. What can we say of the cult of the Sacred Heart of Jesus in a land which had seen great heaps of hearts torn from human breasts to be flung, throbbing, on the altar-stone? Just at the time when Europe was attempting to spiritualize the Passion of her God in drama devoted to Beauty, Tenderness and Intelligence, pre-Columbian America, shattered, annihilated in conquest, crawled bleeding but converted to offer this same God all her reality of human suffering. Only the missionaries (and the Jesuits especially) understood these things, when they called on the natives to copy the scourged Christ *(plate 27)*, Christ crawling on his knees *(plate 22)*, Christ crucified *(plates 19,50)*, Christ in agony, calling aloud, dying *(plates 51,52,53)*, Christ with his breast laid open, showing his burning heart. All this realism of a God nailed alive to the cross, pierced with a spear, hanging limp on his cross, with the too-realistic wounds and sores, the upturned eyeballs, the grinning lips drawn tightly across the skeleton teeth – all this Ignatius de Loyola *(plate 32)* had recommended in his *Spiritual Exercises*. To be obsessed, to toy with the idea of death and agony, of the loathesomeness of decay, these he had even recommended for children, for those also being trained to win souls and soil abroad 'for God and King'. He told them that they should keep a skull in their bedrooms, as a useful object of piety,

together with their crucifix, scapular and rosary. In fact, skulls became such popular toys that eventually they were turned into garlands, then, copied in sugar, into sweetmeats *(plate 31)*.

The Indians never tired of the spectacular side of religion; numbers of them were baptised several times for the sheer pleasure of it, which explains the high figures given in mission statistics. The Indians also liked serving; no matter what the enlightened eighteenth-century traveller might say, it was true, for they had been trained to serve by Aztec, Maya or Inca nobles from ages past.

As for their assimilation of European art, we find a problem confronting us. The faith of a Conquistador, the control of architecture from Spain are logical facts, supported by data familiar in Europe, by social and political reasons. But the faith absorbed by Indian natives, who were given freedom to decorate the architectural plans imposed – this, from the point of view of humanistic tradition, is a freak. Who, for instance, has ever heard of a *yellow* or a *black* Catholic art? Yet the designs that were brought from Madrid, Rome or Antwerp served as a spring-board for a *red* Catholic art. What were its aims exactly, where was it tending? This is no easy question to answer clearly. In the church at Tasco, for instance, a woman kneels to pray before the dead Christ; He is held in the arms of a figure of God the Father disguised as a pope *(plate 51)*. She rises, touches the wound in Christ's foot with her finger, crosses herself and leaves the church. What thoughts have been passing through her head? And what were the thoughts of the Indian sculptor when, in the same church, he carved the face of the Christ of the Column *(plates 28 and 29)*, the scourged figure with the roped hands, after the original in Santa Prassede at Rome? It would be as easy to stop the extraordinary play of light upon this face – changing at every angle of view, now dulled, now tortured with pain, angered, scornful, now lit by some joy beyond human experience – as it would be to trace the sources of the legend that helped the Crusaders to find this column in the Holy Land, whence it

was brought to Rome by Cardinal Colonna in 1223. The papal bull of Alexander is, as it were, the plan of the sacred edifice of Spanish America, and the faith of the natives forms the materials for it – the maize *pisé* of Mexico, the rough brick of Maya, the Andean stone of the Incas, the soapstone of the mulattos* of Brazil. Yet firm or friable, hard or brittle, take it as it comes, still in its weight, resistance, elasticity, in its essential substance, it cannot be explained. But there it is, as we must admit, giving body to this art of the Conquest, the flesh and blood. The conquerors themselves only gave the skeleton, the framework. Yet how did this come about? And why? In what way?

It would seem that we can only explain the predilection of Indian art for the Passion by the liking of these peoples for spectacles, whether church spectacles or others less edifying. 'As the natives could not understand what they saw, the mysteries had to be shown to them in the form of spectacles, so that their faith might be strengthened', Vétancourt remarked in the seventeenth century, and in the eighteenth Raynal observed that among Indians pleasure and piety blended together. The medieval mystery plays were introduced in America by the friars at the time when they were losing their popular appeal in Europe, now turning to the Commedia dell' Arte, and soon these plays were being translated into Nahuatl, Quechua and Aymara. By a bull of 1586 Pope Sixtus V gave a special indulgence for a Christmas mass of the Augustinians celebrated with singing and mime; when the priest turned to the Indian congregation with *Dominus vobiscum*, he made faces, and the throng responded joyfully *Et cum spiritu tuo* with laughing, ringing of bells, firing of squibs, banging drums and warbling water-whistles. Faith of this order would have delighted Rabelais and, like the monks of America he would have thought it all very harmless; how he would have laughed to see an angel at Cochabamba using the most natural means in the world to dowse the fuse of the arquebus which Abraham was just going to fire to sacrifice Isaac. As the only authorised producers of sacred plays, the

Franciscans *(plate 38)*, then the Augustinians *(plate 23)* and the Jesuits *(plate 40)* could hardly be rigid censors of the mime of their native players, any more than they could insist on academic interpretations from their carvers of Christ in death or the weeping Madonna. They had to accept certain infringements of the rules of the Council of Trent on the decency of sacred pictures, to wink a little at coarseness and horseplay.

It seems likely that most of the Indian craftsmen did not know the standard works prescribed on architecture and sculpture and were content to copy the examples provided for them by the friars as faithfully as they could *(plate 48)*. Four were generally needed to make one of the large-scale images for the Easter Passion – a sculptor of sorts, a gilder, a carver of robes and folds, a painter for the flesh. The first shaped the wood to the required attitude, gesture and expression, but does not seem to have refined his work very much after roughing it in. Marquoy, on his way through Cuzco in 1850, saw one of them put together a figure of Christ in a quarter of an hour; he used pieces already carved and made the eyes by melting glass in a pot pierced with holes about the size of a chestnut; then he painted on the concave surface the pupils and eyeballs. Details on the face and limbs and folds in the robes, were carved in the softer material covering the wood; this was known technically as 'facing up' – draping the figure, assembling, adorning. Finally the face, arms, hands, knees, feet and sometimes the entire body were coated with a pigment simulating flesh, on which veins, wrinkles and wounds were painted in the minutest detail, a technique of *encarnación* in which the Indians were past masters; their realistic talent amazed travellers, who otherwise remained rather scornful. This image-maker's craft seems less akin to the sculptor's art than to the work of a ruras potter using a simple kind of armature, round and on which he packs and turns hil plastic material – cob or clay, plaster or stucco – moulding, giving form and surface, adding or taking away, and finally glazing and colouring his pot to gold or skin

hues, to any tint bright enough to disguise the shortcomings in texture and shape.

L'estofado, or imitation gilding, was the most important operation in ornamental sculpture, and the one most discussed, if one may judge by the architecture manuals, which allot much space to it, as much as they give to Vignola's classification of the five orders. And the secret of this process is worth giving here, for the alchemy of the compound used calls to mind long-vanished art-workshops, forgotten now save in the dark back rooms of antiquaries or in national museums. First a size was prepared from shreds of old gloves or parchment, as a fixative for the gold leaf or its imitation. Then twelve coatings of white were given to the carved figuring, because 'white feeds gold'. Next all the details of the carving were picked out again with chisel and scriber, and new notions added: this was called cutting, fetching out and tooling the work. The size was then applied with a boar's hair brush. Now yellow ochre, pounded preferably on sea shell, was laid over all. It only remained to 'fix the job', a delicate operation, and each craftsman had his pet recipe. Here is Félibien's (seventeenth century): take a nut of Armenian bole, some red chalk (just the size of a bean), black lead (just a pea), soot (just a lentil), a bit of butter, a bit of sugar candy, a bit of scorched bread, pound and mix with parchment glue having the consistency of table jelly... A cook's recipe indeed; so craftsmen concocted gold to feed their carvings.

Travellers who saw the work of native Indians tended to criticise their ignorance of bone structure and classical anatomy rather than to appreciate their feeling for the sacred. And indeed their statues and paintings were but naïve expressions of a simple faith; thick layers of bright colour or the sheen of gold on a statue mattered more to them than the quality of its carving, which was often crudely symbolic. The bad taste evident in the Catholic imagery of America is, however, ambivalent; the eighteenth-century philosopher, not sorry to see portrayed the laughable aspect of an obscure faith, enjoyed it with a knowing smile; but the work of the Indian craftsman also speaks of a simple medieval faith; they carved and painted these figures and prayed

before them too, gave them the dark powers of ancient myths which were to arouse so much interest in the scholars of our own century.

These powers are very apparent in the Indian interpretation of angels, a cult which began in Europe in the sixteenth century, when immemorial fables of the spirits of earth, air, fire and water were revived and transformed in the Christian faith, and so winged their way into sacred art. The instinctive animism of the pre-Columbian peoples responded quite naturally: another host of angels soon peopled altarpieces, ceilings and domes in America. But their countenances were strange: there was a tragic eroticism in them unknown in Europe *(plates 30,55)*. The angels of the Indians belong both to heaven and to hell; they scarcely ever smile; they may be ecstatic or they may grimace; at times they seem to suggest the howling face of an Aztec victim with a gaping wound in place of a heart, yet even more they call to mind the souls of the dead, drifting with the winds over the upland plateaux, and swarming among the ferns in the burning valleys *(plates 86,90)*. With their tiny puckered faces among the leaves – all they have for bodies – the Peruvian angels wheeling in the dome of Santiago de Pomata *(plate 124)* are souls of the leaves of day and night, tropical spirits of the forest. Where, for a native, lies the difference in his angel? A Mexican or Peruvian church is a house peopled by angels of every kind *(plates 71,86,90)*, and extremely difficult to pin down. Perhaps the contradiction between the white faith and the red, between the credulity of rational men and the superstition of a coloured race, between their hopes and fears of the unseen, is most strongly marked in these strange colonial contrasts – between souls in ecstasy and souls of the dead, between angels as seen by European eyes and the angel in the mind's eye of an Indian carver *(plate 86,87)*. In the centre of circling archangels and angels, in the dome at Ocotlán, Francisco Miguel the Indian painter added his Holy Spirit in blue with wings outspread *(plate 87)*. Such figures were painted in every church in Europe. Did he remember that in this same pine-tree grove, an

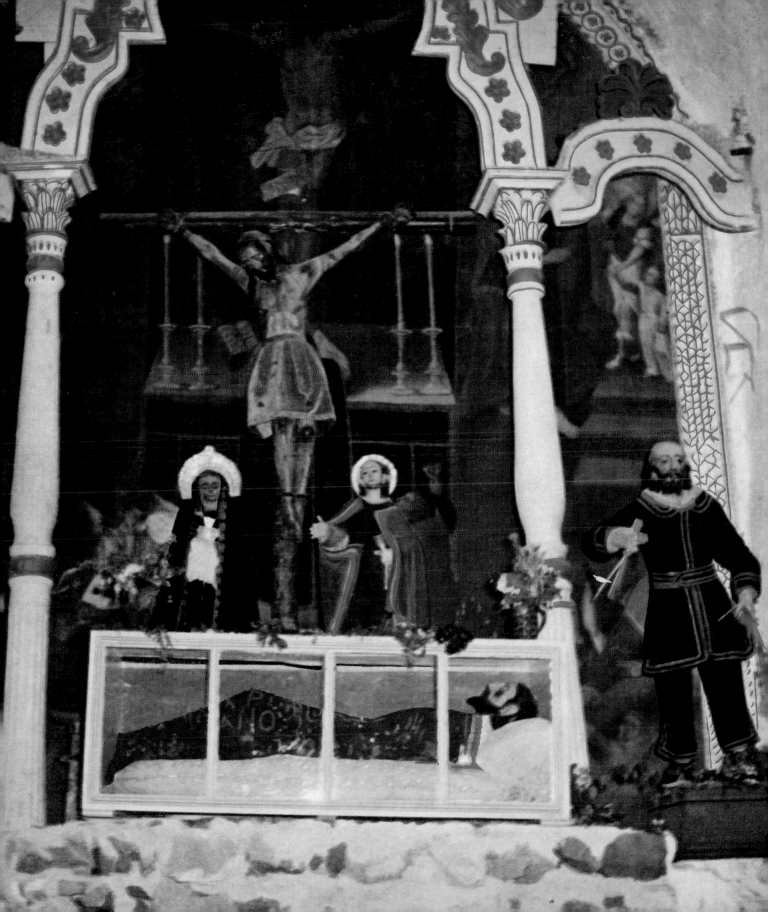

XIII

Aztec *teocalli*, the Great Nahuatl Spirit used to utter his oracles long before the day in 1541 when the Virgin appeared there to a Franciscan friar?

Dark-skinned, of mixed blood, the Madonna it was, even more than her ever-white Son, who gave the Spanish Indies unity. In that vast absurd Empire where everything divided men – blood, traditions, rank, fortune, and among Spaniards even speech: Basques here and Andalusians there, Catalans in one region and Castilians in another, every man tried to pull the vine of prestige his way and climb higher upon it. Yet, at its top, above captains-general and viceroys, above King and Pope and even Holy Roman Emperor, one and all acknowledged Her whose spreading cloak made a pyramid of grace and richness and mercy *(plate 98)*.

Madre de Dios, tributary of thc Amazon, she was the mother of all the wonders of nature. While La Condamine was visiting Quito, 'a great marvel appeared in the sky: a woman robed in the light of the sun, with the moon beneath her feet and a crown of twelve stars on her head. She was pregnant, and cried aloud as if in travail and suffering the pangs of childbirth.' But La Condamine, the philosopher of the Age of Enlightenment come to survey the tropics, was not quoting here the vision of the fifth seal of the Apocalypse; he was simply describing objcctively the ball of fire which he saw rise above the town then vanish into the sea. But this was how an Indian soon after represented the Immaculate Conception: all in gold upon a great silver ball, Virgin of the World of the Andes, of the mirages of Paramo, walking on a moon's crescent among the stars, wonder of the nebulae in her triangular robe constellated with pearls. So the *mezquitos* were to represent her ever and again, adorning yet more what was adorned in Europe, creating a virgin of the lily, of the rose, the palm-tree, the mirror, the door, the fountain, virgin of the walled garden, virgin of the rosary *(plate 129)*, the mountain virgin, virgin of the mine! The mountain of Potosí *(plate 130)* prostituted itself in the hands of all the nations fighting in its bowels and yet, because of the purity of its metal, and the faith of the

tunnelling adventurers, was immaculate always – to satisfy their need to believe that Fortune was always virgin. Gold, blood and disease at Her touch became immaculate, and that was why the Pope made Her, the Immaculate Conception, patron mother of the New World, Light's Portal, beyond which all infamy was forgiven as with folded arms, Virgin of Mercy *(plate 97)*, she gathered in with equal fervour priest and soldier, white and black, the lay and the regular, gathered all Her names into Herself, so continuing to be, in Mexico and Lima as in Madrid and Rome, the Virgin whose praises Eleusis chanted: many a name has She, and yet ever one.

Legend said that Luke the Evangelist had painted Her portrait, and brought it with him to Seville; but that the Moors appeared, and the priests hid the picture so well that all trace of it was lost. But lo! in 1329 a peasant found it again while searching for his cow, and in 1340 it gave victory to Alfonso XI. In 1493 it decorated the standard of Columbus the Jew who implanted it in the soil of a spice island, Guadeloupe, and then at last miraculously, in 1531, it was imprinted on the cape of an Indian called Diego, while he was watching his flock on Mount Tepayac, which as it chanced was a place sacred to the virgin goddess and mother Tonantzin and under the spiritual care – such is coincidence! – of Peter of Ghent. Though white on Christopher's standard she was swarthy now *(la Morena)* on the native shepherd's cape. By great good luck the details of this change have survived – almost as remarkable as if records of a Greek maiden being changed into Mary of Ephesus had survived. Brother Zumarraga, the Franciscan Bishop of Mexico, and Cortés heard the news. Forthwith they ordered a general collection to build a sanctuary, to be in the charge of the Franciscans. The Dominicans and Augustinians at once raised doubts about the genuineness of the miracle. And the Franciscans later had their doubts too, along with Bustamente their Provincial, and the Virgin of Guadeloupe was thereupon secularised. In 1810 Morelos the Insurgent had Her painted on his flag. Yet it was not New Spain, where She appeared, that gave all America a pattern

to follow, but the town of Sucre, on the far opposite coast in the Cold Land, another region where miracles of the red Madonna took place. Not far away stretches the greatest and highest lake in the world – Lake Titicaca – and it was there, at Copacabana (Place-where-one-sees-the-sacred-isle-of-the-sun) that the Aymara Tito Yupangui carved the miraculous image of the Madonna of the Andes.

Naïve copies of European masterpieces – Flemish, Italian or Spanish – from engravings found in prayer-books or catechisms, these pious Indian madonnas are not masterpieces *(plates 93, 94, 97, 98, 136-140)*. They make no claims to be. But we can see now that they have the awkward grace and sometimes the genius of primitive artists *(plates 46, 49)*, a brightness of colour that is refreshing in its naïveté, a change from the schemes of the great masters, whether those of bygone eras or those of today. The sacred art of the Indian is an art of the people, and middle-class travellers often disliked it, yet it satisfied the friars and can touch the heart of a collector, even kindle enthusiasm in the eye of a twentieth-century critic.

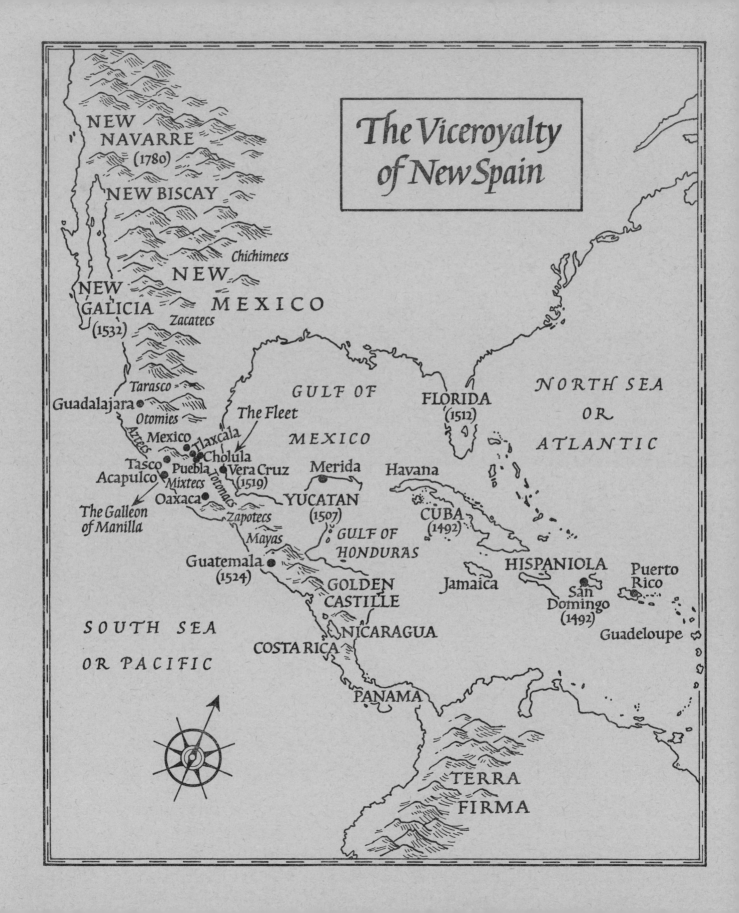

NOTES ON THE ILLUSTRATIONS

XIII Colour plate facing page 70. Interior of a little church on the high Andean plateau between Peru and Bolivia. An example of popular sacred art in the eighteenth and nineteenth centuries.

18 YANNUITLÁN (OAXACA) Church of the Dominican Convent founded by Francisco de las Casas, lieutenant to Cortés (1541), and completed by his son Gonzalo in 1575. The altar-piece is in the Flemish and Plateresque style, as is the reredos in the Franciscan convent of Huejotzingo (Puebla) by Simon Pereyns (1586). *See also plates 23, 33 and 68.*

19 *Christ on the Cross* On an altar-piece in the Churrigueresque style in a country church of the Mexican highland. The irregular columns, also known as *estípites*, were probably introduced into Mexico by Balbas, a pupil of Churriguera.

20 ACATEPEC (PUEBLA) *Ecce Homo* in the church of San Francisco. Popular art, eighteenth century.

21 CHOLULA *Ecce Homo.* Popular art, eighteenth century.

22 *Christ crawling on hands and knees* In a church on the Mexican highland, popular art of the eighteenth century. The archetype is probably Murillo's picture, inspired by the *Meditations* of Alvarez de la Paz (1620): 'Loosened from the column, Thou didst fall to the ground, being faint and weak. So helpless wert Thou from loss of Thy blood that Thou couldest not stand on Thy feet. Pious hearts gazed down upon Thee crawling on the pavement, sweeping Thy blood with Thy body, groping for Thy raiment.' (Quoted by E. Mâle, *L'Art religieux au XVIIe siècle*). On Christ's robe are pinned gold or silver *milagros*, ex-votos in the form of healed limbs.

23 ACOLMAN The Augustinian friar Albertus Patavinus.

24 YANNUITLÁN *Ecce Homo.* Popular art, eighteenth century.

25 TASCO *Ecce Homo.* Popular art, eighteenth century.

27 ACOLMAN *Ecce Homo* and doll-like figure of an *Ecce Homo.* Popular art, eighteenth century. *See plates 50, 58, 59.*

28, 29 TASCO Christ bound to the column for scourging; the original is in Santa Prassede at Rome; the Spanish archetype, by Hernandez, is in the Carmelite convent at Avila. The three letters J.N.S. signify *Jesus Nominem Salvator*; they were the emblem of Savonarola.

30 TONANTZINTLAN (PUEBLA) Ceiling in the church of Santa Maria; an example – like San Francisco of Acatepec *(plate 55)*, less than a mile away – of *poblano* or native Christian art in the region of Puebla, eighteenth century. *See also plate 11.*

31 MEXICO Skulls made of sugar in a grocery store.

32 ACOLMAN St Ignatius Loyola? He was traditionally represented holding a crowned skull, as he advocated their devotional use. *See also plate 96.*

33 YANNUITLÁN (OAXACA) The archetypes of these statues of Death are by Gaspard Becerra, in the Valladolid Museum, and Bernini in Rome. They were probably also inspired by the engravings in the anatomical *Treatise* of Andreas Vesalius (1514-1564) published in Brussels. The best Peruvian sculptor of the eighteenth century, Balthazar Gavilan, made one armed with an Indian bow which was so beautiful that he died of a seizure on seeing it one night.

34, 39, 44 TLACOLULA (OAXACA) *Capilla* of Santa Christo; crucified figures grouped round the crucified Christ. This Franciscan chapel is in the style known as *barroco exuberante*, and dates from the early eighteenth century.

35-37 *Christs on the Cross* in country churches on the Mexican highland and in Tonantzintlan (Puebla). Popular art, eighteenth century.

38 TLACOLULA A Franciscan monk.

40 TASCO A Jesuit on the reredos; the archetype is probably the vision of St Ignatius over the altar of the Gesù church in Rome.

41-43 Statues of Christ on the Cross in the Cathedral Museums of Mexico and Tonantzintlan (Puebla). The 'Christ of Great Power' in Seville is probably the Spanish archetype, but there may also be Flemish and German influence, notably the Nuremberg Christ by Veit Stoss (1440-1533).

45 YANNUITLÁN (OAXACA) Statues covered with veils for Holy Week.

78

46 *La Soledad* in a little country church near San Sebastian and Santa Priscilla at Tasco. The archetype for these Madonnas with the heart pierced by swords is probably the *Soledad* in Santa Aña in Granada. Popular art, eighteenth century.

47 ACOLMAN Nun of the Augustinian order?

48 CHOLULA, POPULAR ART The archetypes for these heads of saints in ecstasy are the Saint Francis of Assisi at Toledo by Alonso Cano and Pedro de Mena, and the 'Christ of the Good Death' in the Escorial.

49 ACATEPEC (PUEBLA) *La Soledad* at the foot of the Cross.

50 ACOLMAN Christ on the Cross in a passage in the convent. Popular art, seventeenth century.

51 TASCO The dead Christ in the arms of God the Father. This theme belongs to medieval tradition; it was condemned by Molanus, painted by Rubens.

52, 53 Christs recumbent, or 'Dead Saviours', in Acolman and the Puebla region. Popular art, eighteenth century.

54 GUATEMALA Christ the King in a small village near Guatzatenengo. Popular art, eighteenth century. The copper aureole probably shows pre-Columbian influence.

55 ACATEPEC (PUEBLA) Part of the altar-piece in the Church of San Francisco, eighteenth century. *See also plate 30.*

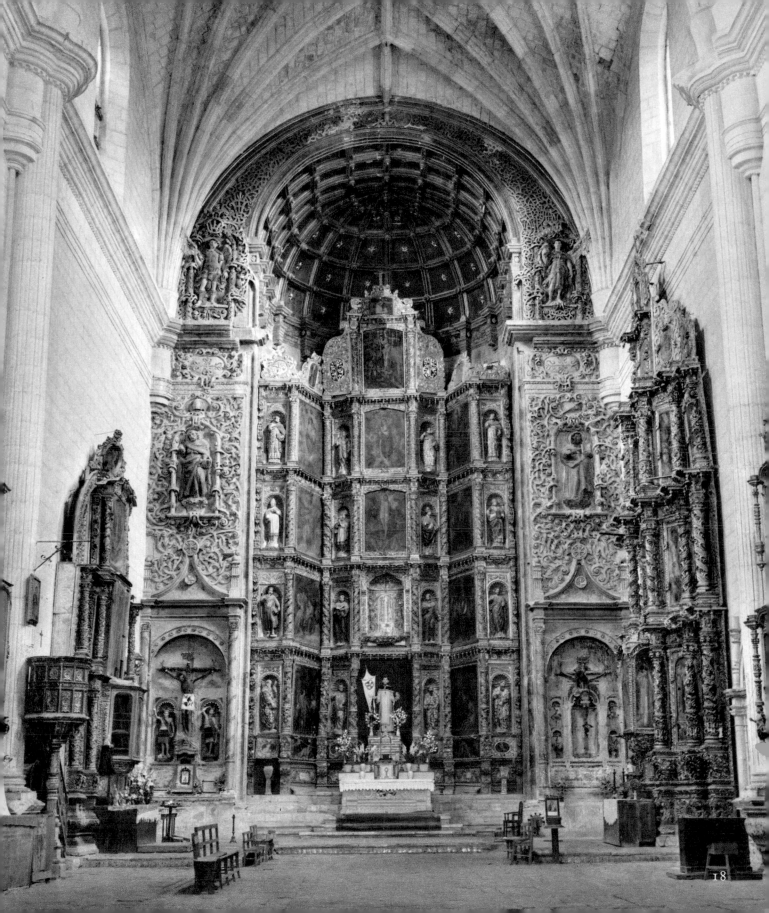

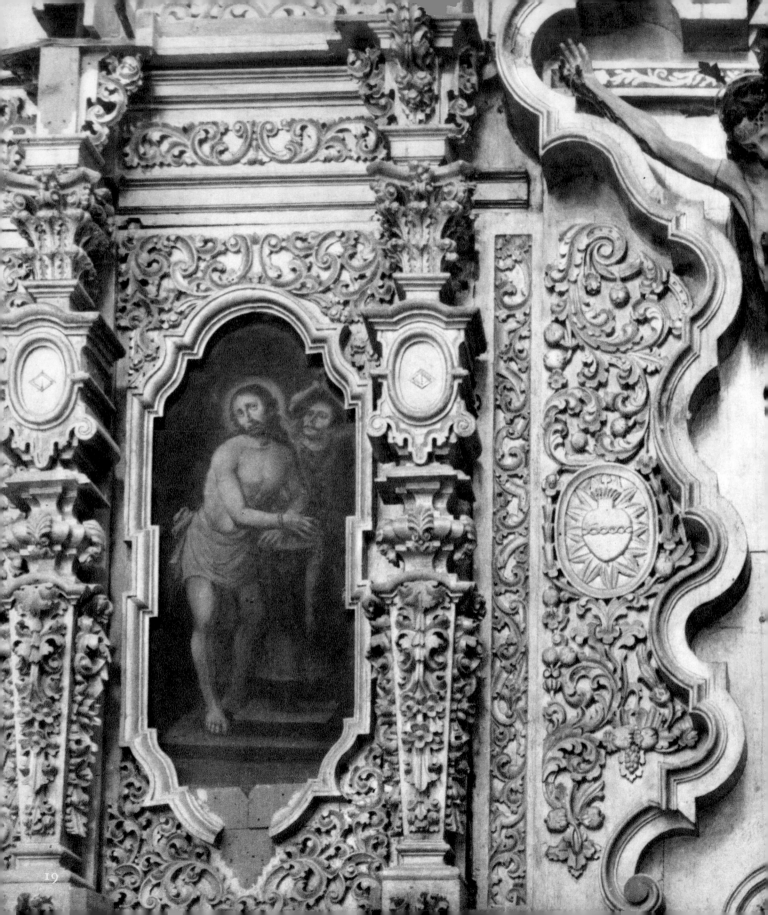

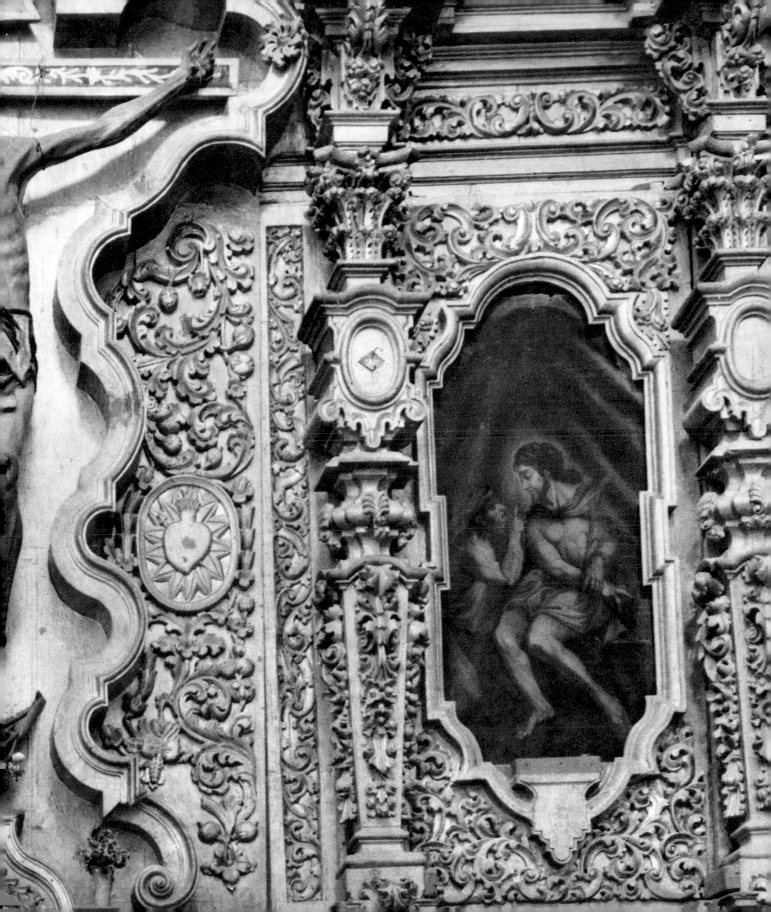

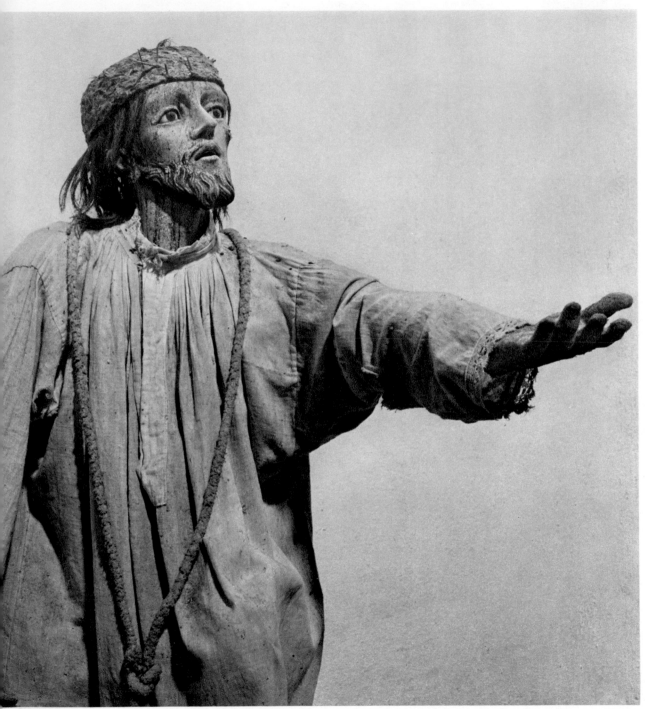

20

21

22

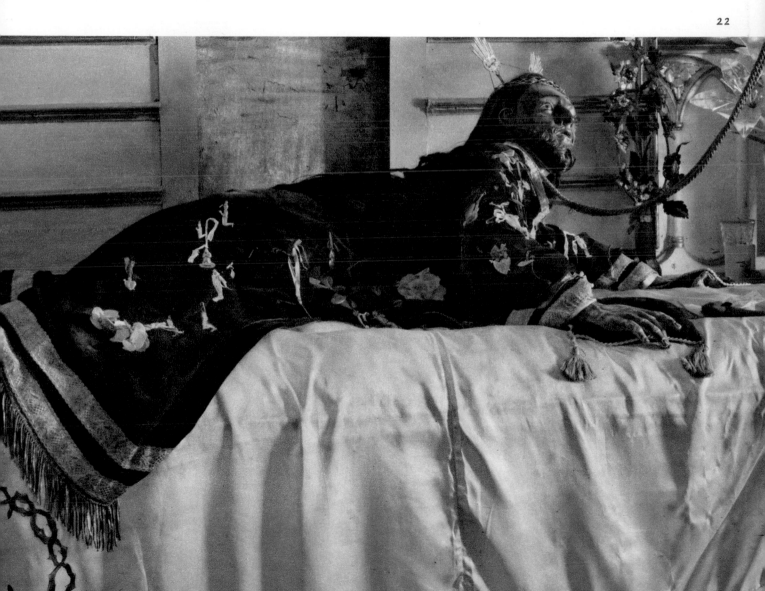

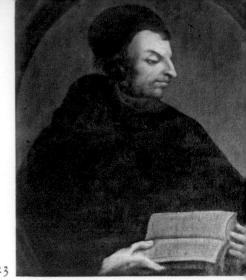

23

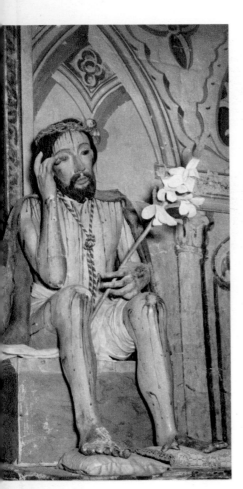

24

25

26

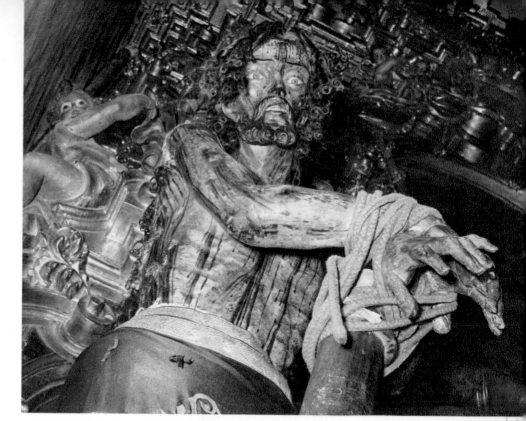

28

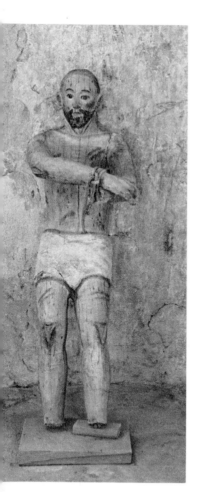

27

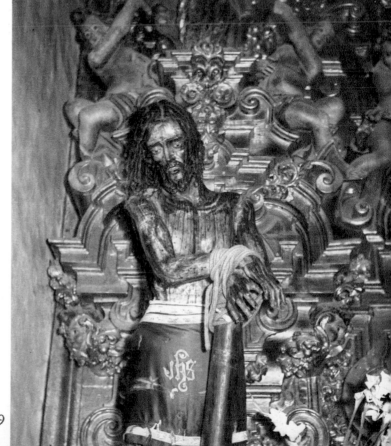

29

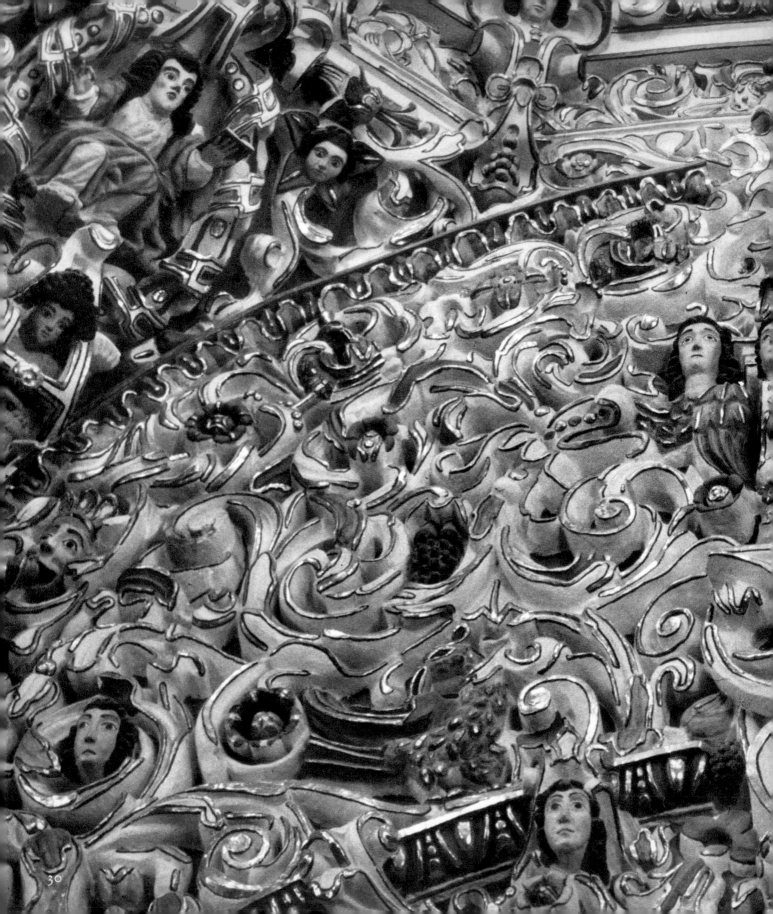

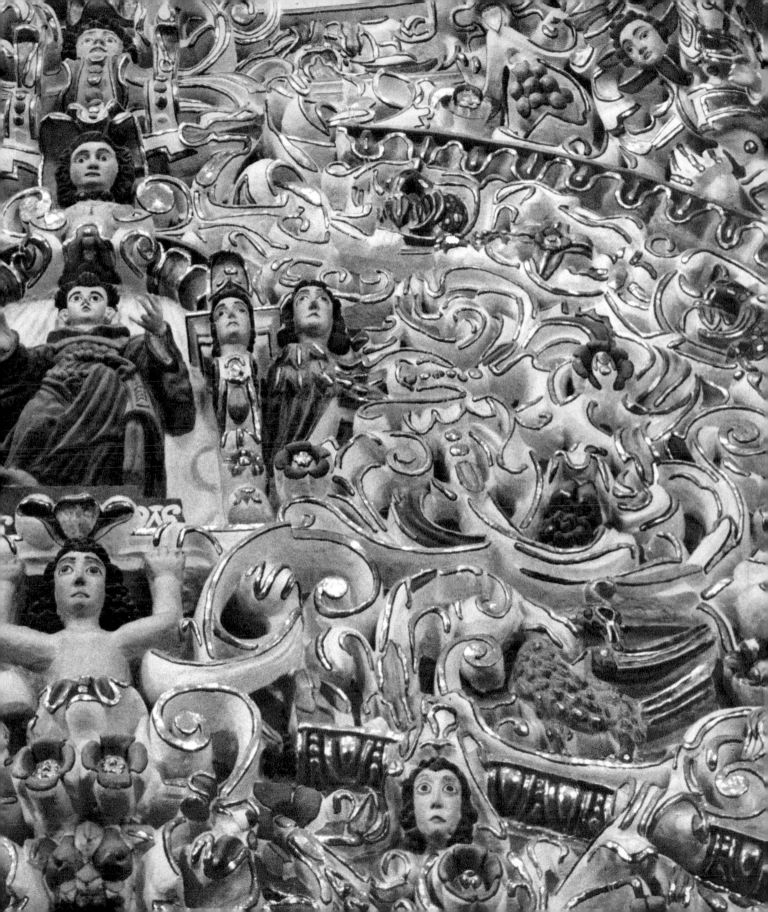

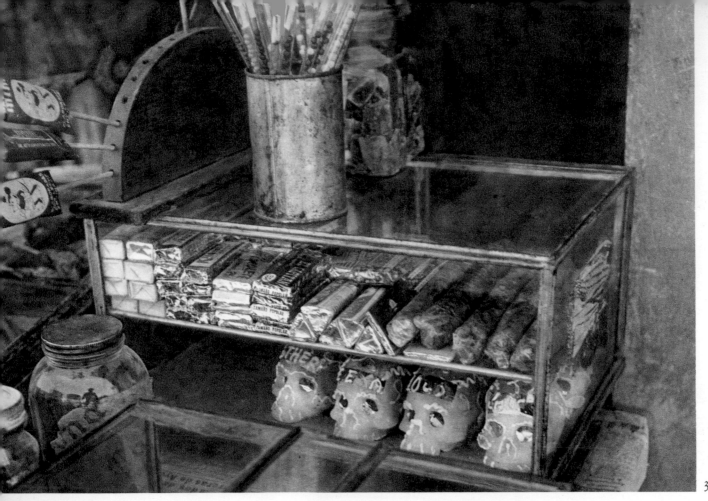

31

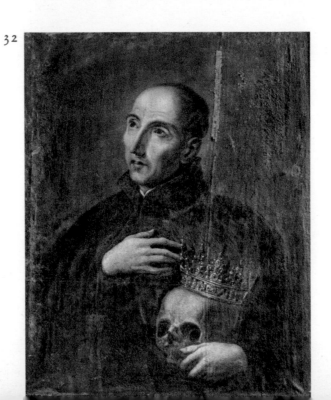

32

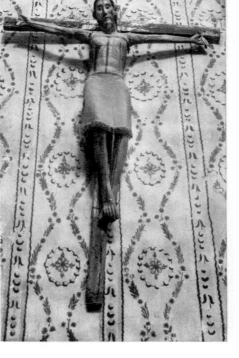

35

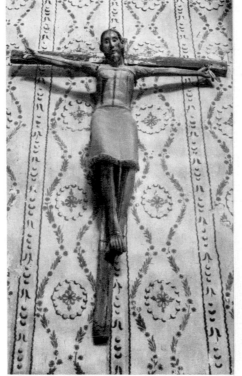

36

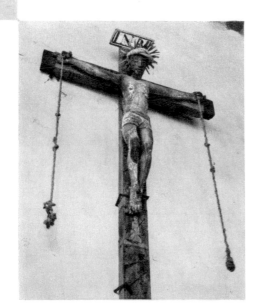

37

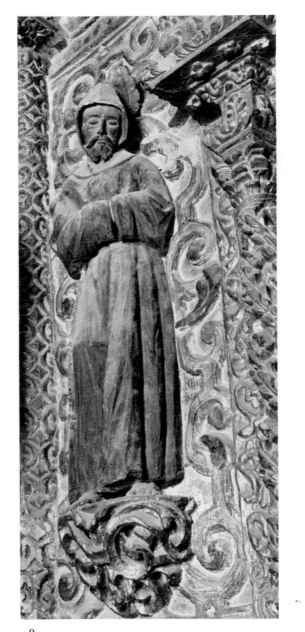

38

39

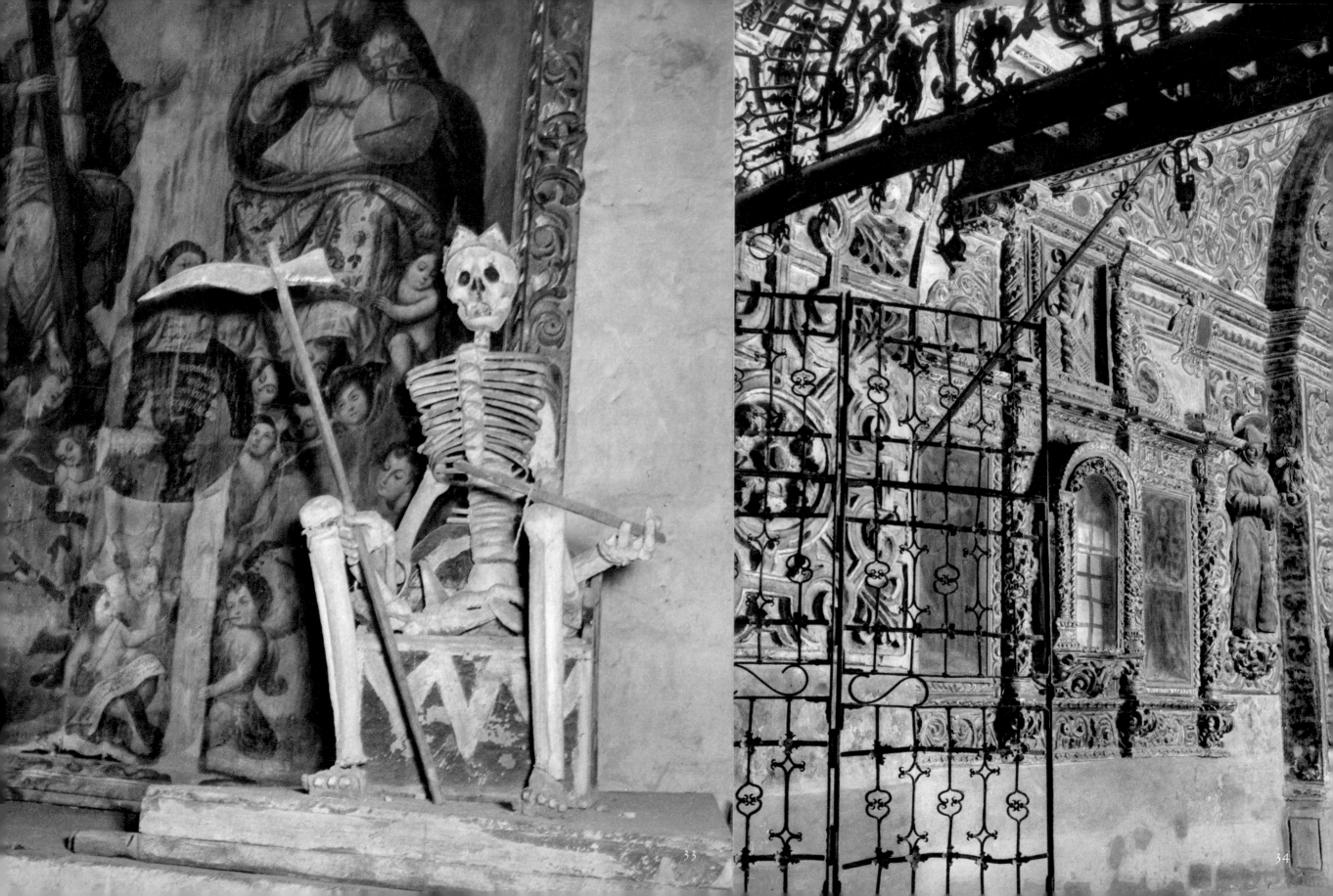

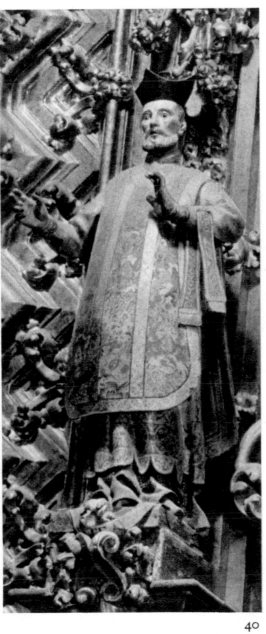

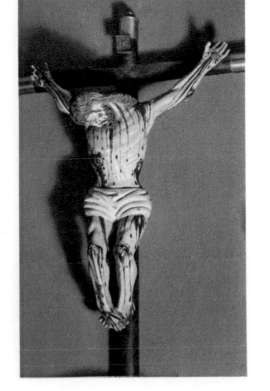

41

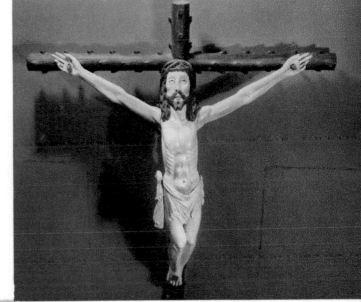

43

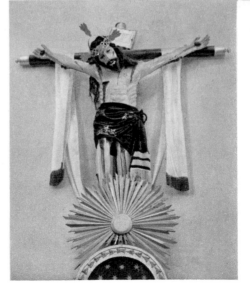

40

42

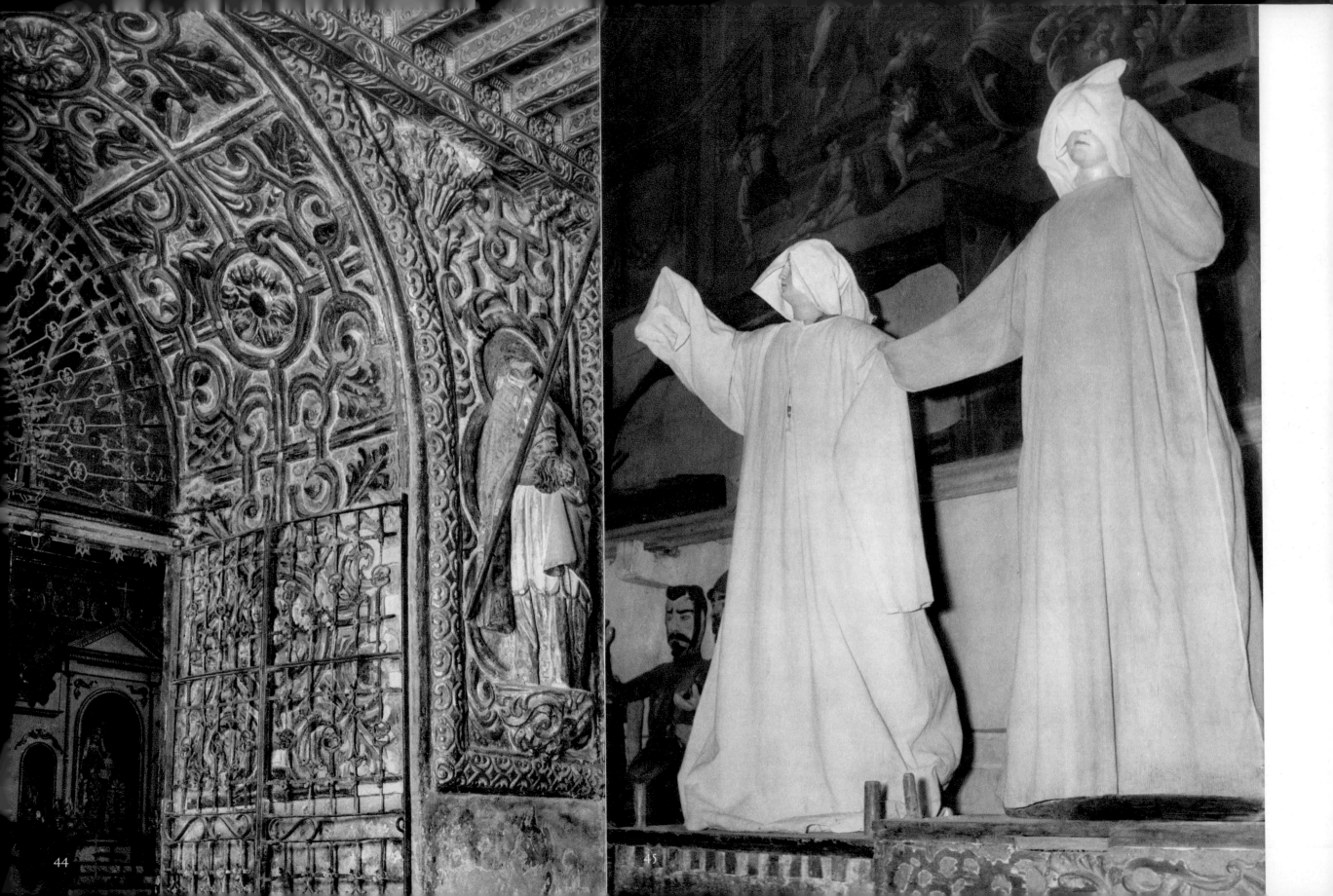

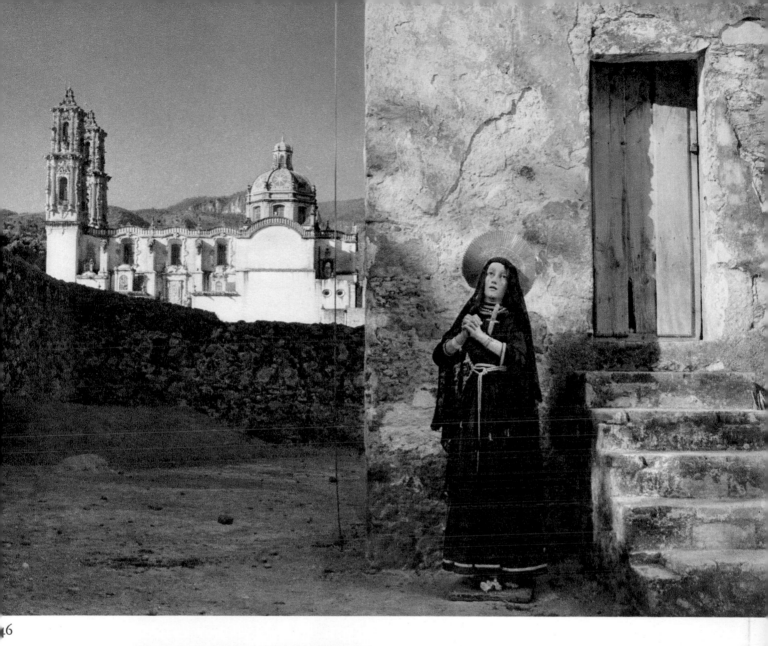

47

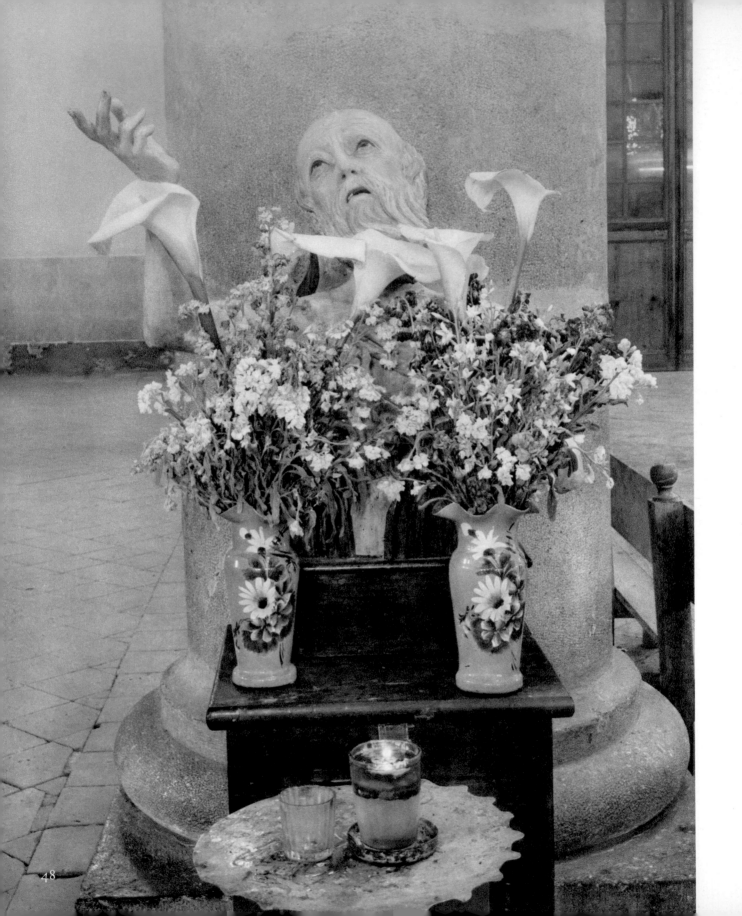

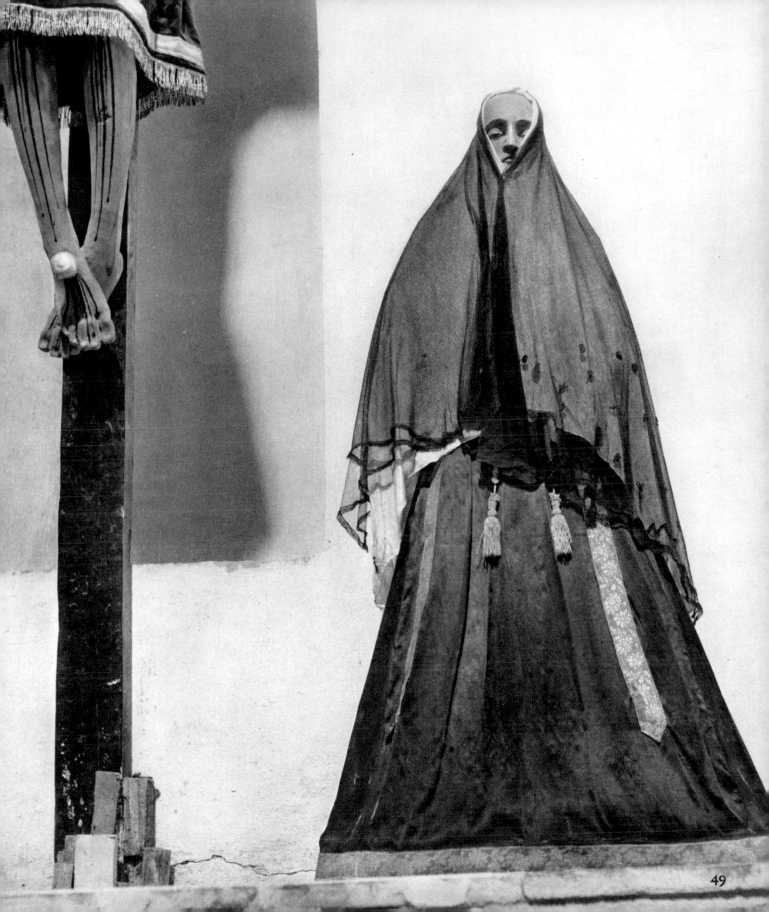

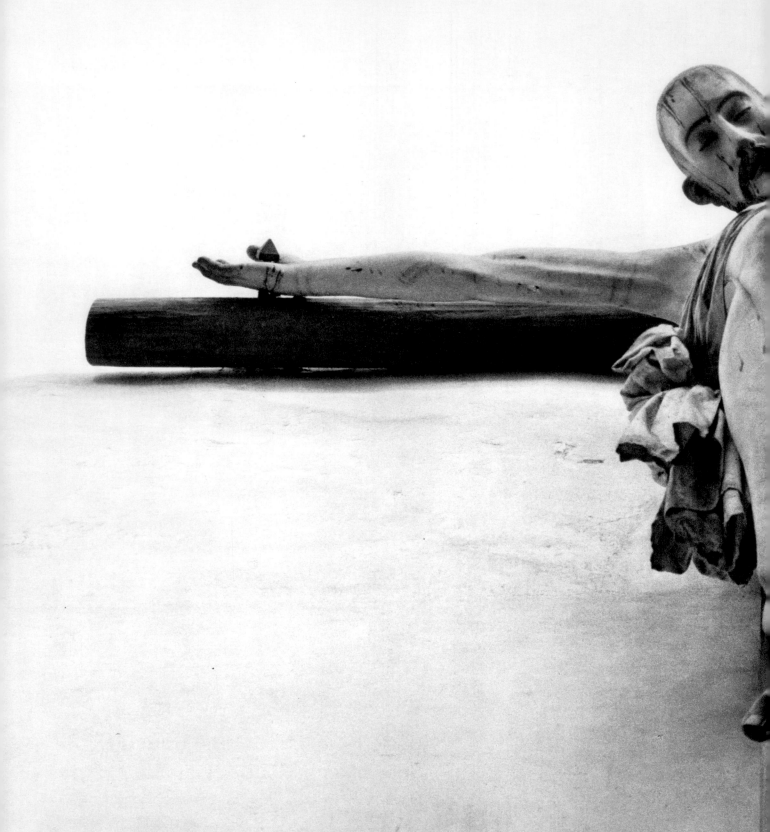

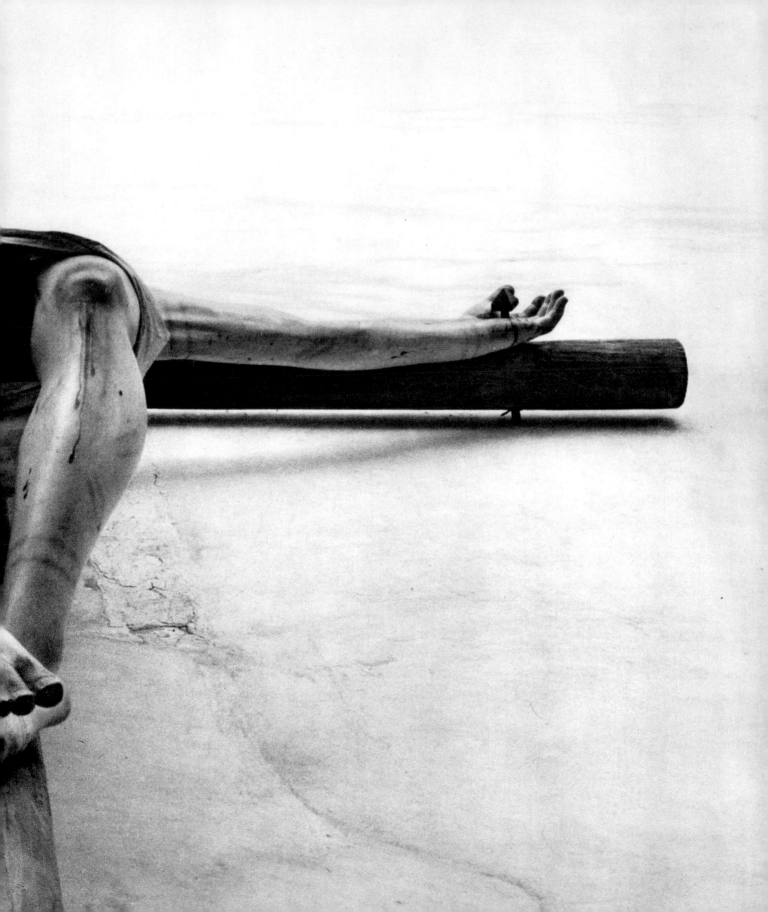

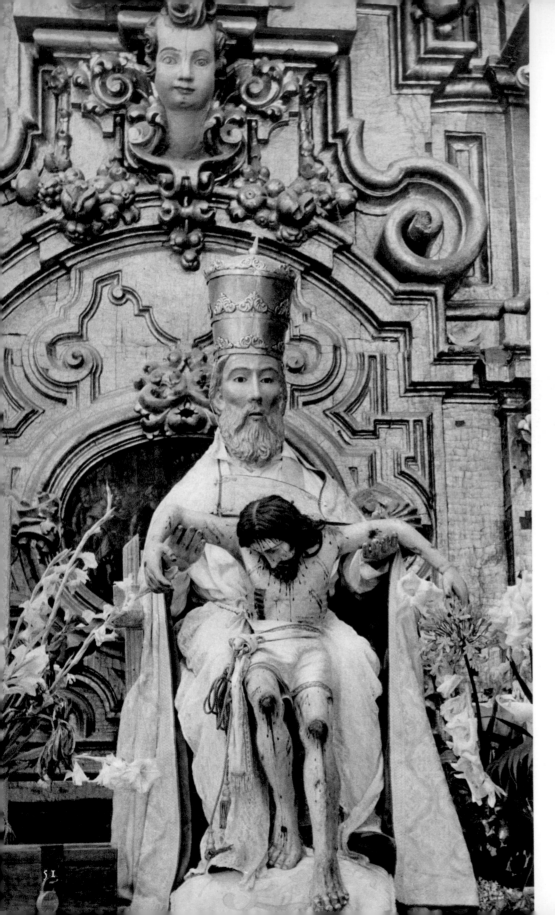

52

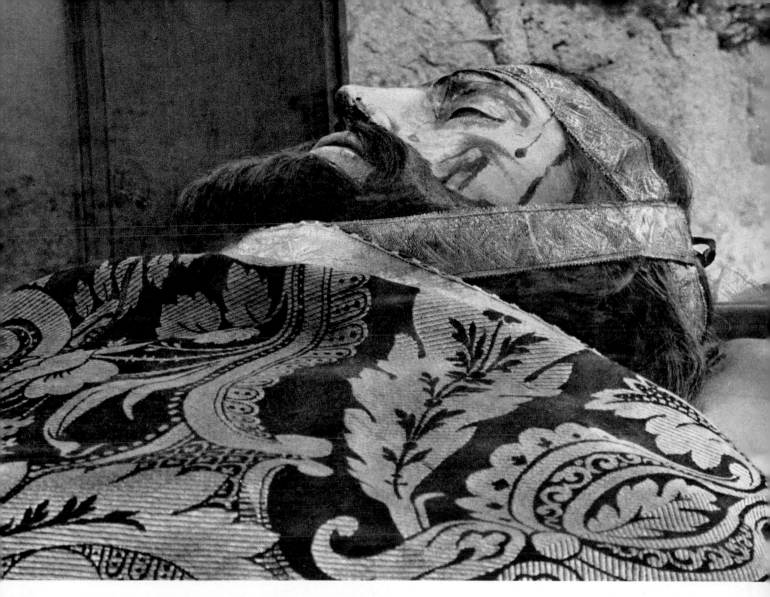

53

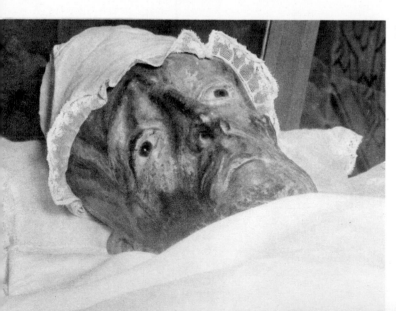

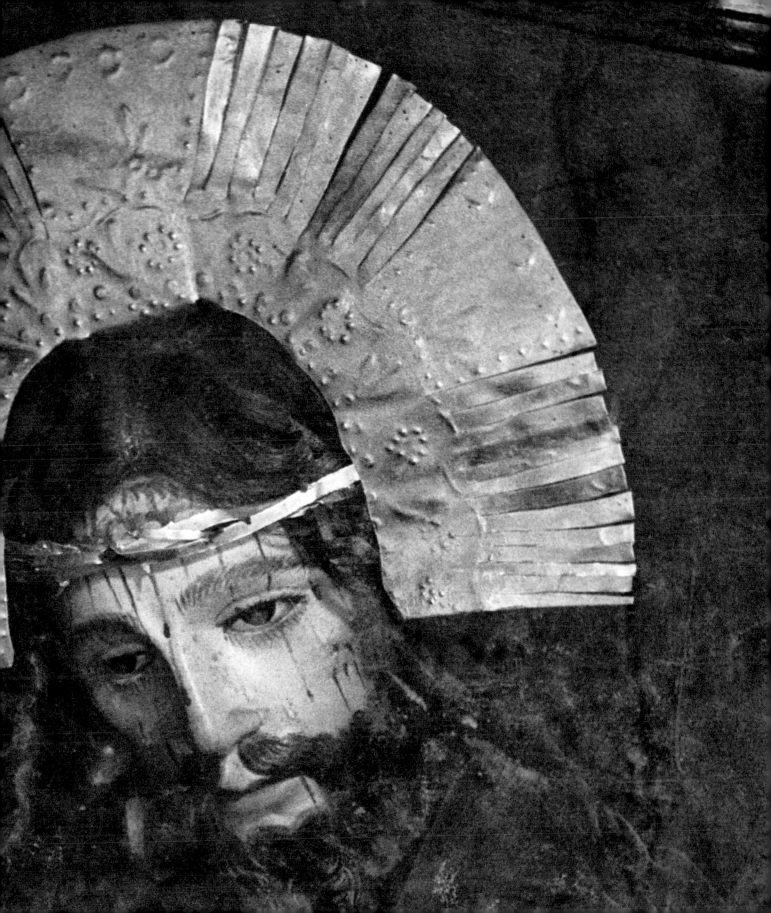

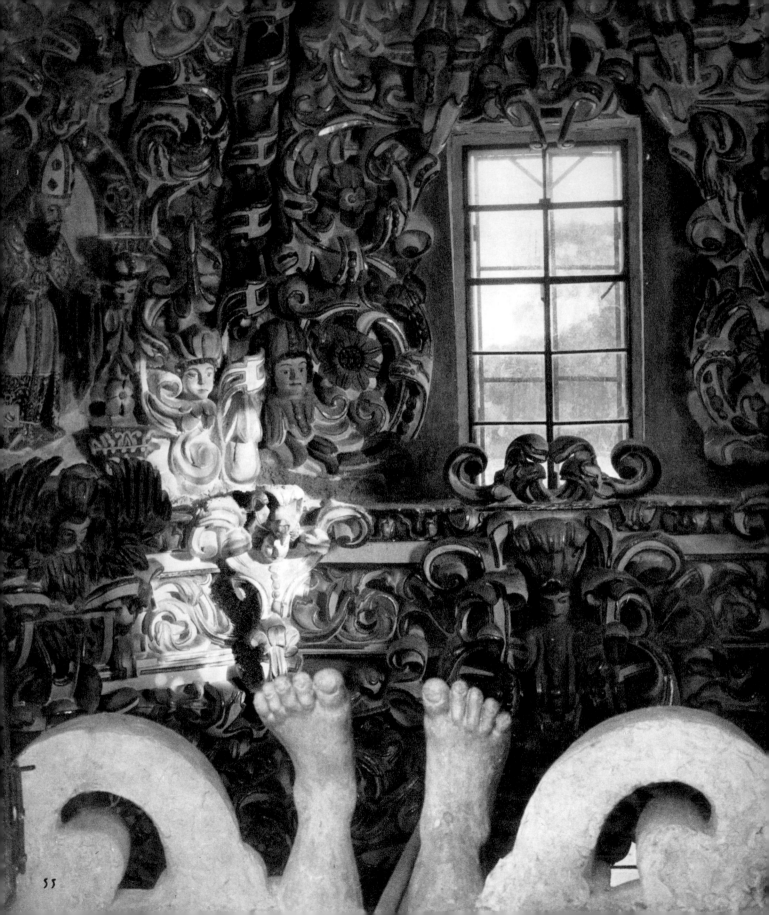

III Los Conquistadores a lo Divino

XIV SIXTEENTH-CENTURY SHIP

THE GOLDEN LEGEND of the friars of America has never been written. Only a few lines, too brief in dictionaries of history, too pious in works for the orthodox, give any account of the lives and characters of the men called the *conquistadores a lo divino*, a phrase which cannot be translated into English. With the help of God, nothing seemed impossible to them, for God was their good fortune. To them the Conquest was God's sweeping judgment upon a continent and its peoples, an ordeal by fire and sword in which they were sure of victory, being so absolutely sure themselves of the eternal verities whose ministers they were. A friar in the New World became a Conquistador *(plates 7, 11)* just as in the Old he became a knight, by calling on his God as witness and, like the knights, the Conquistadors often ended their days in a monk's habit. Gold was sometimes only a pretext of the knights of Castile or Estremadura for something else which they would have found difficult to explain. Thomas Raynal was perhaps the first to understand how these Spaniards could reconcile the conflicting calls of God and gold when he wrote: 'The thirst for gold and the knightly spirit then still reigning... two spurs that drove men to over-run the New World — men of the highest and lowest classes in society, brigands breathing nothing but fire and slaughter and lofty natures who thought they were on the path to glory. And that was why the trails of the earlier conquerors were marked by so many crimes and such extraordinary deeds; that was why their greed was so terrible and their valour so heroic.' Therefore it was logical and necessary that Diego d'Olarte and Augustin d'Avila y Padilla, companions of Cortés, should

XV EARLY MONKS OF MEXICO

turn monk and that before Juan Gonzalez de Mendoza became first Bishop of Popayan in New Castile he should have travelled as a knight all the way to China in quest of God. The Franciscans helped in the transfer from one mode of conquest to the other through their 'soldier missionaries', lay stewards who handled the money matters which their Rule forbade them to touch. And in all the orders we find a brotherly relationship existing between the two careers, for the younger son had no other choice than to become a friar or a knight in the Indies, and both pursued along different and sometimes fratricidal paths that dream of conquest which they shared together in childhood.

Orthodox books declare that the missionaries to America 'aspired after torture.' During two centuries this was true. There were the tortures which the Spaniards inflicted on the natives and on each other, and there were the tortures which a friar inflicted on himself. All that people find so senseless in the cruelties of the Spanish mystics was rife in this land of sacrifice. And just as Spanish America became more Baroque in her art than even Europe, in asceticism it seems that she wished to be more ascetic than the Fathers of the Desert. As in Egypt and Cappadocia, there were hermits *(plates 132-134)* living solitary lives on the high Mexican plateau, on the

paramo in the Andes, and the earliest *conquistadores a lo divino* were not strangers to the purest examples of monastic architecture – the hermit's cave and the hut. This yearning for the austere took deadly toll. For fifty years, though entire companies of monks kept arriving, there never seemed to be enough. They died at their work, not so much by the hands of the natives, but as martyrs to the Rule they kept,

XVI DOMINGO BETANZOS

despising fever and cold and burning sun. Velasco, the Viceroy of New Spain, made complaints to the King, so when the Augustinians were authorized in 1554 to go and settle in Peru, they had to promise beforehand not to be so austere in the Andes as they had been on the high Mexican plateau. But later Bonaventura de Salinas, the Franciscan, reported that they had broken their promise and were on their knees night and day.

When Gregorio Lopez arrived in New Spain in 1562 a thousand monks had already trodden the 220 miles between the port of Vera Cruz and the House of Birds of the Emperor Montezuma*, which now, by the logic of divine equivalence, had become the seraphic abode of the children of St Francis. Forty-four convents of their order had already been built since their arrival in 1524. The Dominicans, or preaching friars, only had fifteen but perhaps they stood higher with the Indians on account of Domingo Betanzos (fig. XVI) and Bartolomé de Las Casas. Betanzos was the author of a *Latin Letter on the Intelligence of the Natives* which inspired the Papal Bull and Decree of the 1st and 2nd June 1537 on the genuinely human nature of the American Indians. These pronouncements were as important in the history of their colonisation as the Magna Carta or Declaration of the Rights of Man are for individual liberty in Europe.

From the earliest days of conquest, and in Peru especially, all kinds of adventurers mingled with the *conquistadores a lo divino*. And whatever their colour – white, black or brown, they had to be forbidden the right to carry cuirass and sword. Francisco de Toledo, the Viceroy, wrote to Philip II about this in 1569: 'Priests, monks, bishops and prelates of every order are absolute masters of all affairs both spiritual and temporal, and this costs Your Majesty dear, for they come at your expense on your ships, claiming to convert the Indians, and depart again enriched at your expense and theirs.' The *conquistadores a lo divino* were caught between Church and King and, even where the Church was concerned, they alternated between a crusading and a triumphant spirit; half their energies were devoted to meditation and half to preaching; one half to missionary enthusiasm, the other to despair at the sight of a whole continent so given over to what they called the Master of This World – the Spaniards to gold and the natives to human sacrifice.

The encounter which the *conquistadores a lo divino* made with the New World was an encounter with Satan. In Europe, demon sabbaths were occasional visitations

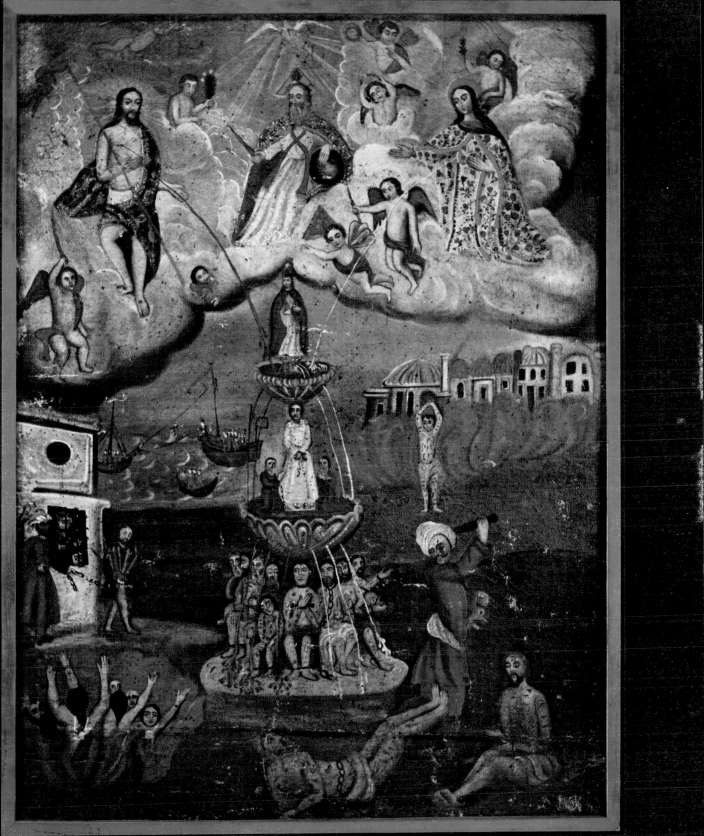

XVII

caused by famine or plague, but in Mexico they were found to be an established practice. Zumarraga, the primate of Mexico, declared that every year twenty thousand human hearts were offered to Tetzahuitl, god of terror, and Bernal Diaz was horrified when the Indians made him friendly offers of slaves for butchery; perhaps he was still haunted by the terror-stricken face of one companion seized by the Mexicans to have his heart torn out for sacrifice. This in itself will help to explain the furious zeal of the monks in their destruction of idols and temples. To these men of God it seemed inconceivable that men's minds could be so bedevilled, frightening to find the Great Beast worshipped after the manner of the true God, having priests and temples like Him, with creeds and litanies and sacred books. This they held to be 'the greatest imposture of the Evil One', a phrase that often comes to their lips. Yet they earnestly enquired into the reasons for such cults, wrote letters on the subject to their superiors and to theologians in Europe. Their findings were not always hostile or disdainful. The native peoples of America they declared to be very religious, and their civilisations degenerate rather than primitive.

It is a little-known fact that the Jesuits often wrote more in sorrow than anger concerning the natives, their character and religion, and even their art, which so scandalised them. Though supposed to be iconoclasts, they were the first to point out that 'it is not through lack of art that the statues in these lands represent attitudes contrary to the natural laws of beauty. If they are fashioned thus, there is reason to believe that it is by virtue of some religious law.' This law they sought to discover and to reform, for with the enthusiasm of their faith they were quick to believe that the natives of South America had once received the Christian message, but that time, distance and lack of contact with Mother Church had wrought a change. They thought that crosses could be traced in Mexican monuments, among the subterranean tombs of the Zapotec priests and kings at Chila and Mitla. But it was a bas-relief at Palenque that most attracted their attention *(fig. XVIII)*; here, to left and

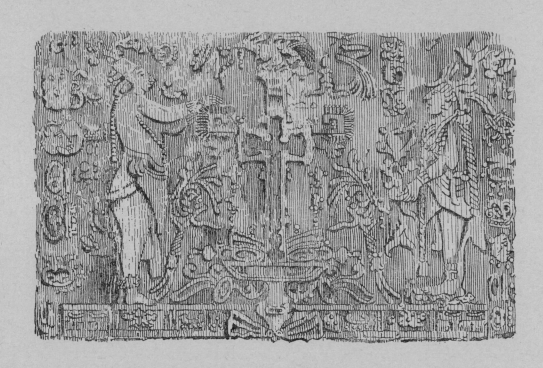

XVIII THE CROSS OF PALENQUE

right, they saw two figures, one lost in admiration and the other holding up a new-born child, strangely formed. Who was this child? Monks had no need to stress the question. And the Toltec god, white-skinned and bearded, in a cloak starred with red crosses, Quetzalcoatl, the serpent clad in green plumes, was he not the leader of an ascetic sect dressed in black who pierced their bodies with cactus thorns? He had taught his people the calendar and the first arts, told them the story of a flood and a snake very like Noah's dove, and then had gone up into the heights of Cateite-petl, the talking Mountain, just as Moses went up into Mount Sinai. Furthermore, at Chichen Itzá in the Maya country, Chilam Ballam, the high priest of Meni, had foretold that bearded men with white skins would come from the rising sun and set up crosses far and wide. And the Muyscas living on the plateau of Cundinamarca

said that Bochica, an old man with a white beard, had taught them the calendar and the arts, and then withdrawn into a valley for a penance lasting two thousand years.

For a complete understanding of Catholic Indian pictures we should have to know all those points at which myths and liturgies meet, and so allow one religion to absorb another and transfigure it, change one theme into another: the bounding puma of the Aymaras, for instance, into Tiger-Christ-Sun. The *conquistadores a lo divino*, it is true, followed the precepts in Deuteronomy: 'Ye shall utterly destroy all the places wherein the nations which ye shall possess served their gods, upon the high mountains, and upon the hills, and under every green tree. And ye shall overthrow their altars, and break their pillars, and burn their groves with fire; and ye shall hew down the graven images of their gods, and destroy the names of them out of that place', but they also liked to quote St Paul disputing with the Athenians on the Acropolis. Sometimes they wanted to make a clean sweep of the past and sometimes they wanted to use the more sacred mysteries which they dimly discerned in Indian rites and legends and link them with Christian rites and mysteries. It was a renowned Mexican iconoclast, the blessed Peter of Ghent, who founded in the College of the Holy Cross at Tlatelulco the first school of art for natives, together with Friar Bernardino de Sahagun (1499-1590) who had his *Story of New Spain* interpreted in Aztec drawings by his pupils. Peter of Ghent seems to have been the *éminence grise* of the Conquest of America. Though only a lay friar, he had the respect of his superiors, and was said to be a cousin or illegitimate son of Charles V. In a letter dating from Mexico on the 27th June 1529 he described how the monks made use of their time, 'never sparing our labours night or day to save this people.' At night they preached and catechised, not without reward; 'being of a servile temper from habit', the Indians meekly received the faith. Peter of Ghent mentions two hundred thousand converts, more than a thousand a day. And Zumarraga, the Franciscan Bishop of Mexico, summing up the results of ten years of conquest, talks

of a million by 1531; between 1524 and 1539 the Franciscan chronicles boasted of seven million, baptised with the left hand when the right hand was tired, which raised doubts about the formal validity of such baptisms. A council was called in Mexico by the Viceroy Mendoza with the Pope's approval and it decided favourably on this question. Under the circumstances, the urgent thing was to win souls, but in future the proper rite must be respected.

In the daytime the friars taught the children to read, write and sing, also to paint and to carve, and the first native Christian artists were children who were taught the rudiments of Catholic art together with their catechism. And it was they who decorated the early parish churches, copying the sacred pictures given them by the monks when they learned their lessons well; an art that lisped and would make them forget their parents' handiwork for ever. Remembering how children enjoy playing Aunt Sally, the monks also made them help when destroying idols. The first occasion was probably in 1525 at Tezcuco when the Franciscan Turribius Motolinia used his pupils; Peter of Ghent had a commando group of fifty of his best schoolboys at work within a thirty-mile radius, destroying idols, preaching and building sanctuaries. Thus children furthered the conquest of their own country. And finally there was propaganda by singing: like the good St Ambrose, the monks composed songs on the sacred mysteries, and the children sallied forth to chant them about the countryside; they were not written in Latin, however, not even in the celestial language, Castilian, but in native dialects. With the help of Arnoux de Bassacio, the grammar master, Peter of Ghent also wrote the first bilingual catechism in Nahuatl and Castilian, published by Plantin at Antwerp in 1529, and the first book to appear in the New World was this same catechism, printed in Mexico in 1539.

The Society of Jesus *(plate 40)* was late in coming to settle in Mexico in 1572 and came at the request of bishops who sometimes had cause to regret it. Palafox

de Mendoza, the Bishop of Puebla, was said to have complained to the Pope about the fair they ran in their convent and the gold and silver mines they owned; he alleged that they had even tried to have him stoned by their acolytes, who had been told to add a phrase to their Sunday litany, still heard, some said, fifty years later: 'Lord, deliver us from evil and from Palafox our Bishop.' The Lord heard their prayer: the bishop returned to Spain where he died in the odour of sanctity, much honoured for the works he had published: the *Correspondence of Teresa d'Avila; A Living Portrait of the Indians* and *The Heart of a Poor Repentant Sinner*. Though they numbered less than a hundred and fifty, the Mexican Jesuits of the seventeenth century governed half a million Indians. Tepozotlán *(plates 60-64)*, the most important of their colleges in New Spain, was built in 1582 at the expense of an Indian Chief and named after San Ildefonso.

In Paraguay the life of the natives was not always idyllic in the Jesuit missions, and they were run by monks whose views were tersely put into a maxim by one of their number: 'You have to turn them into men before you turn them into Christians.' There was a census of the population there and it was divided into districts under a controller responsible for the religious side of life. The produce of the land was kept in public stores, accounted for and then re-distributed according to the needs of each family. Daily life was punctuated by religious services, communal prayers morning and evening, and on Sunday there were mass, vespers and the procession of the Holy Sacrament – college life in fact, except that 'care is taken to see that young men marry as soon as they reach the age, and in this way much irregularity is avoided.' And besides agricultural labourers, the Fathers also trained natives as printers, clock-makers, carvers and painters. There were travellers who testified that their churches of freestone would have been quite acceptable in European towns. All this was certainly to the honour of the Church and the King of Spain, who received one piastre a year for each Indian soul won over. But there

were matters which annoyed more worldly men in Buenos Aires, who chafed at paying for the produce farmed by the missions. And from there to saying that the Jesuits were very rich and robbed the Treasury was an easy step; it was taken. People went further and said they were running gold-mines; there were suits for libel which the Jesuits won. Then in 1732 came the Creole revolt in Paraguay; this was put down by mission troops who remained loyal to the King. One can imagine all the hatred stirred up by this affair, when Whites were defeated by native troops commanded by the Fathers, many of whom did not come from Spain. Finally there was the trouble about the Paraguay grass, also called the grass of St Bartholomew, for the saint was supposed to have taken the poison out of it and made it wholesome; this was the dried leaf of a shrub called *ca* or *caa* by the Indians, which was confused with *cha*, the Chinaman's tea, or with the silver calabash in which it was infused—*maté*, a name which it has since kept. The average yearly consumption of this drink throughout South America amounted to four million pounds, and the Jesuit missions held a virtual monopoly. They were already forced to defend themselves against the raids of Paulist adventurers and Portuguese bullies, and several years had to pass by before they could persuade the Prince of Santo Bueno, the Viceroy of Peru, to abolish a slave-trading company formed by Europeans at Lima; this used to raid Amazonia to supply fashionable ladies with their Sunday morning missal-bearers. It was true none the less that the Jesuit trade in maté reaped profits which caused many an envious eye to open wide.

The last *conquistador a lo divino* who journeyed on foot from Vera Cruz to Mexico was the Franciscan Junipero Serra, the apostle of California, at the end of the eighteenth century. After him the South American friar, jolting along the road in his litter between two mules adorned with pompoms, was more often of a less crusading nature, and he was even known to read Voltaire! The last word might well be given in a story about one of Bolivar's followers, a native soldier, who did not

dare to kill his prisoner, a Hussar in Ferdinand's regiment, because he thought he was a friar on account of his long waxed moustaches.

Independence and the wars that followed transformed the convents into barracks, prisons or stables *(plate 68)*. With the advent of foreign capital and free trade they eventually came to be used as stores and often fell, at the last, into ruins. Only the churches, frequented by tourists, survived, but visitors often forgot how bare were

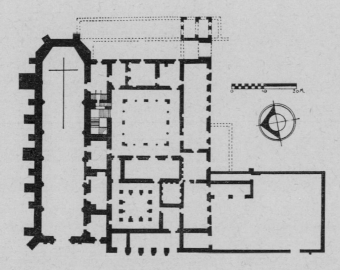

XIX ACOLMAN, PLAN OF THE AUGUSTINE CONVENT

the courts and corridors, the stairways and cells behind those exuberant façades and the darkening gold of the domes *(plates 62, 63, 64)*. And the contrast is significant; the essential problem of the *conquistadores a lo divino* lies there. They sought to impress the natives, without forsaking their traditional poverty and austerity. Monastic architecture in Mexico is a remarkable example of an ascetic Baroque which contrived to remain severe, though combining the most complex forms and volumes of different geometries: Romanesque, Gothic, Classic and even Chinese *(plate 66)*. If the religious orders had not so often clashed with one another on this earth in the

defence of their cures of souls one would be tempted to call these architectural exercises within the ruined convents – no matter who their founders – 'the spiritual exercises of New Spain'. Long might one dwell upon the story of these men, sent forth by faith to the uttermost ends of the world, who saw every civilisation and succumbed at last under the weight of the one they brought with them.

NOTES ON THE ILLUSTRATIONS

XIV Page 110 SHIP OF THE SIXTEENTH CENTURY, from *Relation de Voyage* by Barentz (1596-97), published at Amsterdam in 1605.

XV Page 112 THE EARLY MONKS OF MEXICO, fresco in the convent at Huejotzingo (Puebla), after M. Toussaint, *Arte Colonial in Mexico, fig. 34*. There were twelve Franciscans with Martin de Valencia and Cortés.

XVI Page 113 DOMINGO BETANZOS, a preaching friar; fresco at Tepetlaoxtoc (Mexico) after M. Toussaint, *Arte Colonial in Mexico, fig. 29.*

XVII Colour plate facing page 114. Primitive painting of the seventeenth century, a Peruvian version of a medieval subject, treated notably by Martin de Vos: Christ giving his blood and the Madonna her milk to refresh the martyrs in Moorish hands, grouped in the mystic fountain. This may have been painted to adorn some shrine of the Brothers of Mercy, a religious order whose mission it was to buy slaves back from the Moors. *Collection Claude Arthaud.*

VIII Page 118 THE CROSS OF PALENQUE, from M. le Baron Henrion, *Histoire generale des Missions*, Paris 1846, vol. I, plate XV. Palenque (Chiopas) is a town of the ancient Maya empire. This bas-relief was in a building to which it gave its name, the Temple of the Cross. It is now in the National Anthropological Museum of Mexico. The subject gave rise to much controversy in the nineteenth century; the cross is probably a symbol of earth and life, with the sacred bird, the quetzal, above, and a priest on either side. See P. Rivet, *Cités mayas*, plate 85, Albert Guillot, 1954.

XIX Page 123 ACOLMAN, plan of the Augustinian convent, after M. Toussaint, *op. cit.*, fig. 83. *See plates 58 and 59.*

56, 5-67 ACTOPAN Augustine convent built by Friar Andes de Mata at the end of the sixteenth century. An example of *barroco sobrio. Plate 66:* the round door may be derived from Chinese architecture. Mexican convents were stopping-places for missionaries from China and Japan.

57 TEPOTZOTLÁN Belfries of the Dominican convent (1560-1570), built over the shrine of the god Ometochtli by Domingo de l'Annunciacion (1551-1559). *See also plate 170.*

58,59 ACOLMAN Augustinian convent founded in 1539 by Father Roman; *see plan, p. 123.* Statues forgotten in a hall, perhaps a kitchen or refectory. *See plate 26.* During the siege of Mexico, the two lieutenants of Cortés, Alvarado and Olid quarrelled, sword in hand, for quarters in Acolman.

60-64 TEPOTZOTLÁN Jesuit college founded in 1582 and rebuilt at the end of the 18th century. *Plate 60:* cistern and octagonal fountain in one of the courtyards. This traditional design for fountains dates back to St Ambrose in the fifth century, and symbolises the perfection of the eight virtues of baptism.
Plate 61: the church apse seen through a cell window.
Plate 62: the Churrigueresque façade of the church, contrasting with the simplicity of the convent buildings on the left.
Plates 63,64: corridors and stairs in these buildings.
See page 123 and plates 70,71.

65-67 *See plate 56*

68 YANNUITLÁN (OAXACA) Ruins of the Dominican convent founded by Cortés' lieutenant, Francisco de Las Casas (1541), completed by his son Gonzalo in 1575.

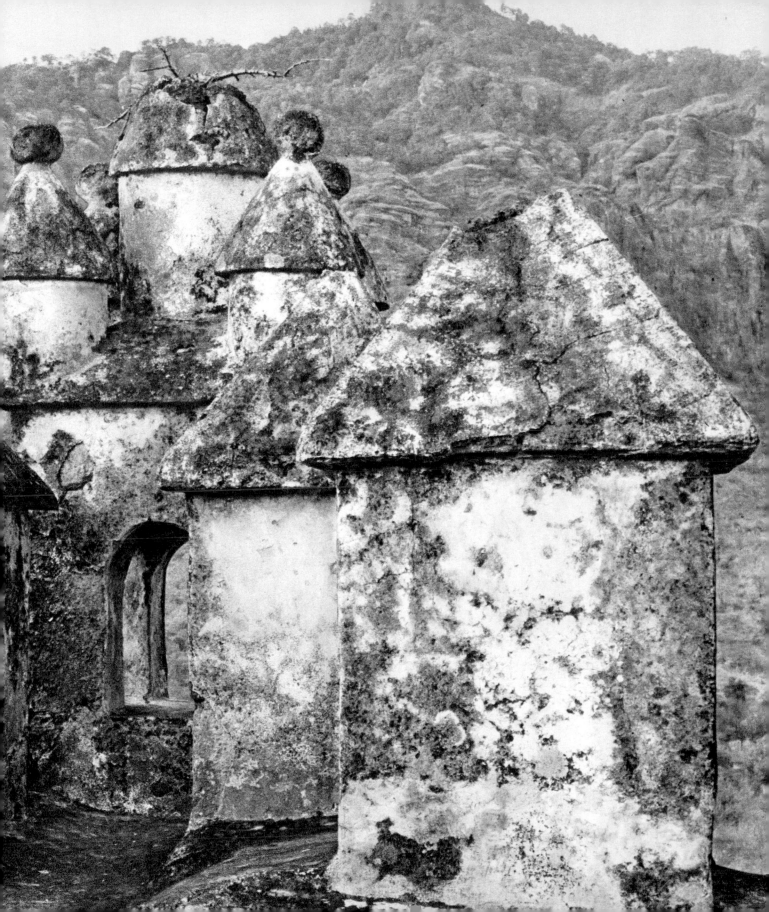

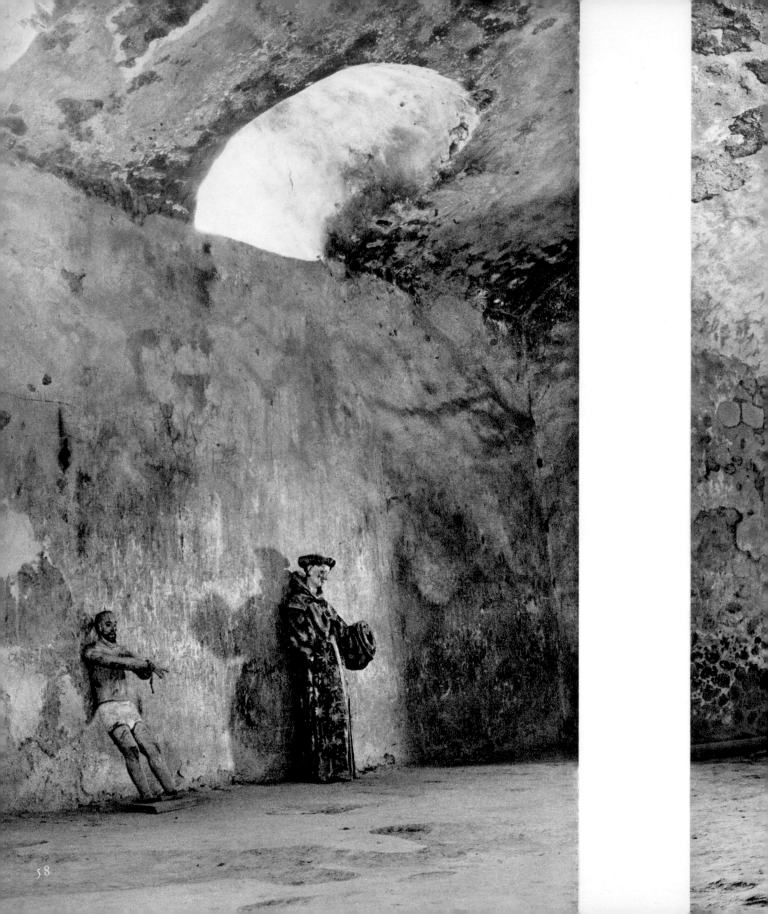

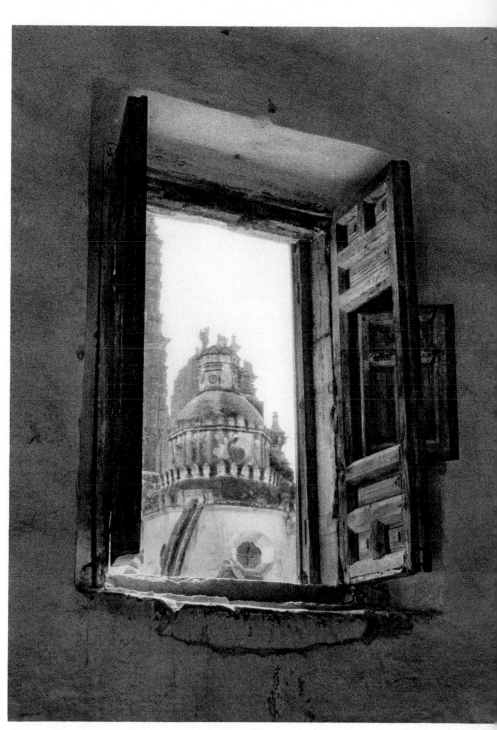

61

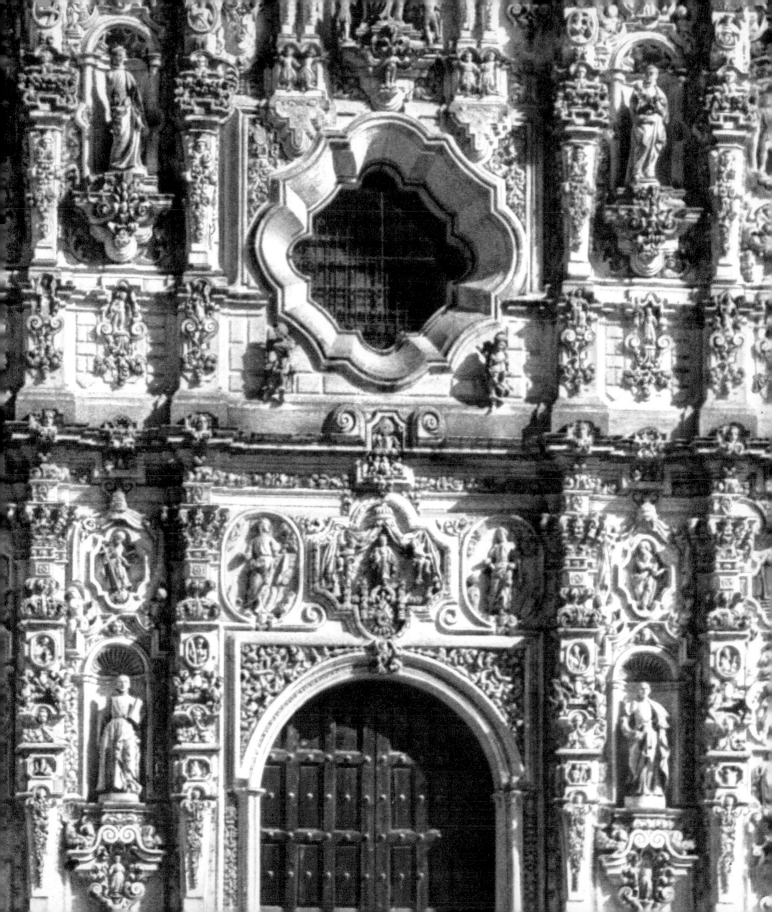

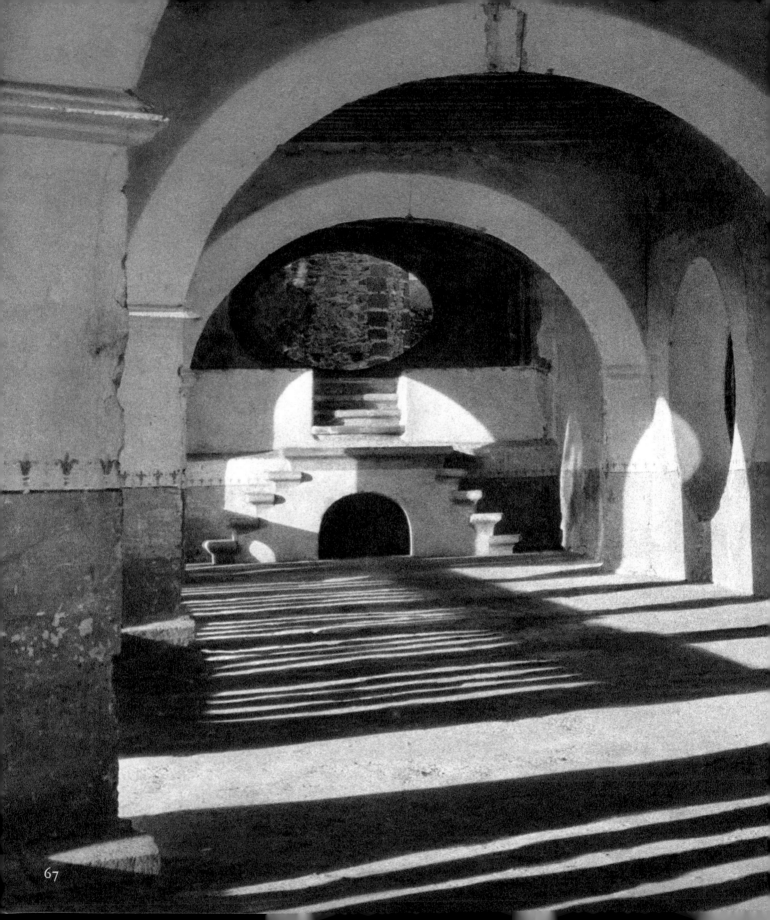

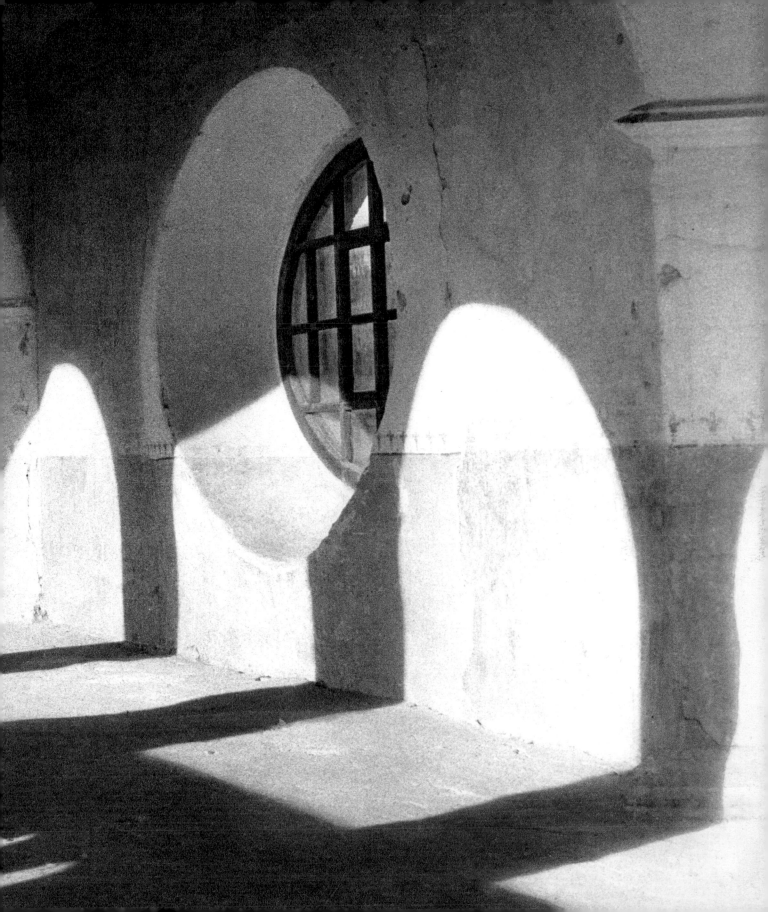

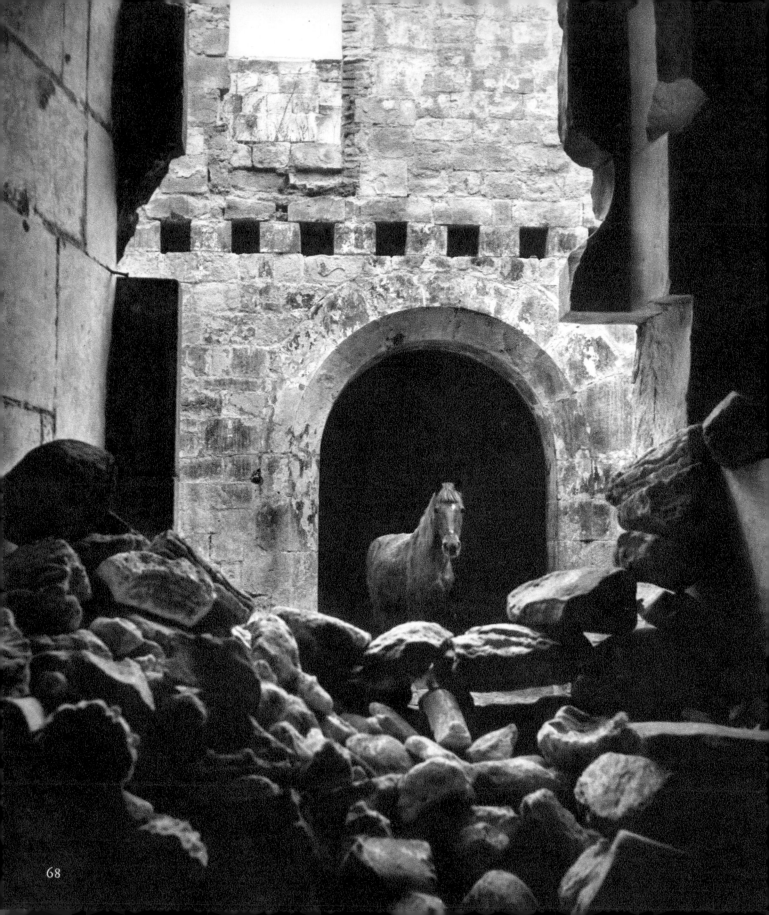

IV The Spice of Luxury

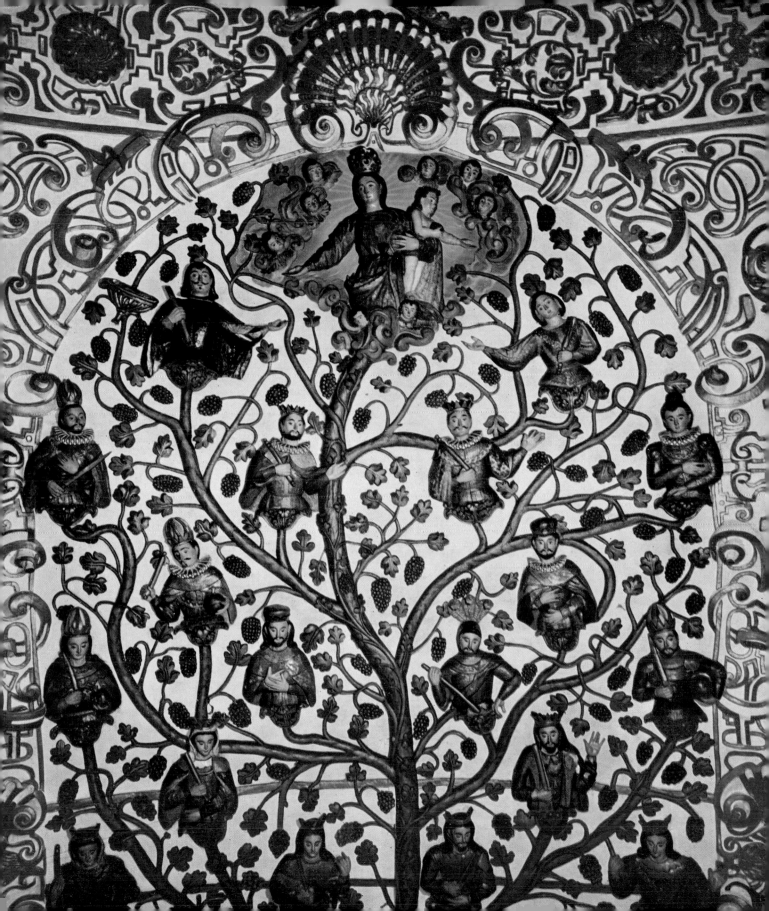

XX

MOST OF THE Conquistador families had little to sustain them in the seventeenth century beyond pride in their origin. Bernal Diaz had already complained when he saw Cortés distributing land and benefits to his Medellín relations instead of rewarding his soldiers. And fifty years after the Conquest their descendants were poverty-stricken; they had been ruined by extravagance, law-suits and idleness. So Philip II sent out his favourite friars, the bare-footed Carmelites, under Juan of the Order of the Mother of God, to found a monastery for the education of poor girls born of the conquerors. Admirable as their education might be, these girls had only two choices before them: to take the veil or marry some upstart, probably a Creole. The names taken by the wealthy Creoles tumble over each other, just as the honourable pieces on their Conquistador coats of arms jostle together with quarterings, mantellé and tranché. And what could be more Baroque than these heraldic devices flowering within the strict frame of the shield, blazoning Vanity *(plates 75,77,78,82)*. For two whole centuries, the seventeenth and eighteenth, the story of America is the story of *nouveaux riches* playing the alchemist in reverse, trying to convert their gold into blood, to transmute such titles as Merchant of Sugar, Precious Metals or Chocolate, Vanilla or Tobacco into the title of Marquis or Count.

The money squandered by these upstart nobles was incredible; on a mere picnic, it was said, they would spend enough to keep a citizen of Spain in good standing for

a whole year. And once they had made their fortune, luxurious living and the climate of the country very quickly gave them that air of insolent indolence which suggests the aristocrat *(plates 83, 84, 85)*. We may be sure that Señor de Galvez *(plate 89)* has the hair under his three-cornered hat just as agreeably curled as his horse's mane, and a man whose barber used scores of curling papers is not likely to over-burden his perfumed head with affairs of state, with mines or agriculture. He just reclines on a long comfortable cane-chair. 'In these hot climates the greatest pleasure consists in keeping still,' said Monsieur d'Orbigny the traveller and naturalist. But the Creoles showed no lack of courage when it came to spilling blood for a woman's sake. The courtesan was their heart's desire; the pleasures of love might well vanish in lawful wedlock. And the character of the Creole woman, for all her angel face, matched the climate... Look closely at their portraits in their golden frames; there is one little detail there, a little convention which speaks volumes: the black beauty spot worn on the temple or at the corner of the eye. So placed, it was called La Passionnée *(plates 72, 74, 75, 81, 82)*. They even wear it as children *(plate 79)* and already hold between finger and thumb the rose of love *(plate 73)* or fan of coquetry.

Good Catholics too; they went to church to hear mass every morning, followed by a little Negro boy or Jivaro in silk livery, carrying their prayer-book and kneeling mat. Yet they all wore wigs, though sternly forbidden to do so by St Bernard of Sienna. This was deadly sin for four reasons: *firstly* offending God by blaming his handiwork, *secondly* knowingly deceiving others, *thirdly* deceiving oneself, *fourthly* offending the dead from whom the hair is taken. But fortunately Cardinal Cajetan is there to prove that the sin is only venal, also the Jesuit Gabriel Henao can describe paradise as a viceroy's ballroom: 'The angels will be dressed as women and appear to the saints in women's dresses, with their hair curled, and farthingales, and the finest of linen; men and women shall take their pleasure, with masquerades and feasts and ballets.'

Young Creole women had every gift that the heart could wish: rank, wealth and beauty, and yet numbers of them forsook the world for religion. Travellers often expressed surprise to find Latin America one vast convent. Here is Doña Maria Francisca *(plate 82)*, the 'legitimate' daughter, the scroll says – the point is important if you want to become a nun – of Don Antonio José de Esquivel and Doña Maria Serruto. She was born at Michoacan in 1768, and was eighteen years of age when she entered the convent of St Brigid of Mexico. But why? She looks a charming girl and intelligent too; was she penniless or was this really and truly her vocation? Or was there perhaps a secret delight for a girl in becoming for one whole day the central figure in a ceremony of greater splendour than she might expect as a bride? Then there is Sister Maria Ignacia of the Blood of Christ *(plate 92)* portrayed on the day when she took her vows in the order of St Clare. Her age is given on the scroll – twenty-two years and three months – yet one would think she was scarcely fifteen, her face seems so diminutive under her heavy head-dress, and her body cannot be seen for pearls and plumes, embroideries, velvet and silk.

The long day is ending, leaving memories of fumes of incense and candles, of tears scarcely restrained by the closing bars, and soon Maria Ignacia will be in her cell like so many others *(plate 95)* in her nun's robes now, after renouncing the world... But is renouncing really the right word? In the sixteenth century yes, in the seventeenth perhaps, in the eighteenth – well, scarcely, and still less at the beginning of the nineteenth century. Madame d'Aulnoy, familiar with the world of enforced retirement and of gallantry too, had noticed something in Old Spain equally true of the New: nuns saw many more cavaliers than ladies in the outside world.

Music held an important place in the almost fashionable life of convents: the chaconne, much exploited by Johann Sebastian Bach, among others, was said to have come from Mexico. A great deal of reading was also done, and not only of novels; the Inquisition's censorship gave added inducement, and wine-barrels were

used to smuggle books in. On the shelves of Inez de la Cruz *(plate 95)* stand, side by side with the *Corpus Civilis*, the *Corpus Canonica* and works by fathers of the Church, the very different writings of Martial and Lucan.

Luxury and fashion in the New World were paid for by trade in chocolate, cocoa, ipecacuana, sugar, vanilla, tobacco, cochineal and Negro slaves. Everyone bought and sold, often on a lavish scale. And while the Negroes and Indians toiled, high society reached a peak of gracious living.

NOTES ON THE ILLUSTRATIONS

xx Colour plate facing page 144 OAXACA The stem or vine of Jesse in the Church of the Dominican convent, end of seventeenth or beginning of eighteenth century. *See also plates 99, 177.*

69 TASCO Medallion on one of the doors: Fortune under the Holy Sacrament between two Corinthian capitals; eighteenth century. *See also plates 15, 16.*

70 TEPOTZOTLÁN Altar-piece in St Joseph's shrine; eighteenth century. Example of Churrigueresque Baroque. *See page 33.*

71 TEPOTZOTLÁN Chapel of Our Lady of Loreto; angel dancing on the Ark of the Covenant; eighteenth century.

72 MEXICO, NATIONAL HISTORY MUSEUM Lady with fan, eighteenth century. Example of a colonial frame, carved and gilt, Louis XV style.

73 MEXICO, NATIONAL HISTORY MUSEUM Doña Maria Josepha de Aldaco y Fagoaga, daughter of Don Manuel de Aldaco and Doña Juana de Fagoaga, born 27 February 1739, painted by the Augustinian Brother Miguel de Herrera in 1746. The African marigold (as we call it) was regarded as the symbolic flower of conquest and often called the 'great conqueror'.

74 MEXICO, NATIONAL HISTORY MUSEUM Doña Anna Christina Pablo Fernandez Arrea y Mendizaval, of the City of Mexico.

151

75 MEXICO, NATIONAL HISTORY MUSEUM Portrait by Ignacio Maria Barreda of Doña Maria Romero, wife of Don Jose Manuel Garcia Aurioles de Leon, at the age of thirty-four in 1794.

76 MEXICO, NATIONAL HISTORY MUSEUM Portrait (1770) by Joannes Fernandez of Doña Josepha Rosa de Sardeneta, Legaspi, Oxeda, Espejo, Torres, Luna. Probably the wife of the Marquis de Las Reynas, the wealthiest miner in New Spain and perhaps a descendant of Miguel Lopez Legaspi who annexed the Philippines in 1564.

77 MEXICO, NATIONAL HISTORY MUSEUM Sister Maria Narcissa, born Doña Maria Perez Cano, legitimate daughter of Capitan Don Juan Perez Cano, on the day of her profession in 1757. In her right hand, a scourge?

78 MEXICO, NATIONAL HISTORY MUSEUM Doña Juana and Doña Maria Josepha de la Fora Gay y Arce.

79 MEXICO, NATIONAL HISTORY MUSEUM Doña Ignacia Dionisia y Ybargoyen y Miguelena.

80 MEXICO, CATHEDRAL MUSEUM Angel in painted wood, end of the seventeenth century. Three fingers of the right hand raised, and the forefinger of the left hand. This is the angel of the Trinity: *Tres vidit, unum adoravit.*

81 MEXICO, NATIONAL HISTORY MUSEUM Doña Maria Serruto, legitimate daughter of Don Pedro Serruto and Doña Ana de Nabe y Mota, 24 April 1763 at the age of twenty-five.

82 MEXICO, NATIONAL HISTORY MUSEUM Doña Maria Francisca, legitimate daughter of Don Antonio de Esquivel and Doña Ana Maria Serruto, born at Salvatierra de Michoacan on the 15th August 1768; entered St Brigid's convent in Mexico on the 30th April 1786. She may have been descended from Juan de Esquivel, a nobleman of Seville, sent in 1509 by Diego Colombus, the son of the admiral, to represent him in Jamaica.

83 MERIDA, YUCATAN HISTORICAL MUSEUM Don Juan el Castillo de Arrue, campmaster, *alferez major* of Merida and *regidor de encomendero dos Indios*. Wig and coat of the seventeenth century. The founder of the Yucatan school of painting was the friar Julian de Quartas (1530-1587).

84 MERIDA, HISTORICAL MUSEUM Señora Rafaela del Castillo y Solis, wife of Don Manuel Bolio. Late seventeenth or early eighteenth century.

85 MERIDA, YUCATAN HISTORICAL MUSEUM *El capitan de Corazas, don Manuel Bolio y la Helguera, alcalde hordinario de la Santa Hernandad* (the Inquisition), *regidor perpetual dos Indios*, 1763.

6,90 PUEBLA Angels decorating the cathedral pulpit. Poblano art, eighteenth century.

87 OCOTLAN (PUEBLA - TLAXACALA) Cupola of Santa Maria, painted by Francisco Miguel between 1745 and 1765. The first circle represents the Fathers of the Church in the midst of angels; the second, the Virgin Mary among the twelve apostles. In the centre, the Holy Spirit. *See also plate 17.*

88 MEXICO, NATIONAL HISTORY MUSEUM His Excellency Señor Conde de Galvez, painted on 25th October 1796 by Brother Pablo de Jesus, with calligraphy by Father San Geronimo. The forty-ninth Viceroy of New Spain, Count Galvez in 1785 opened the Academy of San Carlos, founded in 1781 by Don Jeronimo Antonio Gil and the Viceroy Don Martin de Mayorga.

89 PUEBLA Cupola of the Rosario Chapel of the Convent of St Dominic (1690). The theme relates to the seven gifts of the Holy Ghost according to Isaiah, XI, 2: *Requiescet super eum spiritus Domini, spiritus sapientiae et intellectus, spiritus consilii et fortitudinis, spiritus scientiae et pietatis; et replebit eum spiritus timori Domini.* The sun of the Holy Ghost is surrounded by allegories of Intelligence, Strength, Piety, Fear, Knowledge, Counsel, Wisdom and Divine Grace; these are probably inspired by the *Iconologia* of the knight Cesare Ripa.

91 LOQUETERIOS, a trellis in iron or wood used in parlours to separate nuns from their visitors. *Pedro de Osma collection.*

92 MEXICO, NATIONAL HISTORY MUSEUM Sister Maria Ignacia of the Blood of Christ, daughter of Don Manuel de Oribe y Sandoval, painted by Don Jose de Alcibar on the day when she took her vows in the order of St Clare in Mexico on 1st May 1777 at the age of twenty-two. She may have been descended from Gonzalo de Sandoval, one of Cortés' captains, who married a princess of Tlaxacala and took part in the arrest of Montezuma. He was the son of an alcade of a fortress at Medellin, where Cortés was born, and was held to be the bravest of his soldiers. He was an illiterate, short and stocky man with bandy legs and a lisp. When he laid hands upon Narvaes, Cortés' rival, he cried: 'Victory for the Holy Ghost!' He commanded the advanced force on the Triste Nuit, was wounded at the second capture of Mexico and enriched with gifts of land by Cortés. On return to Spain he died in 1528 of exhaustion, in an inn where the landlord stole thirteen gold bars from him.

93-94 LIMA Madonnas; popular art of the seventeenth and eighteenth centuries. Compare the cloth of the robes with that in the portraits of Creole women.

95 MEXICO, NATIONAL HISTORY MUSEUM Portrait by Miguel Cabrera of Sister Juana Iñes de la Cruz in the convent of San Jeronimo de Mexico (1651-1695). In her library may be seen the works of St Augustine, St Gregory, St Ambrose, St Anselm, St Bernard, the *jus canonicus*, the *jus civilis*, the collection of Papal Bulls, a treatise on moral theology, one on surgery, and another called *De Rustica*, Records of the Council of Trent, works of Louis de Granada, John of the Cross, Laertius, Martial, Seneca, Cicero, Quintilian Lucan and Virgil. *See page 150.*

96 CALPAN A cell in the Franciscan convent *(see plate 2)*. An example of naïve Baroque decoration in the severe setting of monastic life.

97 LIMA The Virgin of Mercy (seventeenth century).

98 *The Virgin of Guadeloupe*, also called *la Morena* (the Dark), the most famous in America. She appeared to the Indian Juan Diego in 1531 at Tepeyac. (It was here, during the march on Mexico, that the horse of Solis Casquete broke a leg, and Botello, the army astrologer, considered it a bad omen). On the history of this picture, *see page 74*. This picture is one of many copies of the painting made by Brother Diego de Ocana at Sucre, early in the seventeenth century. In the centre, parrots and the caravel of Columbus, who carried the picture on his standard. The original had a diamond, ruby or

emerald in each little square on the robe and was covered with *milagros* – miniature arms, feet, hands, legs, hearts, ears or heads in gold or silver, indicating which part of the body had been cured by the help of *la Morena*. The present shrine in Guadeloupe was built in 1777 by the people under the direction of Francisco de Guerrero y Torres.

99 OAXACA, CHURCH OF THE DOMINICAN CONVENT (1731) The stem or vine of Jesse, according to Isaiah, XI.1: *Egredietur virga de radice Jesse*. This is the genealogical tree of the Kings of Israel, with Virgin and Child at its top 'displayed as a standard before all people'. The sculptor is probably Pedro Maldonado (1688-1690). The Dominican Convent of Oaxaca was the most important in New Spain. Founded in 1570, it was rebuilt in the eighteenth century. The chapel of the Rosary was plundered by Maximilian's French forces. *See page 23 and plate 177.*

100 TASCO The altar-piece of St Nicholas, seen from the choir gallery. Example of Mexican Churrigueresque. Isidoro Vicente de Balbas, the son of Jeronimo, who introduced Churrigueresque into Mexico in 1718, probably worked with Cabrera on the altar-pieces of Tasco.

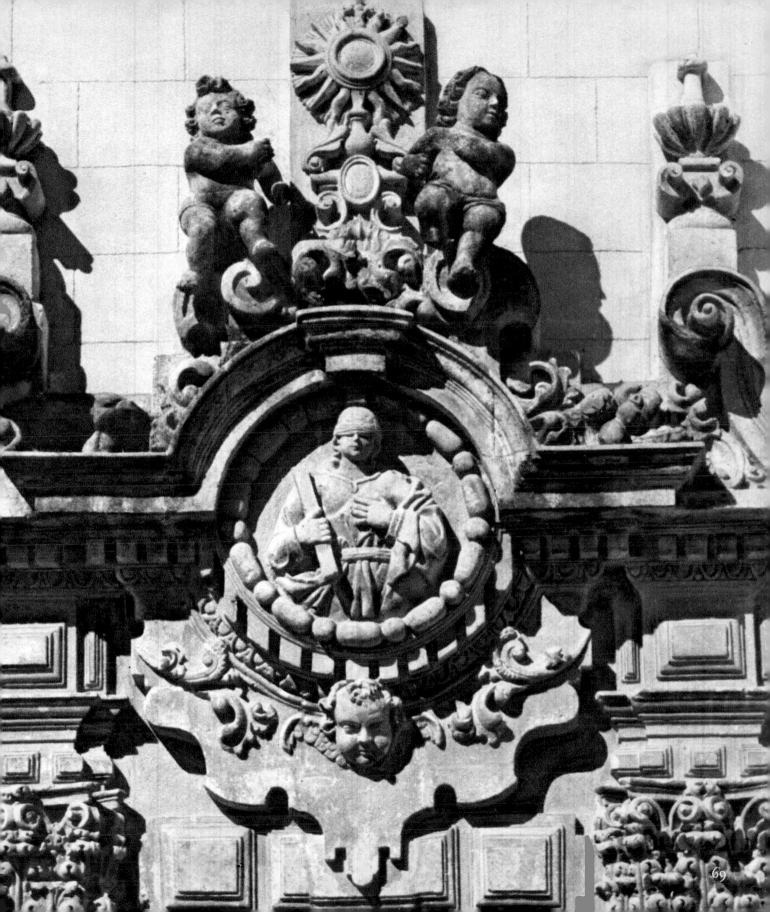

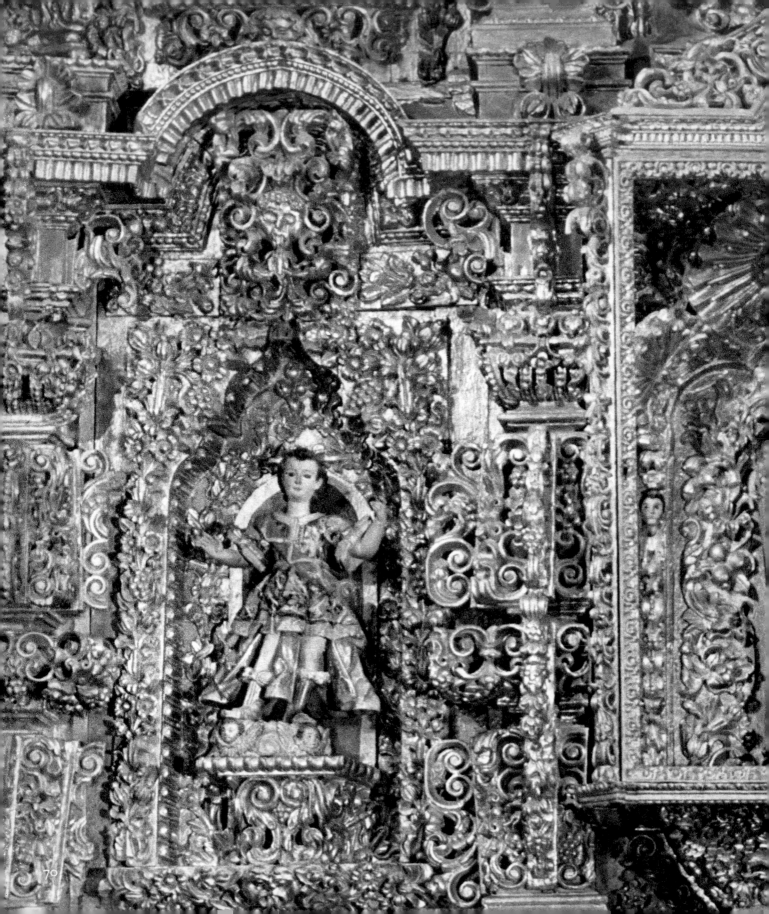

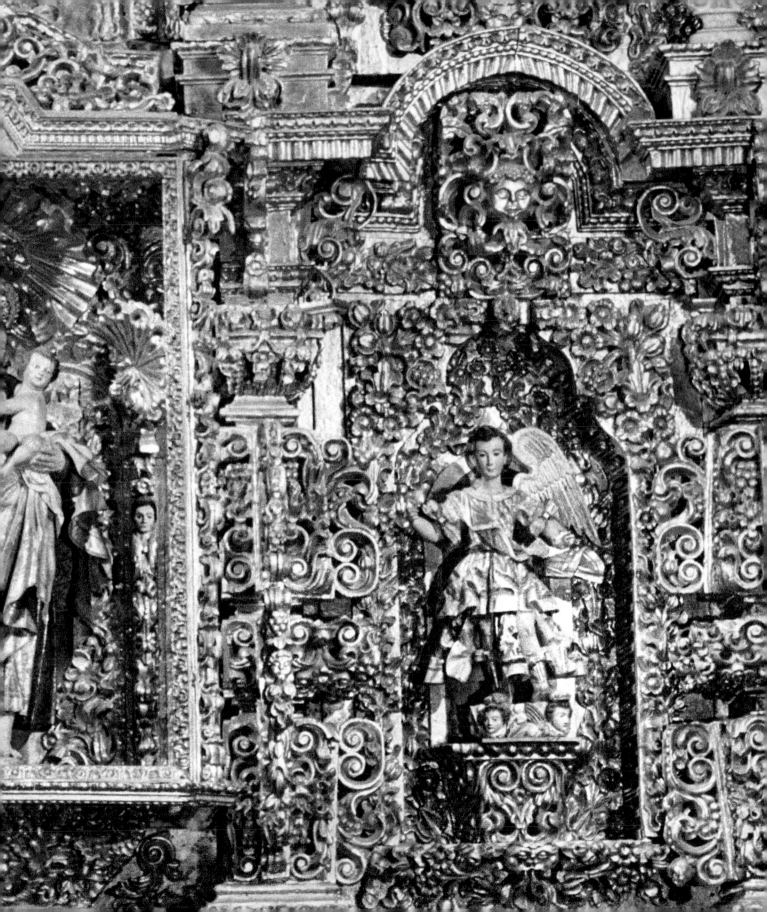

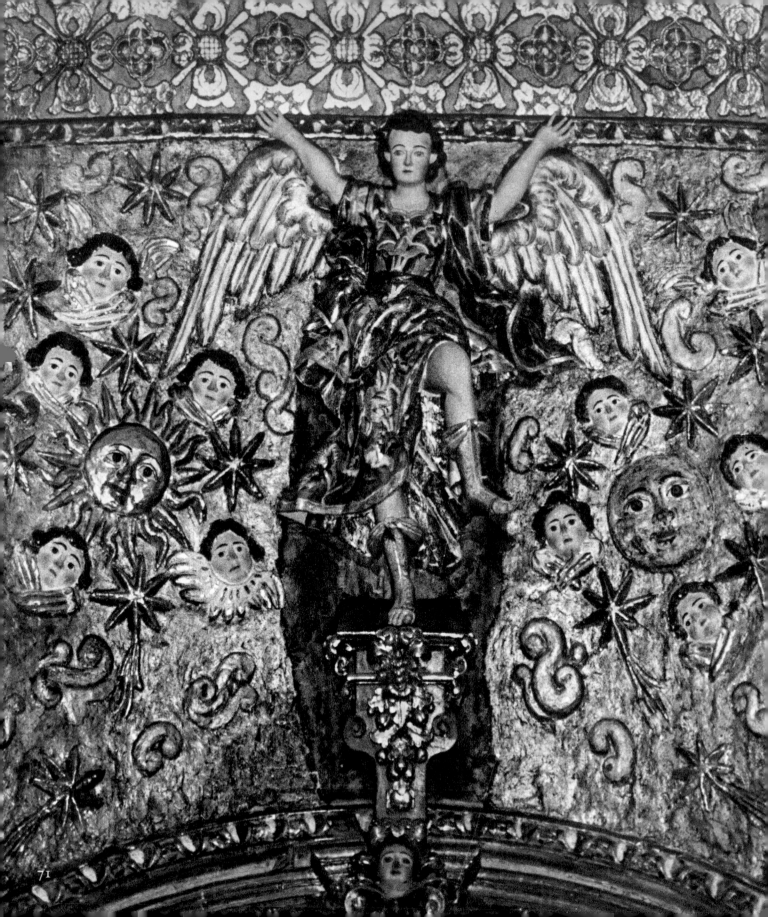

72

73

74

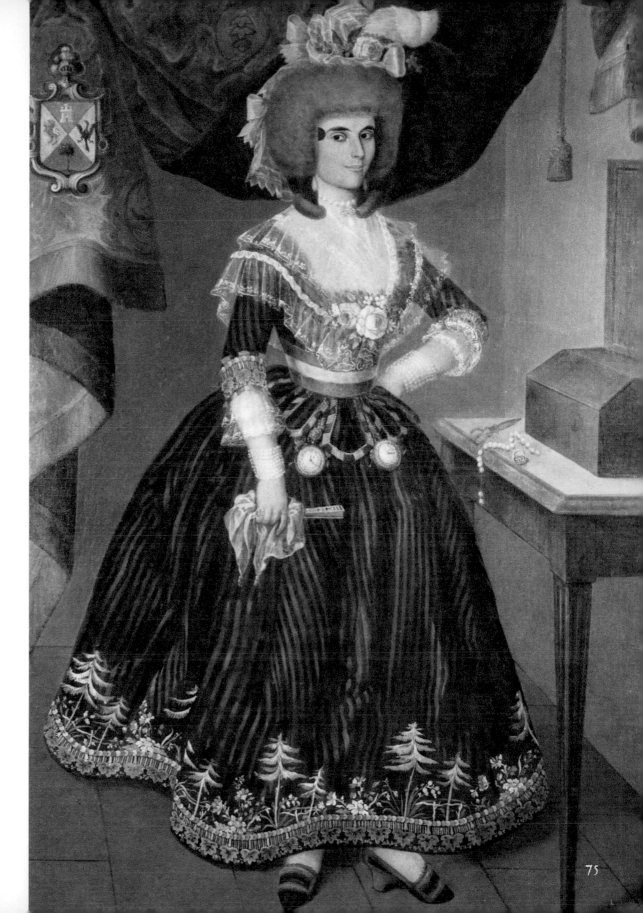

75

76

7

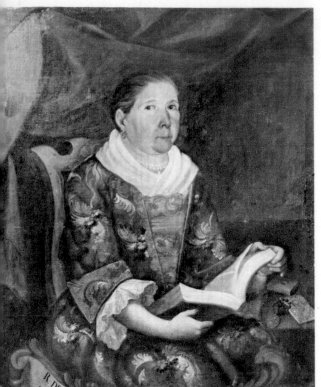

77

79

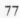

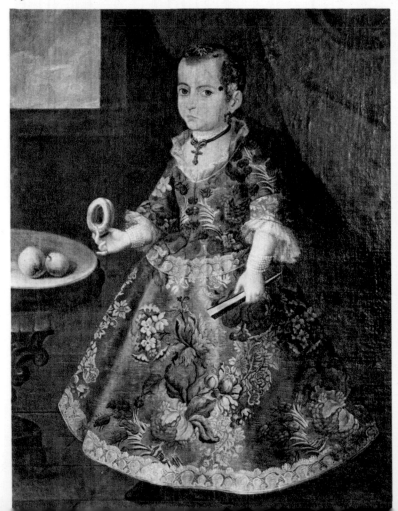

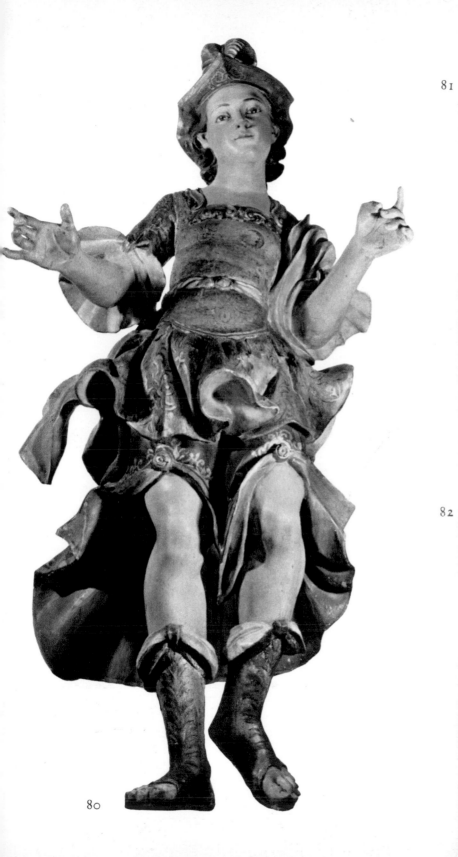

80

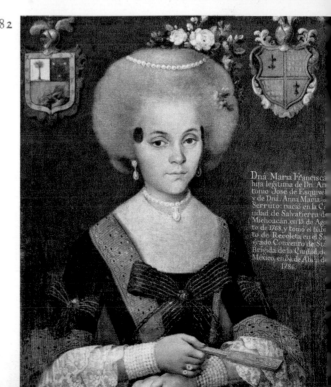

81

82

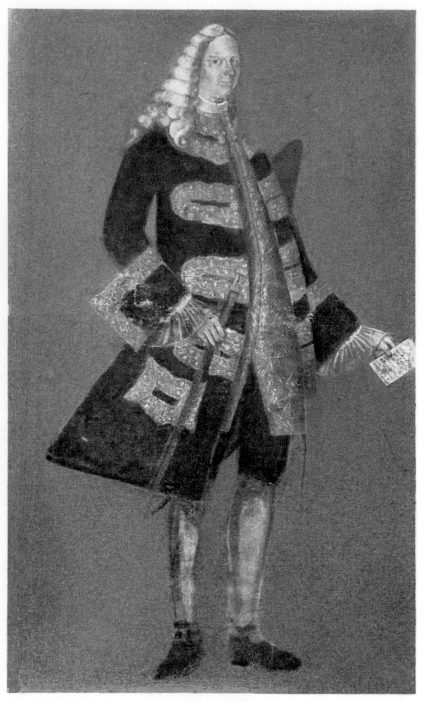

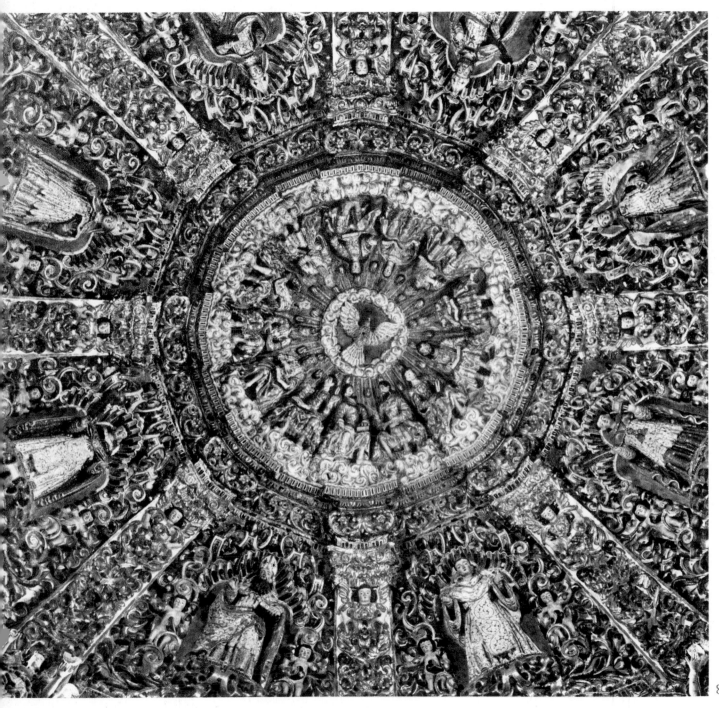

87

88

84

85

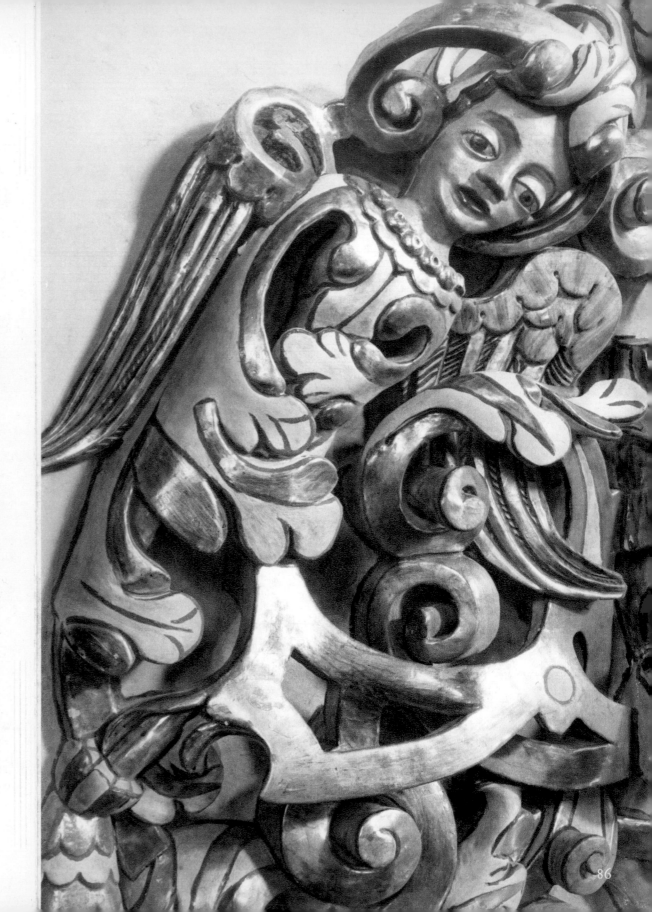

86

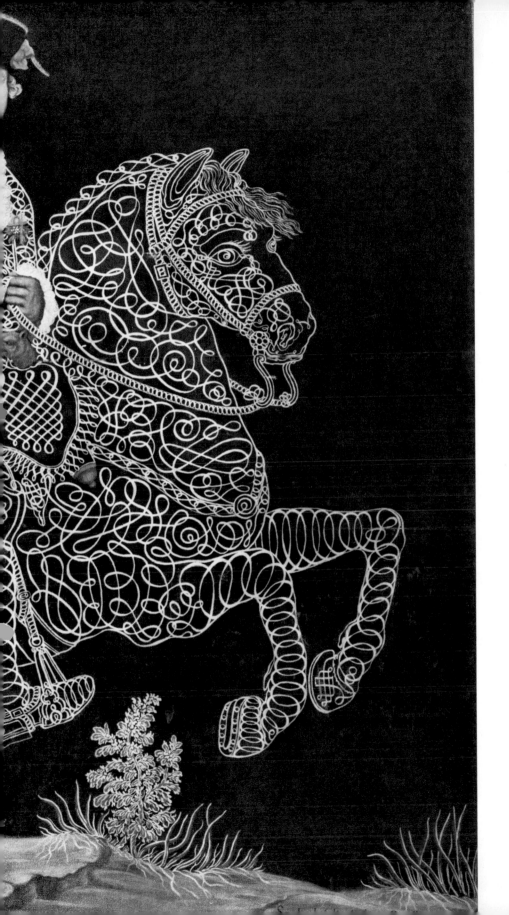

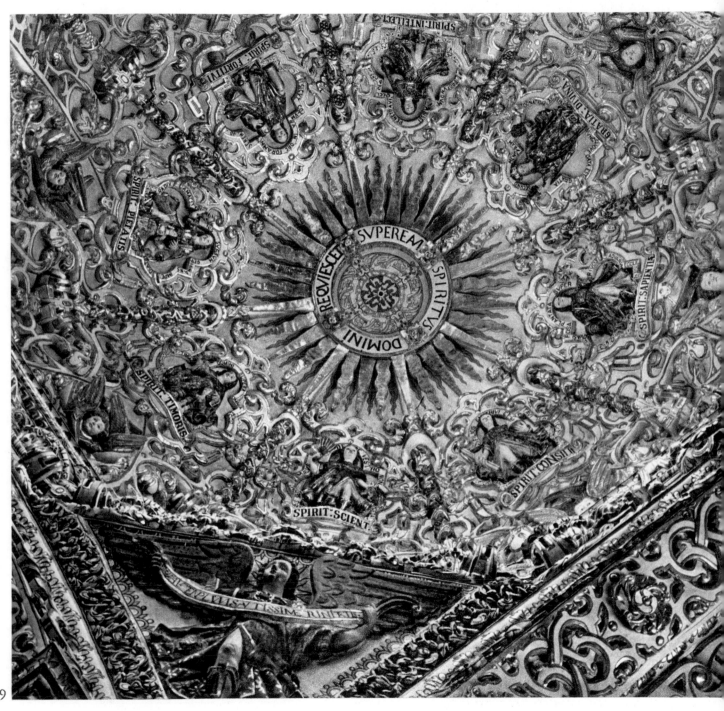

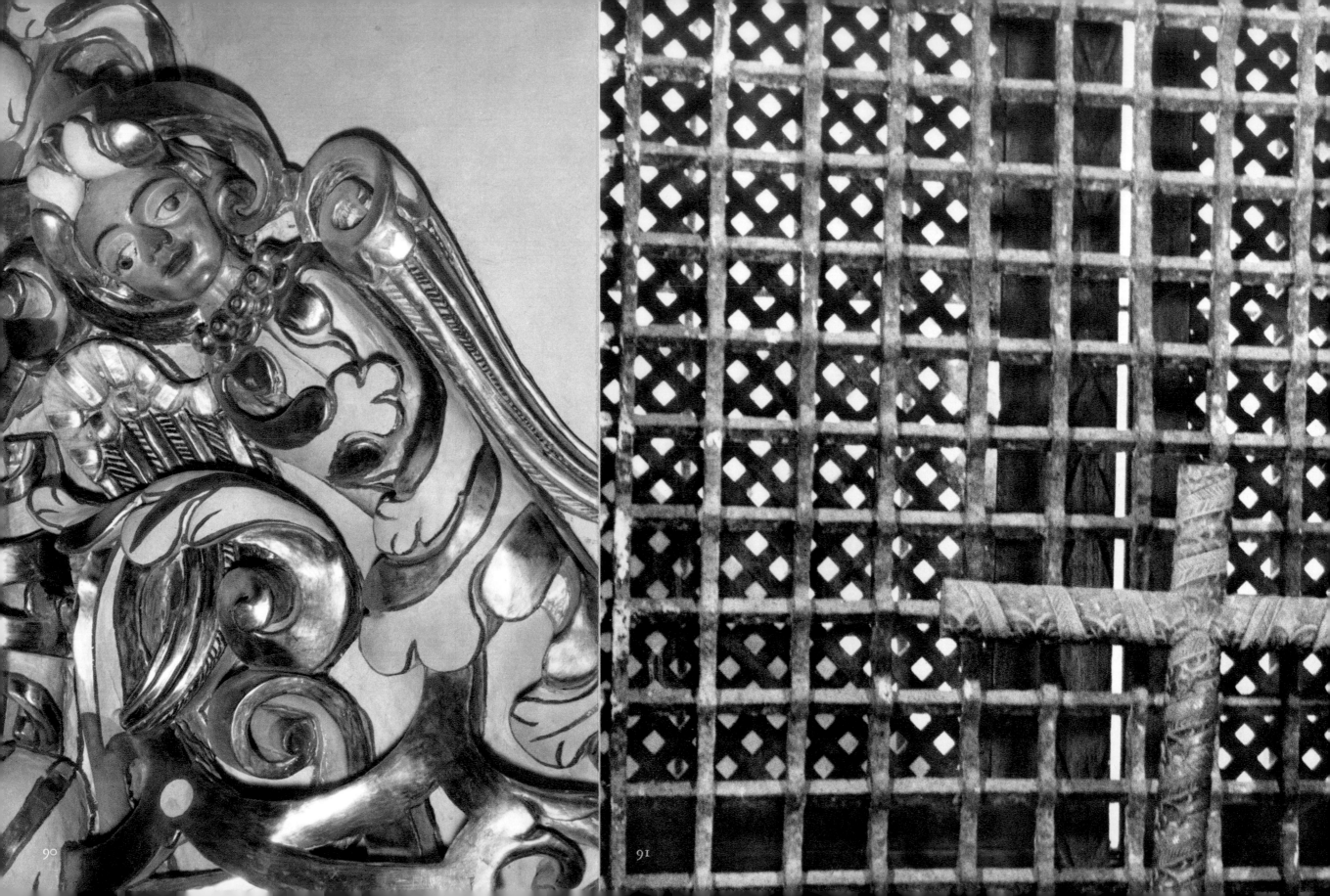

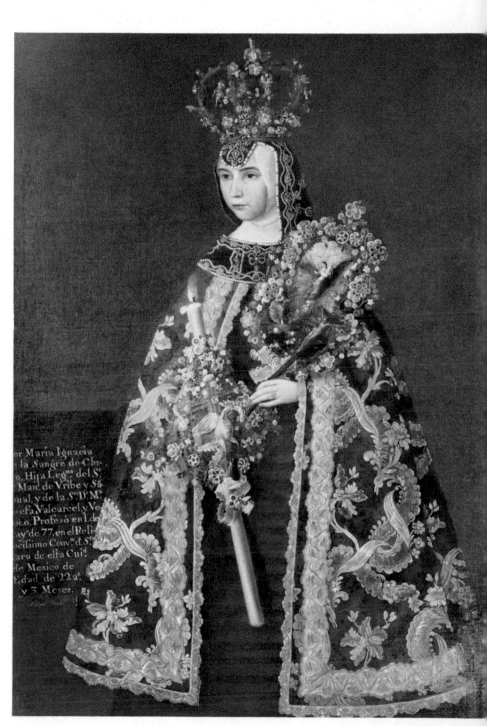

or Maria Ignacia
la Sangre de Chr.
o, Hija Leg.ma del S.r
Man.l de Vribe y Sa
ual, y de la S.ra D.ª M.ª
efa Valcarcel y Ve
co, Profesó en 1.de
ay.o de 77. en el Reli
císimo Conv.to d. S.ta
ara de esta Ciu.d
de Mexico de
dad de 22 a.ª
y 5 Meses.

92

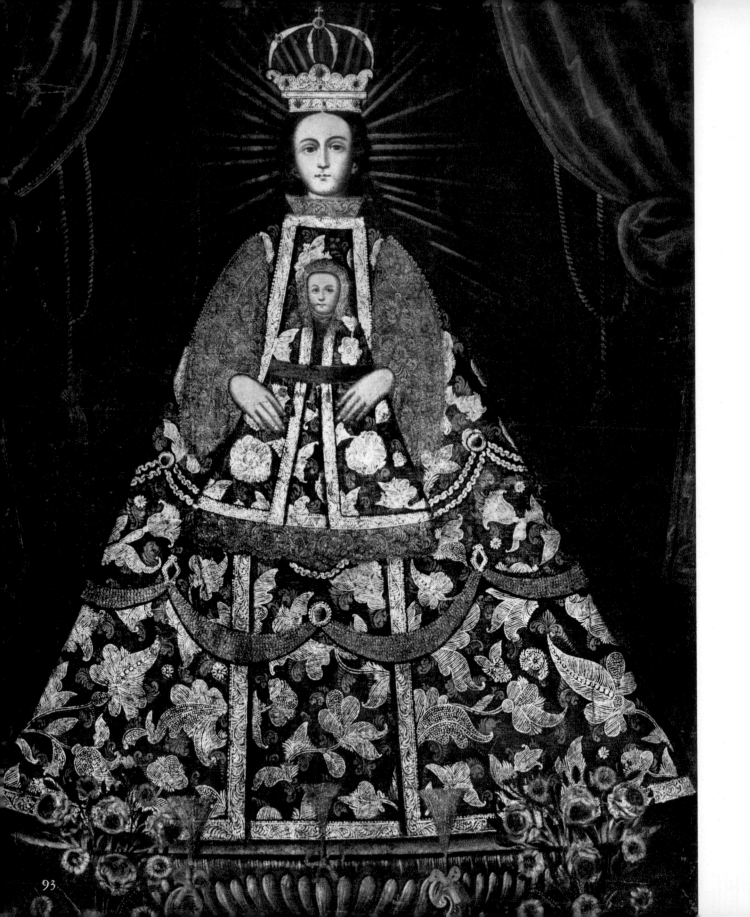

93

EFECTOS DE SV AMOR FINESAS DE MI AMADO

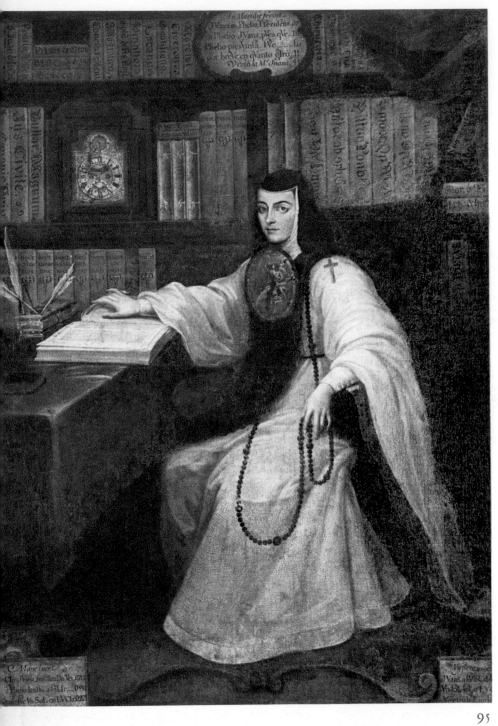

95

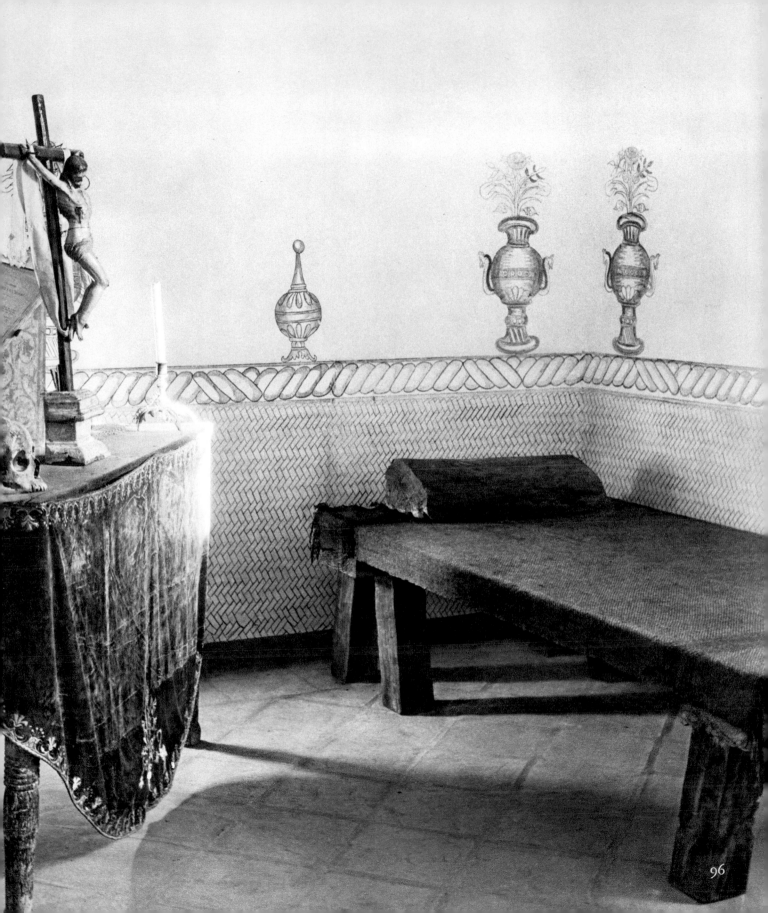

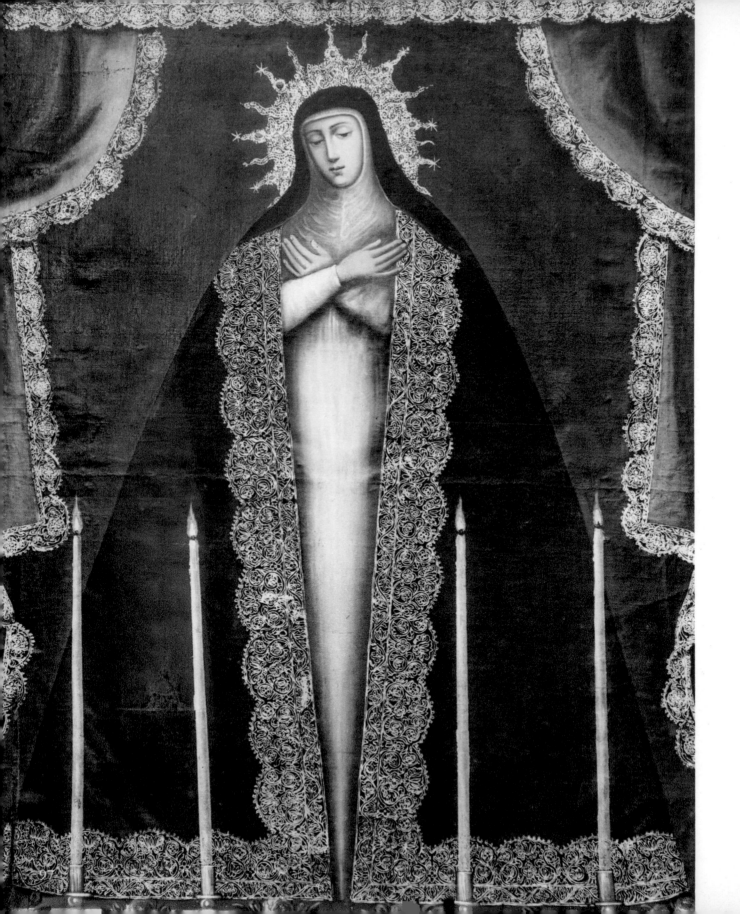

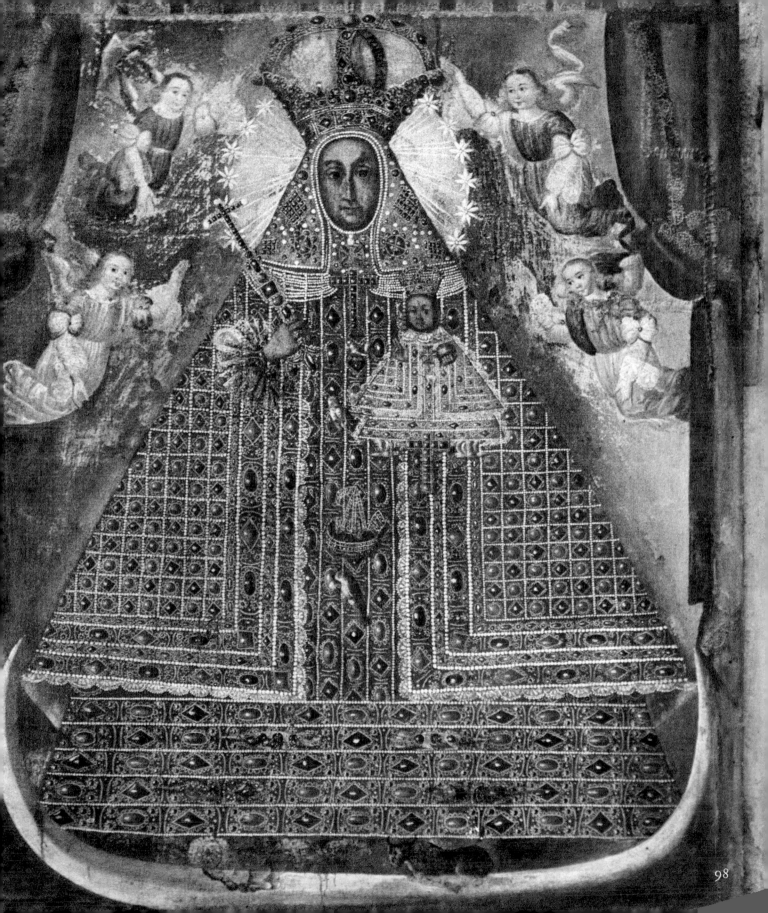

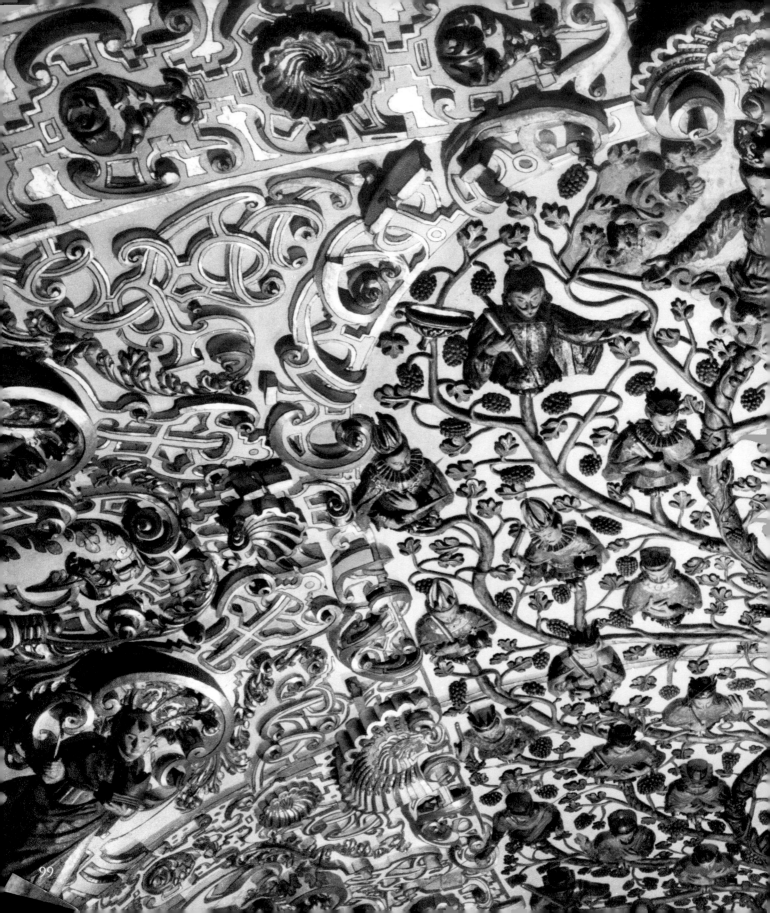

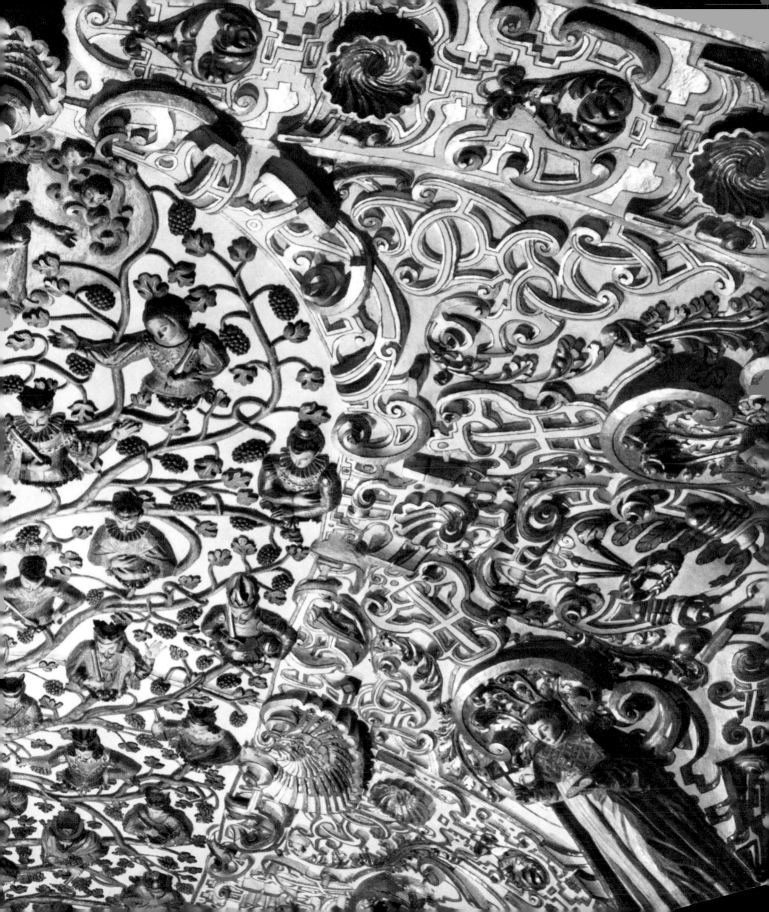

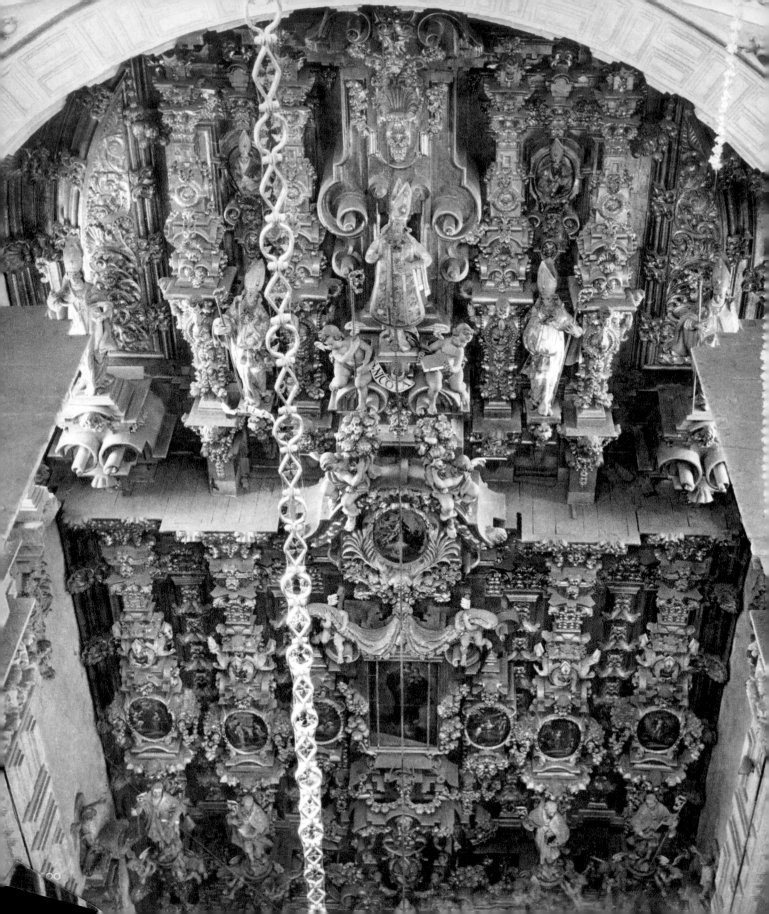

V The Incas of Castile

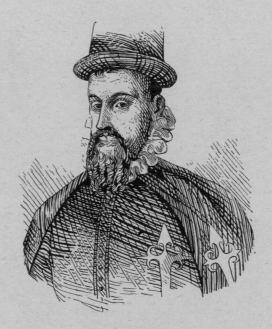

XXI PIZARRO

TO THE SPANISH the privileges of blood and birth had always been important and there was no getting away from the fact that by the rules of their own feudalism, the noblest blood in the Spanish Indies ran in the veins of the descendants of the Indian princes. The Conquistadors, mostly of very humble origin, received their titles only with the official posts allotted to them or in some cases by taking a native wife of noble rank.

But being very strongly feudal in outlook, the Spanish conquerors would have felt it derogatory to themselves not to acknowledge the natural and almost divine right of certain Mexican and Peruvian families to rule others. The Aztec and Inca aristocracies were too well established to question, and the Spaniards respected them, *de jure* at least, throughout the days of the Empire. When the petty nobles of Mexico had their portraits painted, their wives were dressed in the latest fashion at court, but the descendants of the Incas were portrayed in the seventeenth and eighteenth centuries by the half-breed painters of Cuzco like Spanish cavaliers *(plates 101-103)*, and only their wives wore the traditional national costume with its wonderful embroidery; this seems to have been thought a privilege rather than a mark of servitude.

Todo blanco es caballero (every white man is a nobleman) was a maxim that only became universally recognised towards the end of the eighteenth century, when colour prejudice was intensified by the black slave traffic, and the growing numbers of foreign immigrants – English especially and French and German – added to class

prejudice a special mark of esteem which gold itself could scarcely depreciate. Pure white blood, *sangre limpia*, indeed only existed in these new settlers, as they did not fail to make clear to the Creoles descended from the Conquistadors, for however handsomely quartered their coats of arms might be, there was always that addition of a drop of Indian blood. However much royal favour could give 'dispensation from colour' by letters patent – just as once it dispensed from fasting at the price of a Crusade – in the eyes of society this made no difference. The recipient was still denied the right to become a sheriff, a public letter-writer, a student at the university or a sergeant-major. The wife alone secured substantial benefit: she now could take a kneeling-mat to church. 'In the exercise of this privilege, a new one for them, they indulge in an ostentation and luxury that only pride and pettiness can explain.' Everyone else had to kneel on the hard floor – the pure Blacks and the pure Reds; the *chino* and *zambo*, born of Negroes and Indians; those who were nameless, born of a coloured man and the woman exposed to public gaze at the convent door, who kept discreetly silent as to their race; the 'back-jumps', *saltos atras*, born of a quadroon and a half-breed; the 'up-in-the-air', *tente-en-el-aire*, born of a terceroon and a half-breed. White plus colour, half-breed; half-breed plus white, terceroon; terceroon plus white, quadroon; quadroon plus white, quinteroon; after that, distinctions ended: you were white.

Mexican princesses were often not prepossessing: they tended to be swarthy, rather thick-lipped and short in the leg. They were not glamourized by the romantic aureoles of those Inca maidens born in far-distant towns of the sun, of which the *Lettres d'une Péruvienne* say: 'In vain had vast distances divided them from our world; they became its prey and most precious possession.' Inca princesses were indeed white enough to appear pale-skinned at the Court of Spain beside certain Andalusian ladies; they were beautiful enough not to put their European husbands or lovers to shame *(plate 112)*; they were like the virgin brides of fairy legend incarnate

in highly exotic and sensual form; they came robed in the hues of the Moon and Sun from which they claimed descent *(plates 105, 107)*; with a blue bird perched on one shoulder, they moved through magical valleys bright with rainbows and rare trees and curious flowers and little monkey-lions with human faces. Such are the delightful, ingenuous pictures of the Inca maidens handed down to us by the Cuzco painters, and instinctively we prefer them to paintings of the mummified, sun-blackened creatures that squat in the glaring dust under citadel walls, because they chime with our nursery imaginings of the Conquest, of distant wonders and exotic delights.

What thoughts occupied the minds of the sons of such mixed marriages? We can refer to the testimony of Garcilaso de la Vega, an Inca who sought, in his retreat at Valladolid in Spain, to reconcile a two-fold pride, the pride of a son of Chimbou Oclyo, grand-daughter of Tupac Yupangui and part of the spoils of war after the fall of Cuzco, and the pride of the descendant of Captain Sebastian Garcilaso de la Vega, formerly Pedro de Alvarado's lieutenant. In 1560, when he was twenty, he sailed to Spain, fought in the war against the Moors and under Don Juan of Austria; he hoped that his services would be rewarded at least by the return of his mother's lands. But they were confiscated by the Crown and Philip II refused to receive him, being displeased, not with his colour, but because his father had once lent a horse to the rebel Pizarro. He died in 1616, leaving a considerable sum to be spent on masses for the repose of his troubled soul, also a chronicle of the Conquest which became a bedside book for all readers curious about the marvels of the Incas and the ravages which can be caused in the hearts of men who thirst after gold and women.

The Inca dynasty was not, as is often believed, brought to a sudden and violent end when the Spaniards arrived and Atahuallpa*, the thirteenth Inca *(plate 103)*, was executed. Pizarro and his successors preferred to make skilful use of their authority behind the throne of these children of the sun (even more tyrannical than

Charles V and Philip II), but when they became troublesome the Spaniards had them respectfully executed and interred with much ceremony.

The Conquistador, whether of gold or *a lo divino*, jack-booted or frocked, is only comprehensible if one accepts his very real belief in life eternal; that alone can explain and justify the atrocities committed in Peru. For almost two centuries the Andes from Caracas to Santiago were the highland seat of a peculiar market in which, willy-nilly, the immediate riches of this world were exchanged for the future riches of the next. 'Give me your gold and I will give you immortality here and now, by sending you out of this world into the other.' This may seem incredible today, but the Spaniards were absolutely sincere; they truly believed that when they conferred death upon the Incas they were bestowing an incomparable blessing.

The Mexican peoples had not suffered unduly from the greed of the Spaniards; the authority and intelligence of Cortés knew how to contain it. But Cortés was single-handed; Pizarro had two lieutenants, Almagro and Luque, all three of them still true members of the warrior-race which had created the first Castilian kings and bluntly told each of them on their coronation day: 'We, who are as good as you, make you our king on condition that you keep our laws; but if you do not you are not our king.' For Pizarro, and even more for Almagro and d'Aguirre, the king was not an end in himself, but a means of satisfying their ambition, as the Bishop of Santa Marta clearly saw when he wrote to Charles V in 1541, not without irony: 'Your Majesty has more servants in these lands than he thinks, for there is not a single soldier here who is not bold enough to say publicly that if he attacks, plunders, destroys, kills or burns the subjects of Your Majesty to obtain gold, it is in the actual service of Your Majesty, since part of this metal is intended for you.' At Las Salinas in 1538, when Almagro's men faced Pizarro's, the cry on both sides was *Long live the King!* At Cuzco in 1532 and again in 1571 and once more in 1781 it was in the King's name that children of the sun were beheaded. In vain did the King write in

protest, saying: 'I sent you to serve kings, not to kill them.' The Conquistadors of Peru and their descendants continued to do as they wished. Their political maxim was that of Belalcazar, first governor of Quito: 'The king's orders are respected, not executed,' especially when protection of the human rights of the Indians was concerned and observance of the laws which the Council of Indies was continually passing with that purpose. Still more than in New Spain, the domestication – not to say enslavement – of the Indians was essential to the economy of Peru.

People living in the Andes today are no doubt still distant descendants of the Princes of the Sun who, according to legend, always ate off gold dishes. But the legend is dead; there is no gold left in Peru.

Tradition said that the walls of the Temple of the Sun at Cuzco had been covered with sheets of gold from the top to the ground: the walls of the colonial cathedrals certainly shimmered with gold painted over the stucco *(plates 119, 120)*. Tradition also said that the great gold sun had sunk into the icy depths of Titicaca between the Island of the Sun and the Island of the Moon. The monstrance in colonial cathedrals was another such sun, but it blazed with a very different light, and its beams flashed every Sunday in every country church *(plate 121)* during the procession of the Holy Sacrament. 'The Incas and Jesuits alike,' Raynal said, 'made religion respected by pomp and by the imposing richness of the vessels and images used in public worship.' The priest bearing the Sun Christ was preceded by two players of the *turututu* – the sea conch once used to summon the Inca's soldiers to battle – and behind walked some native prince dressed as a Castilian nobleman; his hands, gloved in leather like a captain's, bore the standard of His Most Catholic Majesty *(plate 117)*.

Was there really much difference between Mama Ollu the Moon *(plate 106)*, giver of the art of weaving, and the Virgin of the Spindle? They were blended into one in the portrait of the little girl Virgin *(plate 122)* covered with flowers and wearing on her brow the curl of fertility.

NOTES ON THE ILLUSTRATIONS

XXI Page 186 PIZARRO, a copy of the portrait in Lima Museum, from *Les Voyageurs anciens et modernes*, Paris, 1855.

101 CUZCO Seventeenth century. The conversion of an Inca, probably Saire Tupac the XVth, crowned by the Spaniards at Vilcapampa in 1561 with the *masca paycha* taken from Atahuallpa.

102 CUZCO Seventeenth century. Huascar Inca, murdered by his brother Atahuallpa shortly after the coming of the Spaniards.

103 CUZCO Seventeenth century. Atahuallpa, the thirteenth Inca, executed by Pizarro; *see plate 115*. He was the last independent Inca emperor.

104 COPACABANA, BOLIVIA *Yaravi* player at the door of the most venerated shrine in South America, 'Place-where-one-sees-the-sacred-isle-of-the-sun-of-Titicaca'. Here the Virgin was said to have appeared to a native, and the Augustinian friars were authorized to erect a church there in 1580. This was rebuilt in 1618 and forms part of the present church erected in 1668-1678 by Francisco Jimenez de Sigüenza. On pilgrimage days mass is celebrated hourly owing to the numbers of the faithful.

105 POTOSI, BOLIVIA Sun carving, with one of the sirens on the façade of San Lorenzo. Andean Baroque art.

106, 107 POTOSI, BOLIVIA The Moon and Sun decorating each end of the door lintel of a seventeenth-century house.

108 CUZCO Seventeenth century. Mama Ollu, the Moon, wife of Mancocapac.

109 CUZCO Seventeenth century. Mancocapac, first Living Sun, founder of the dynasty. At his feet the sea-conches which the Inca warriors used to blow, now used in processions of the Holy Sacrament. On his left the totem eagle of his *aylu;* on his right, Inca architecture with cyclopean details.

110 CUZCO Seventeenth century. An Inca noble with hand laid on the imperial crown. On his coat of arms registered at Madrid, the eagle of the Inca *aylu*.

111 POTOSI, BOLIVIA Andean Baroque in the church of San Lorenzo, built 1547-1552 and restored in 1896. It was the church of the Indian quarter; its façade is the work of the native sculptor José Kondori.

112 CUZCO Seventeenth century. An Inca princess, holding in her right hand sacred flowers, red bells called *nukchu*; in her left hand the weaving spindle which according to legend was Mama Ollu's gift to her people. See the interpretation of this theme in the Virgin of the Spindle *(plate 122)*.

113, 118 QUITO The instruments of the Passion, splendid spoils and trophies of war, carved tablets on the façade of the Compaña (1665-1754), by the German Jesuit lay brother Leonard Deubler. For the interior, *see plates 119, 120*.

114 CUZCO Eighteenth century. Inca emperor of the line under Spanish subjection – Christoval Paulu XVII, perhaps, who abdicated to retire into the Valley of Yuncay.

115 CUZCO Seventeenth century. Native picture portraying, centre, the execution of Atahuallpa (who in fact was strangled); the scene is based on the story of Tupac Amaru, the sixteenth Inca emperor, who was beheaded by an Indian from the Canaries in the main square in Cuzco in 1571. The Dominican Vincente Valverde, Pizarro's almoner and first Archbishop of Lima, assists. On the right, all the dead about to greet him – those killed by the Spanish arquebusiers, his brother Huascar, whom he assassinated, his mother Chachapoya. On the left, his father Haynacapac and Mama Oello, founder of the dynasty. Centre: Francisco Pizarro with his brothers Juan and Fernando and his captains Candia, Alvarado and Herrera.

116 POTOSI, BOLIVIA Church of San Lorenzo: destroying angel of the Apocalypse or the archangel Michael with flaming sword, in the guise of an Inca warrior.

117 CUZCO Eighteenth century. Marco Chiguathopa Inca, a 'Catholic Knight by the grace of God'; he holds the standard of Castile, recognisable by the two towers, two lions and golden fleece.

119, 120 QUITO, INTERIOR OF THE COMPAÑA The *manpara* or door and central nave, in Moorish and pre-Columbian mixed styles set in a Classical plan. Founded in 1595, this church was pulled down and rebuilt in 1605, on a combined plan based on the Gesù Church and the Church of S. Ignazio, completed in 1754 by Venancio Gandolfi. *See also plate 176*.

121 ANDAHUAYLILLAS, PERU A Quechua parish church in the neighbourhood of Cuzco founded in 1580 on the ruins of an Inca temple. The altar was built under a Mudejar ceiling with a great scallop shell in 1631 by Juan Perez de Bocanegra, the vicar, who was also author of a Quechua dictionary, antiphons to the Virgin and a poem on the Incarnation of the Word in the Quechua tongue.

122 CUZCO Eighteenth century. The Virgin Mary of the Spindle, seen as an Inca princess. The curl on the brow is considered characteristic of Indian art, and is a sign of fertility.

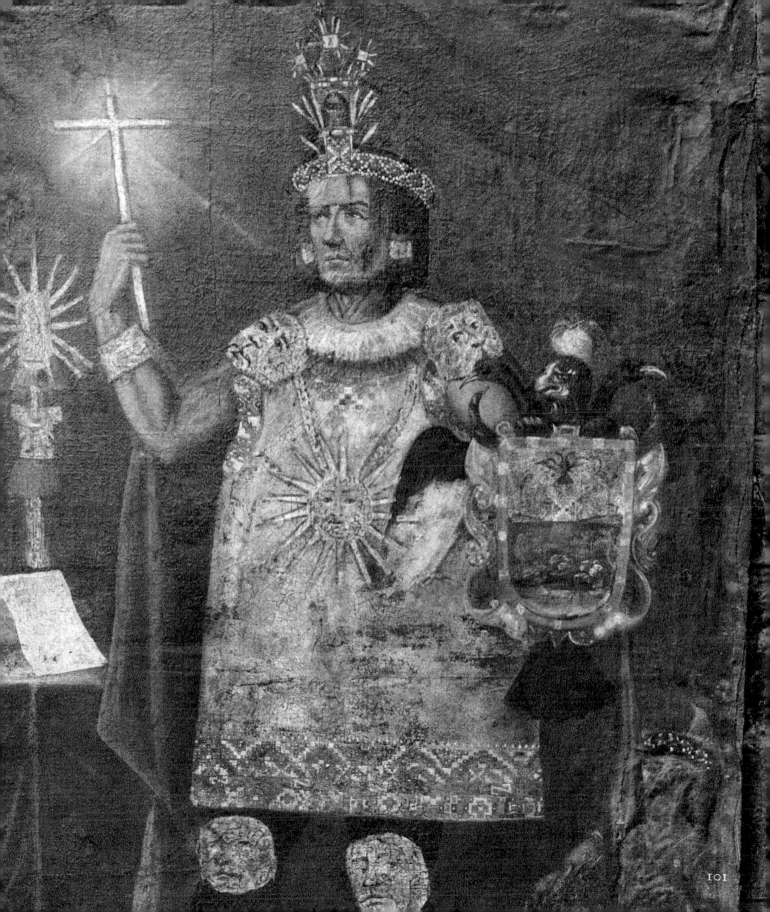

HUASCAR YNCA 13

102

AHULLPA YNCA 14

103

105

104

106

107

108

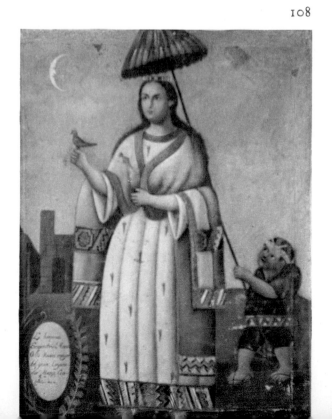

109

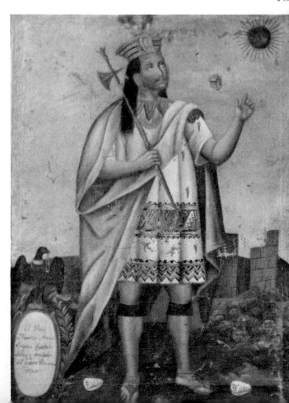

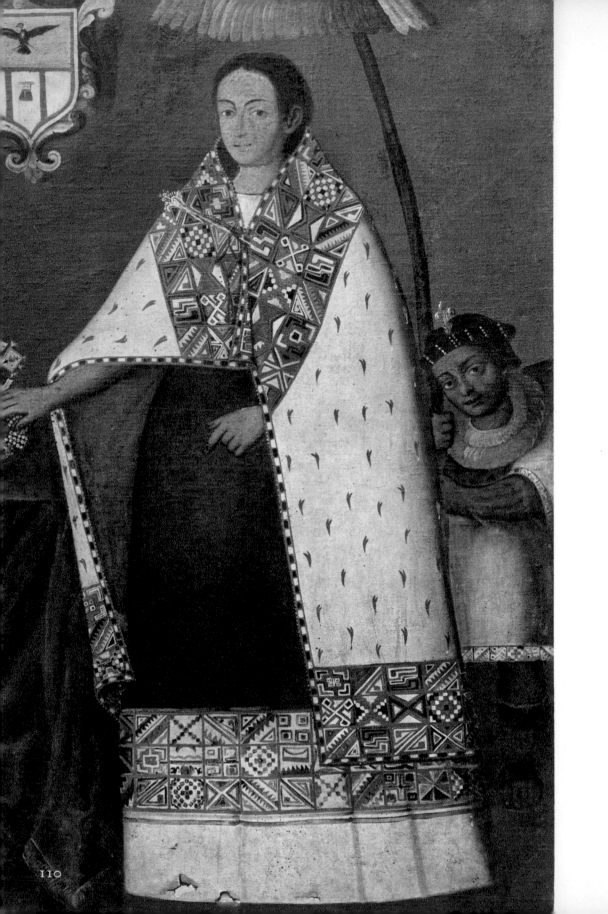

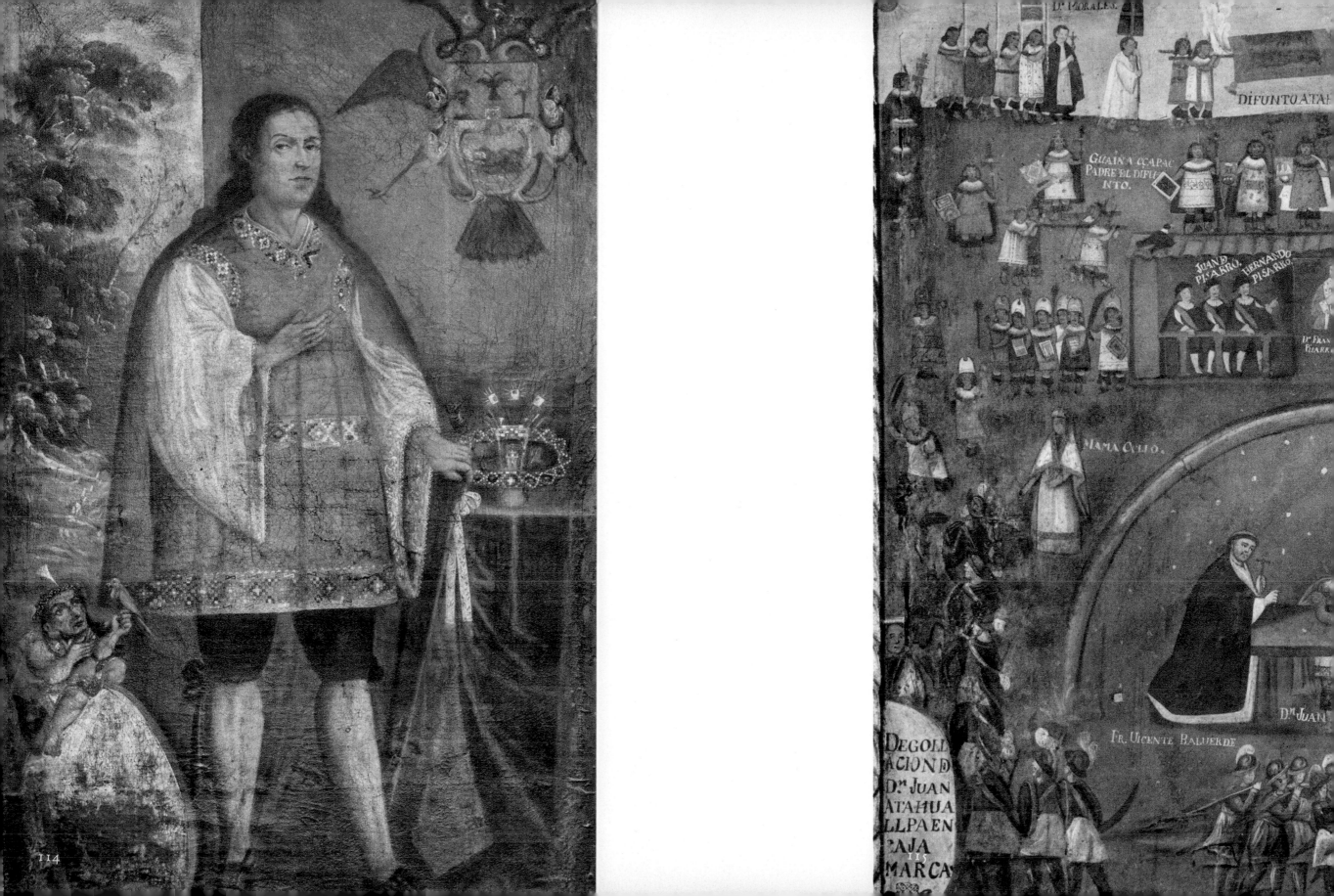

Dr MORALES.

DIFUNTO ATA[

GUAINA CCAPAC
PADRE DEL DIFU
NTO.

JUAN D
PISARRO.

HERNANDO
PISARRO.

Dr FRAN
PISARRO

MAMA OCLLO.

Dn JUAN

FR. UICENTE BALUERDE

DEGOLL
ACION D
Dr JUAN
ATAHUA
LLPA EN
CAJA
MARCA

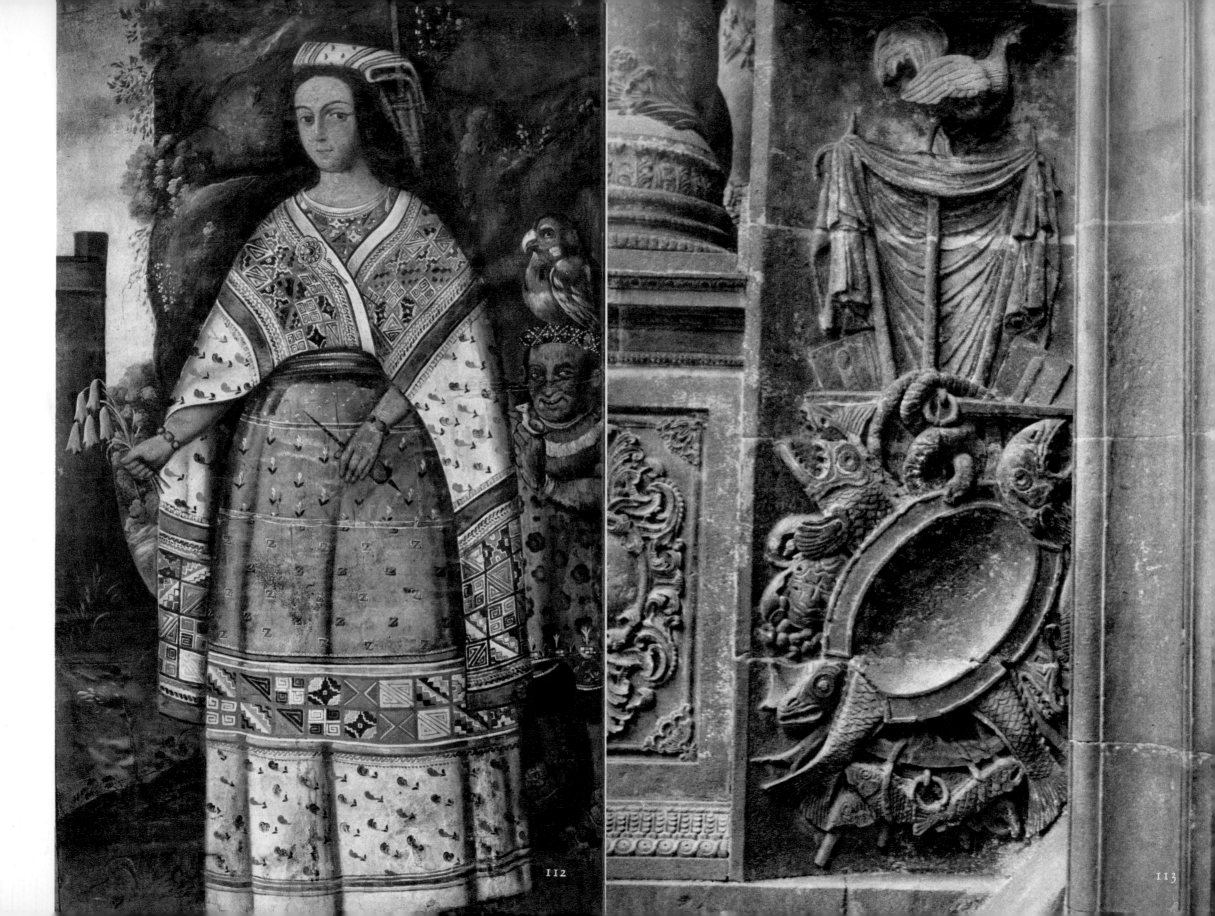

111

112

113

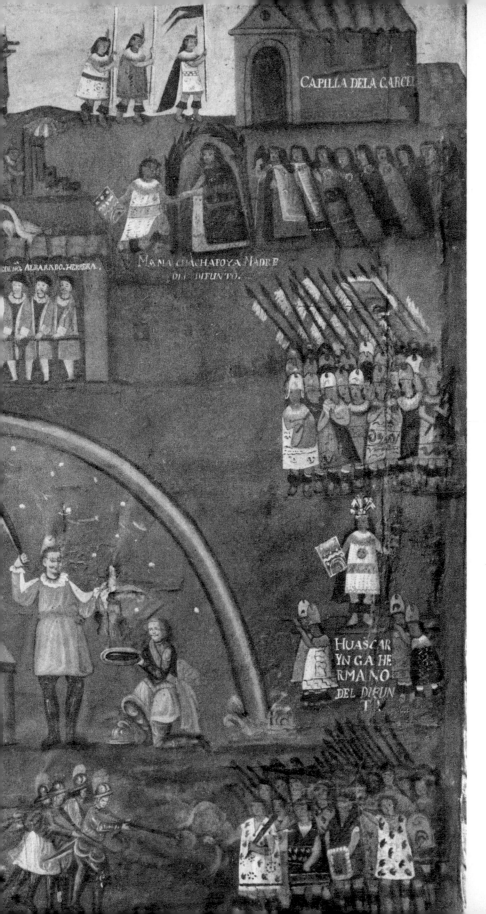

CAPILLA DELA CARCEL

MANA CHACHAPOYA MADRE DEL DIFUNTO

...DE Nº ALBARADO HERRERA

HUASCAR YNGA HERMANO DEL DIFUNTO

116

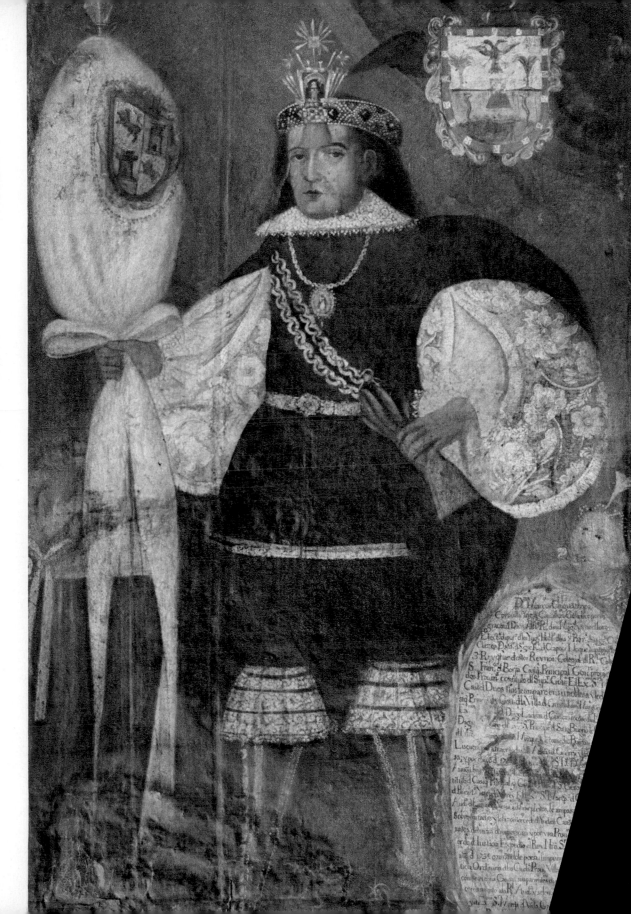

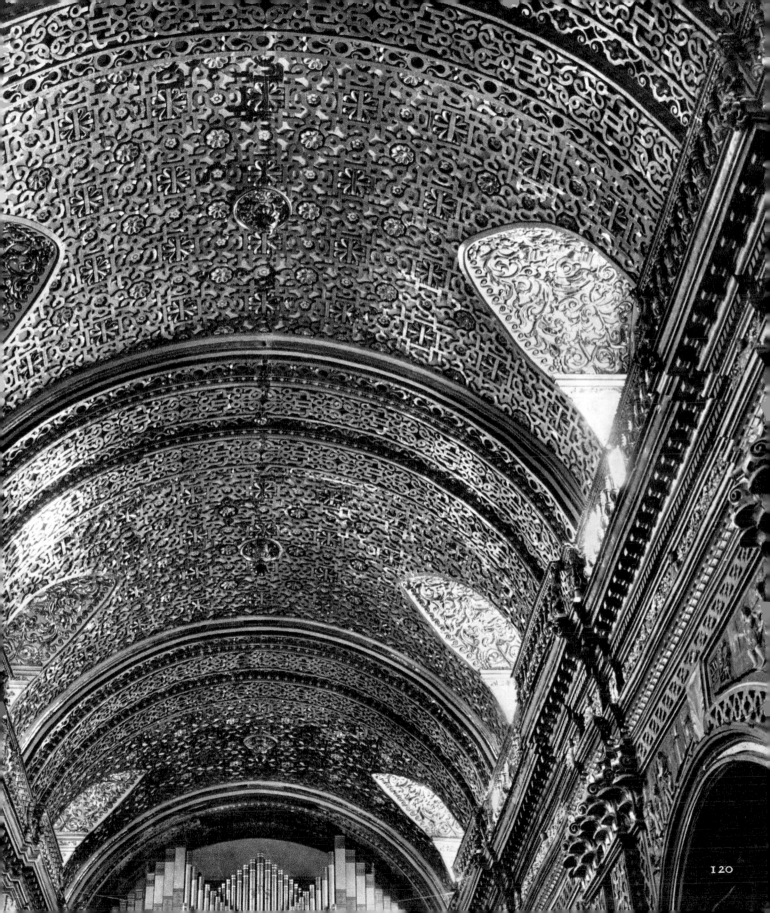

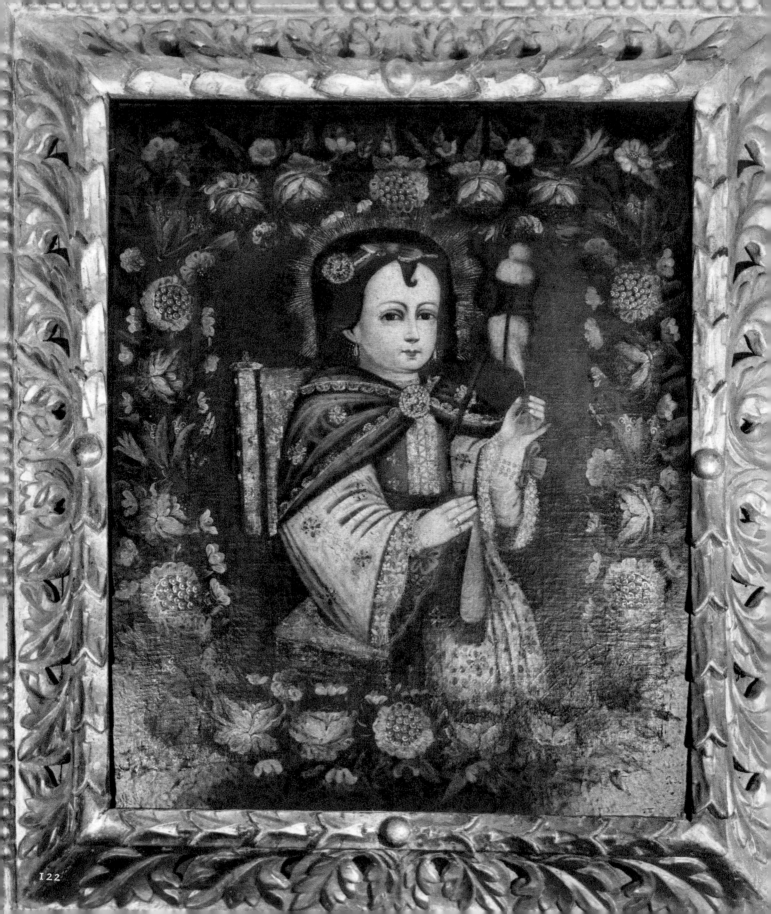

122

VI The Sirens of Peru

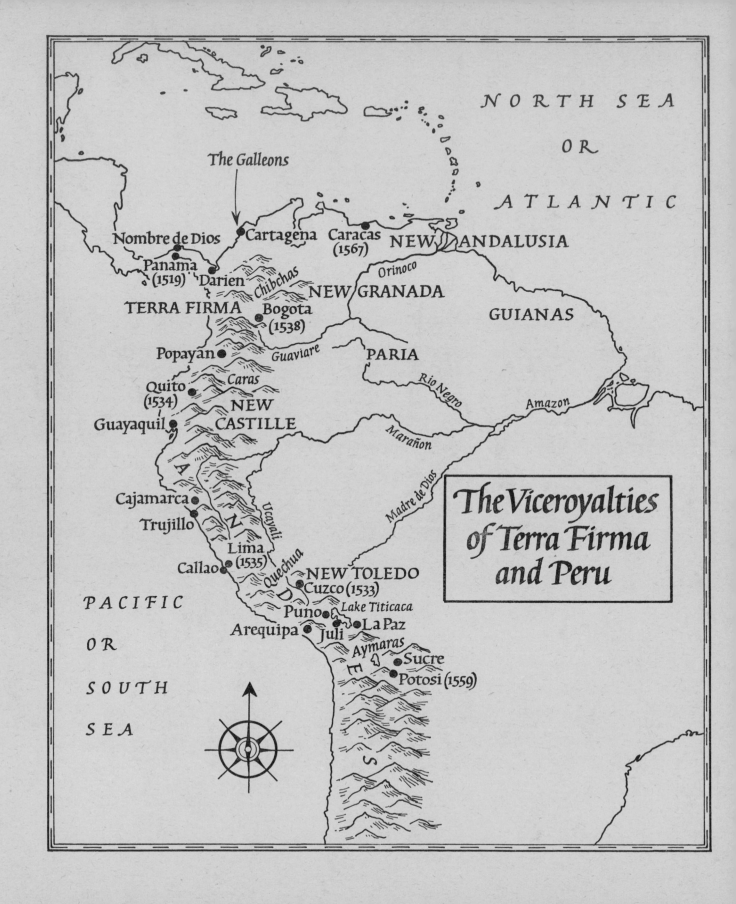

The Viceroyalties of Terra Firma and Peru

AMERICA WAS AS RICH in fables as in gold, in myth as money, has been and perhaps still is the promised land for adventurers spurred on by dreams. Commenting on the Book of Genesis, St Augustine maintained that the earthly paradise still existed, but was inaccessibly perched on the top of a high mountain, so high that it reached to the third heaven of the astrologers, almost touching the Moon – have not men always longed for a Peru, for the Moon itself! Commentators upon St Augustine in their turn maintained that this mountain stood between the gates of the sun, Cancer and Capricorn; and being fascinated by the strange splendours of the setting sun, *illuminati* and cosmographers, philosophers and geographers from Plato to Columbus were convinced that Eden lay in the West. And so, when an illegitimate son of Estremadura discovered mountains between the two tropics, some twenty thousand feet high, where gold and emeralds were ripe for the taking, that settled it: the Andes range was Eden and the earthly paradise Peru. When news was brought back from New Spain by the Franciscan, Marco of Nice, that Pizarro had laid hands on treasure worth millions, the new kingdom was threatened with depopulation, and at home in the ports of Spain ships were besieged by swarms of adventurers. The sirens of Peru had burst into song. Few men had the heart to stop their ears; the Emperor himself was deaf to all other music, and Cortés, forgotten now, approaching the royal coach one day, heard this question: 'Who art thou?' 'Sire, the man that brought you more kingdoms than prince ever had.' Dust, dust in the wind! Charles V had ears only for the gold of Peru.

In the Spanish Indies there was only one civil building that could rival the cathedrals for cost – the Royal Treasury, the Casa Moneda. The one in Potosí *(plate 128)* cost two million piastres or two million dollars. It has been forgotten since Spain declined and first the pound and franc, then the United States dollar, became heir to the Spanish dollar, or *peso de a ocho*. Its name was never varied and from the sixteenth to the nineteenth centuries it counted in the world as the Swiss franc counts

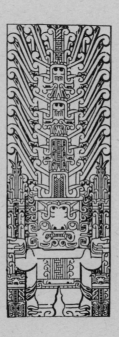

XXII RAIMONDI STONE STELE

today. Minted for the first time in Mexico in 1535, on the reverse it bore the arms of Spain between two columns and on the face the Emperor's effigy crowned with a laurel wreath. The gold piece, the *peso de oro* or *castellano*, was stamped with a cross and was the unit of weight; a hundred coins went to a pound of four hundred and sixty grammes – work that out in the values of today. In the shape of ingots or coin, loaded in skin-bags on the backs of mules (of which Peru imported a hundred thousand in 1712), gold and silver plodded along the road to Vera Cruz or Porto

Bello. The Fleet sailed from the first, galleons* from the second: paunchy vessels bursting with cargo, sterns cocked up and noses down to the sea, slow in the water as priests in procession bearing the Holy Sacrament; yes, a sea procession of St Isabel and St Rose, St Isidor and St Ferdinand, little St John and the Immaculate Conception, with their pious banners thwacking in the trade winds. Carved on their poops – all wreathed in sirens, tritons and horns of abundance, dolphins leaping, lions rampant, and beaming angels blowing trumpets – the statues of the saints aforesaid gazed at the fumy waves closing over the ship's wake, and sometimes to seaward they sighted a privateer's sail. One highly picturesque way of studying the development of the Baroque altarpiece and its influence on Indian artists would be to compare the poops of galleons in the sixteenth, seventeenth and eighteenth centuries, for after their fashion were they not altar-pieces tossing on the ocean?

The arts have always been travellers, but perhaps the best of all to follow on its voyages is Baroque, which was born in the hour of great discoveries, and rose to its height when Europe was becoming furrowed with high roads and the oceans with vessels; the delirium of Rococo* followed at the time of the scandals and profits of the West Indian companies.

Then suddenly all melted away like snow in April – the riches and splendour, satins and silks *(plates 143,144,145)*. At Potosí the King's fifth dropped to five million pounds, then to three then to two, while the population dwindled to fifty thousand, to twenty-five, then to less than ten thousand. And when at last in 1825 Potosí decided to have a cathedral as imposing as its Treasury, out of five thousand tunnels into the mines only fifty were active, and even from these the yield was often lower than in the older workings which English companies had taken over. The silver of Cerro had had its day, but not before laying solid foundations for industrial wealth in England, France and Germany – Spain was an exception – and making some private fortunes too.

One of the paradoxes of Peru is that the standard of living and the reputation of the country outlived the collapse of its revenues by nearly a century. They even survived a colonial policy which wrecked all attempts to compensate for the loss of metal by encouraging the cultivation of wheat, olives, vines and weaving. With the exception of the fine arts – and this may explain their flourishing history – handicrafts were also discouraged. Peru was importing almost everything from Spain, who herself was importing from Europe, but these importations were lining the pockets of the higher officials, well accustomed, since the earliest days of the Conquest, to turn their position to golden account. Only the glittering certainty of such prospects, the possibility of becoming a viceroy and regilding an over-prodigal parent's shabby coat of arms, could lure a Spanish grandee of the eighteenth century aboard a ship for Lima, or worse still Bogota, where women were said to be 'sanctimonious creatures deep in devotion, stay-at-homes afflicted with stomach-ache through over-indulgence in garlic, tobacco and pork.' Quito was more in favour; there the air was so pure, so cool and health-giving that 'though loose living and indifference make venereal diseases almost general, the effects are but little felt.' Lima, the City of Kings, was known as 'women's paradise and man's purgatory.' Despite four state laws promulgated by the censors, women always went about in summer *tapados*, that is to say wearing only a chemise under their clinging skirt, and of course a mantilla, but the chemise was worth a fortune, a thousand pesos, and was all of Flanders lace. A foot, if fashionable, went bare, resting on the merest slip of leather, fastened at the ankle with a diamond from Ceylon.

As early as 1583 a council was held at Lima to reform morals; it condemned and sentenced a professor of theology whose familiar angel had assured him that he was to become Pope and transfer the Holy See to Peru. The Council's president was Alfonso Turribe of Mogrobejo, former governor of Granada, who was made Archbishop of Lima by Philip II in 1581. Scandals ceased during his episcopacy, which

XXIII FLAG OF BARCELONA XXIV THE GALLEONS' FLAG XXV FLAG OF GALICIA

was notable in that he was the only prelate of Peru who ever visited his diocese, town by town and village by village, learning Quechua and Aymara for this purpose. He spent twelve years on these travels and indeed died at his work, far from Lima. Beatified in 1679, he was canonised in 1726, fifty-five years after Rose of Lima, the greatest woman saint in Latin America, who atoned for the errors of her sisters by inflicting great suffering on herself. She used to rub her face with cayenne pepper, it was said, use ointments to attract mosquitoes, and plunge her beautiful hands into quicklime. When she was gone, the well to which she used to walk for her meditations became the resort of unhappy lovers; they threw notes down the shaft imploring her to make them happier.

The colours and perfumes of Peruvian flowers, some of which, like the nightingale were eloquent at dusk, intrigued botanists and flower painters of the eighteenth century. Cargoes, not of metal but of pearls, shells, emeralds and precious vicuna wool, still acted as a magnet to those on the other side of the Atlantic. Treasury officials were even discovering that there was a vegetable currency in tobacco, cocoa, jalap, potatoes and the celebrated quinine. But the nineteenth century was approaching and the Catholic kingdoms of the south would soon begin to crumble, much like their cities, so often plagued by earthquakes. And by the icy shores of Lake Titicaca, as the tearful moon went down and the new sun stared fiercely over the horizon, the sirens of Peru fell to wailing in the straw at the doors of barns which once had been churches at the mines of Potosí.

NOTES ON THE ILLUSTRATIONS

XXII Page 214 RAIMONDI STONE STELE; drawing from a photograph taken at the National Museum of the Magdalena Vieja, Lima. Chavin art, the oldest in Peru, between 1000 and 500 B.C. Probably represents a god with a feline face holding rods of office in his claws, with a frieze of jaguar faces and serpents' tails mounting above his head. The same tail pattern is suggested on the heads of the sirens at San Miguel de Pomata (*see plate 123*).

XXIII Page 217 FLAG OF BARCELONA, blue, bearing a friar dressed in black and holding a rosary.

XXIV Page 217 THE GALLEONS' FLAG, with three bands, red, white and yellow; the middle one bears a black eagle ringed by the Golden Fleece.

XXV Page 217 FLAG OF GALICIA, white, bearing a gold chalice and red crosses. From *Les Pavillons ou Bannières que la plupart des Nations arborent en Mer*, Amsterdam, 1718.

123 POMATA, PERU San Miguel Church, beginning of the seventeenth century. Example of Andean Baroque with pre-Columbian influences. The sirens are playing the *charango*, the guitar of the Andes. Carved in red sandstone, or Andesite. *See also fig. xxii*, the Raimondi Stele.

124 POMATA, PERU Church of Santiago. Cupola decorated with tree-angels showing pre-Columbian influence. Early seventeenth century.

125-127 POMATA, PERU Andean interpretation of the mystic vine and Aymara puma. *Pomata* in Aymara means the House of the Puma. This was a pre-Columbian halt on the road to Bolivia. Under Dominican control in 1540, together with Juli, it was assigned to the Jesuits by the Viceroy Francisco de Toledo in 1569. Pomata was a mining district, and almost as many churches sprang up here as in Cuzco and Lima.

128 POTOSI, BOLIVIA In the foreground, the Mint (*la Monedad*) where silver was smelted into ingots. Founded in 1547 on a native place whose name meant 'noise', Potosí was recognised as a 'most loyal

and imperial town' of the Indies in 1562. By the end of the century, houses probably numbered four thousand, churches thirty, and the population a hundred and fifty thousand, including some ten thousand Spaniards and other Europeans – Dutch, Genoese, Irish and French. In 1780 twenty-five thousand of these remained, and in 1825 only eight thousand. The Cathedral (1809-1836) was built on the foundations of a church dating from 1573, and on the plan of Havana Cathedral drawn by the Franciscan Manuel Sananja.

129 POTOSI, BOLIVIA The Virgin of the Rosary, seventeenth century. Being worshipped by the Dominicans, She wears the emblem of that order. Tomas de San Juan brought Her to New Spain in the sixteenth century, and She is said to have appeared twice in America, notably at Pomata in Peru in the middle of the sixteenth century *(see plate 138)*. She is also the Virgin that redeems souls from Purgatory through recital of the rosary: each *Ave Maria* is a round-headed angel that flies off to free them. The original of the Virgin of the Crescent is thought to be the Santa Maria of Montserrat in Rome, early seventeenth century. But the picture was already common in sixteenth century Books of Hours.

130 POTOSI, BOLIVIA Virgin of Mercy of Corro, the silver mountain; popular art, end of sixteenth or early seventeenth century. The Virgin of Mercy was patroness of the order of the same name, founded in 1218 by Pedro Nolasco and the King of Aragon to succour and ransom captive Christians in Moslem hands. She is traditionally represented with open arms, gathering sinners into her wide mantle, with the Pope and Emperor at Her feet, and above Her, Father, Son and Holy Ghost. Here the mantle has become the mountain itself, on which vicunas can be seen, an Inca delivering a message in *quipu* (knotted strings), and seekers after precious metals imploring or thanking Her on their knees.

131 SUCRE, BOLIVIA The City with Four Names: Chuquisaca, Charcas, La Plata* and Sucre (after General Antonio Jose de Sucre, 1795-1830, Bolivar's companion) was founded in 1538 on the site of the Indian village called Bridge of Gold. It was an important halt on the road to Buenos Aires, had an archbishop from 1604, a university from 1620, and was under Jesuit control till 1767. The cathedral, completed in 1600, was the work of Jose Gonzales Merquelte. In 1920 the town had eight thousand inhabitants, and was still celebrated for its gardens.

-134 Paintings of the Quito School* depicting the life of hermits in the Andes. End of the sixteenth and early seventeenth centuries, and showing the Flemish influence of Joachim de Patinier (1480-1524). On the left, St Francis of Assisi preaching to the birds and fish which cry *Halleluia*! Out at sea, a caravel or galleon; in the woods a puma, a peccary, a tortoise, an ant-heap. On the lowest bastions of the Andes, a town and, in the foreground, tramps or poor whites, drinking, smoking and playing

dice; above, in solitude, a hermit kneeling at the foot of a cross, another reading, and beyond, on the upper plateau, pilgrims, one of them black, supplicating a stylite friar.

135 ANDAHUAY LILLAS, PERU Mural fresco illustrating Psalm 106: 'They lusted after meat in the desert, and tempted God in a place where there was no water... They made a calf in Horeb, and worshipped the molten image.' Conquistadors are seen courting damnation.

136-138, 140 Madonnas of the Quito School, seventeenth to eighteenth centuries. *Plate 138:* Virgin of the Rosary, or of Pomata, where she was said to have appeared *(see plate 129)*. *Plate 137*: Virgin of the Lily.

139 OTAVALO, ECUADOR Indian *cara* with child.

141 POPAYAN, COLUMBIA The Man of Sorrows, or Christ with the Sugar Cane. Churrigueresque art (1750-1775).

142 Adoration of the Holy Sacrament, with the Pope on the left and the King of Spain on the right. Quito School. Eighteenth century.

143 Creole nobleman in seventeenth - century costume, extravagantly flaunting court array at Versailles – plumed hat, cane, sword, scarf, lace cuffs, and bows on his shoes. *Pedro de Osma collection.*

144 A Creole interior realized in the house of the largest collector of Colonial art in Latin America. Venetian candelabrum, *Mudéjar* ceiling, portrait of a lady of the sixteenth century. *Pedro de Osma collection.*

145 POPAYAN, COLUMBIA Siren in gilt wood decorating the foot of the pulpit stair in the cathedral (1750-1775).

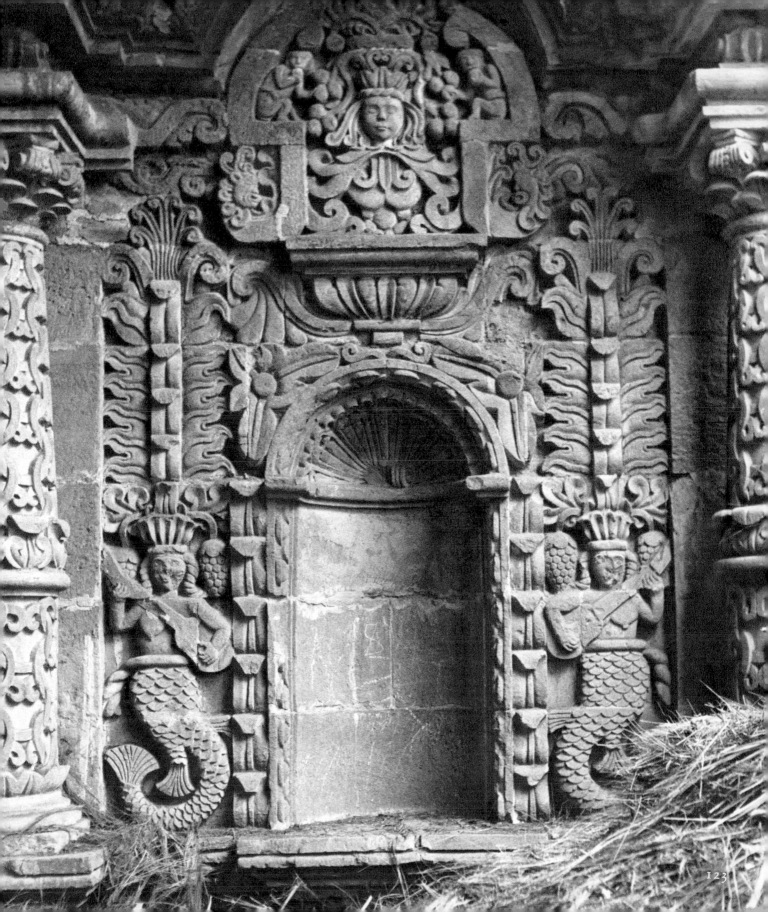

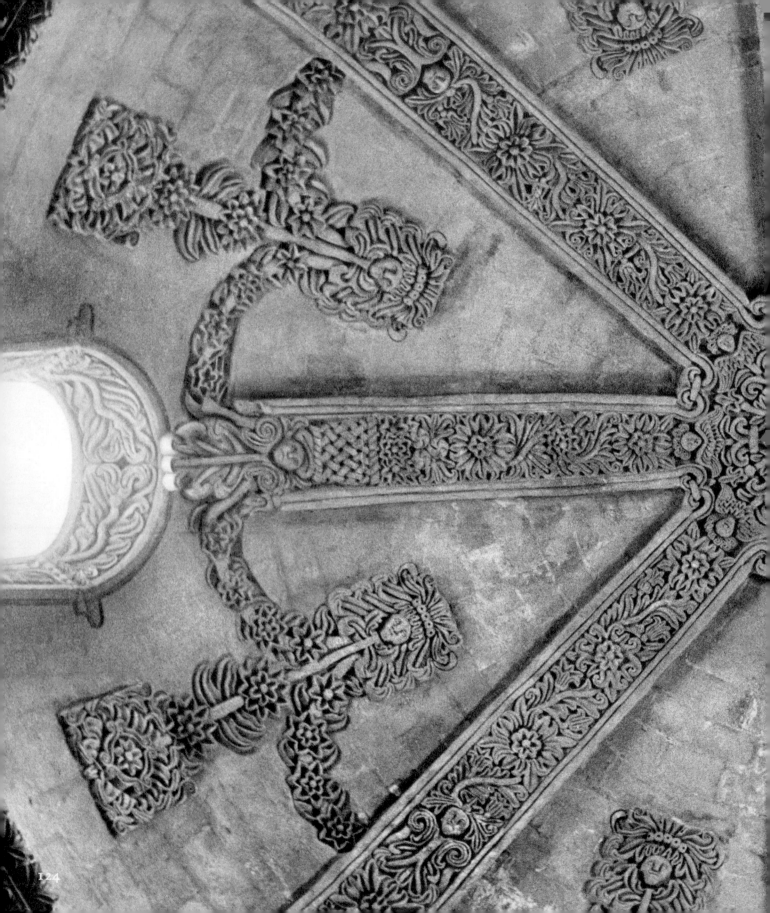

124

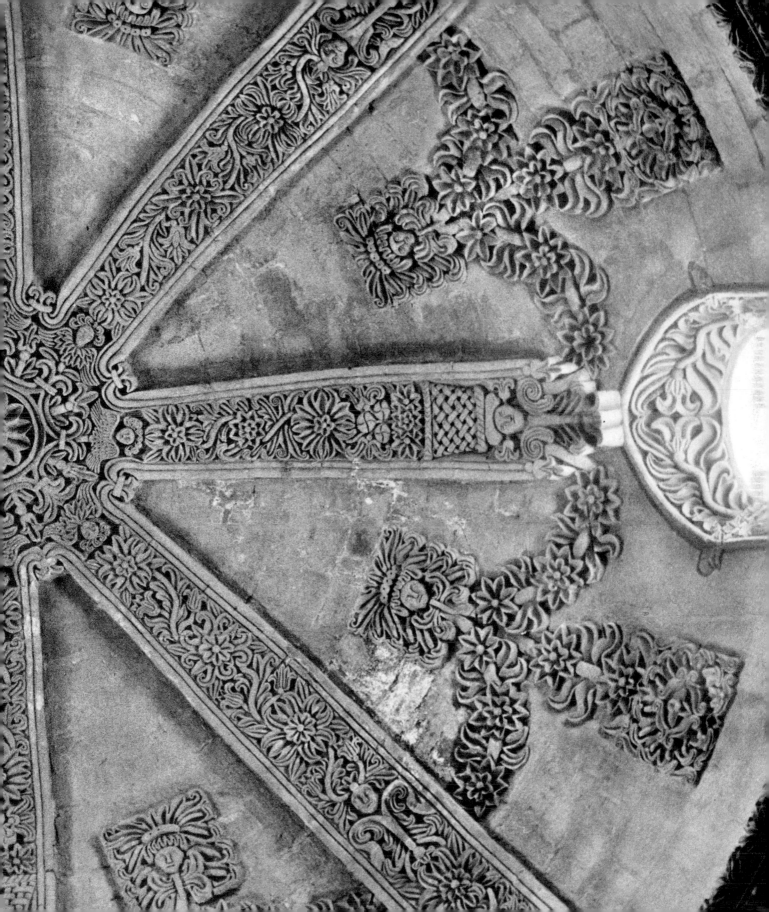

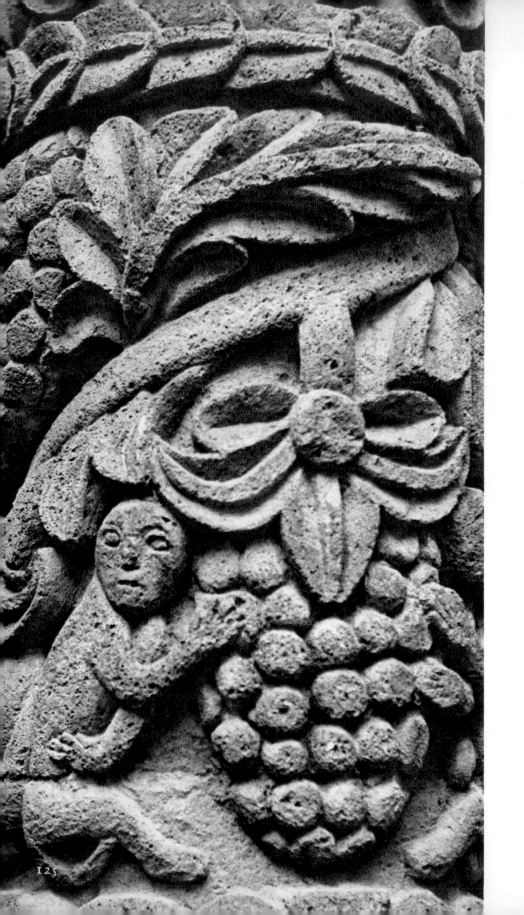

126

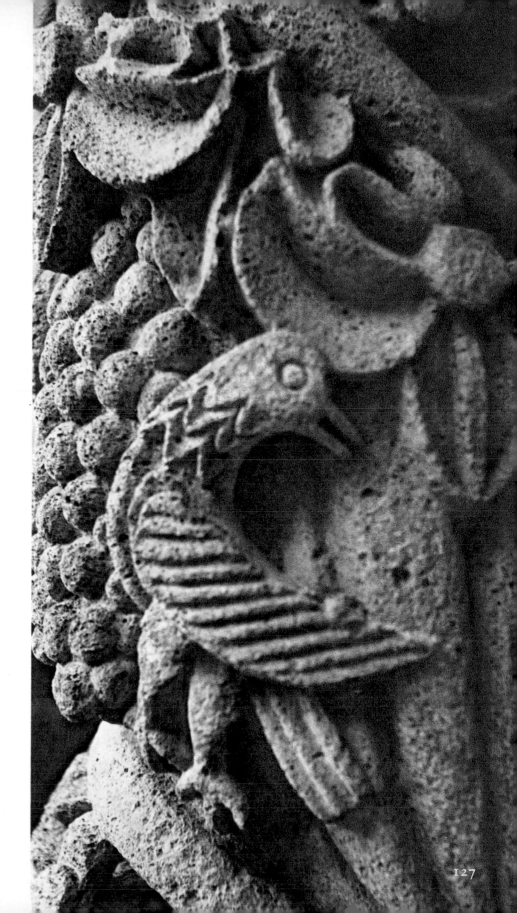

127

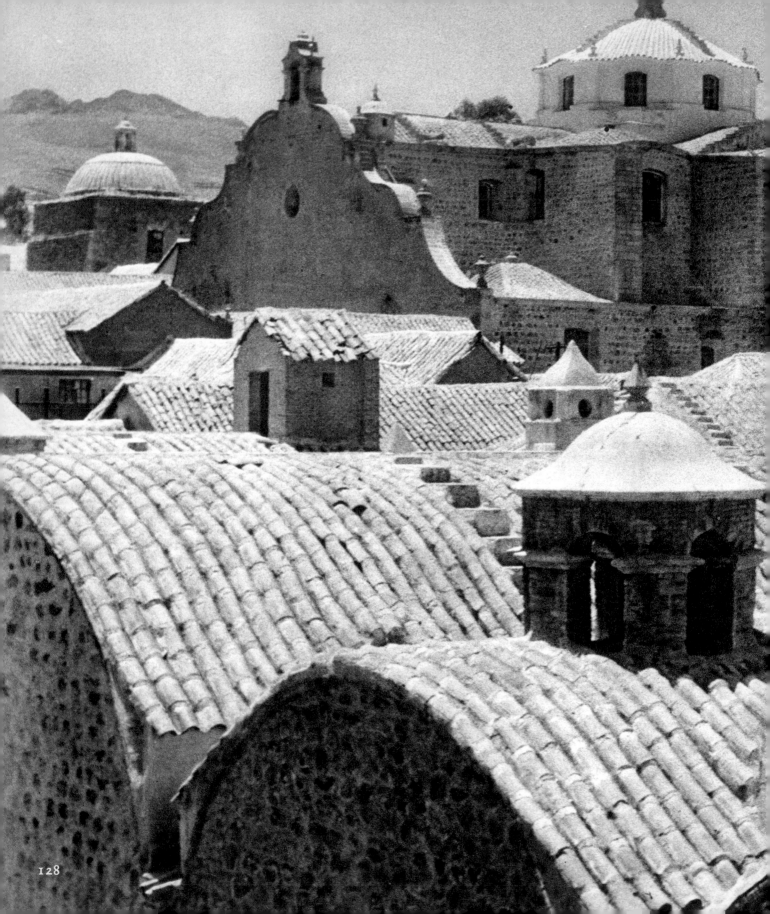

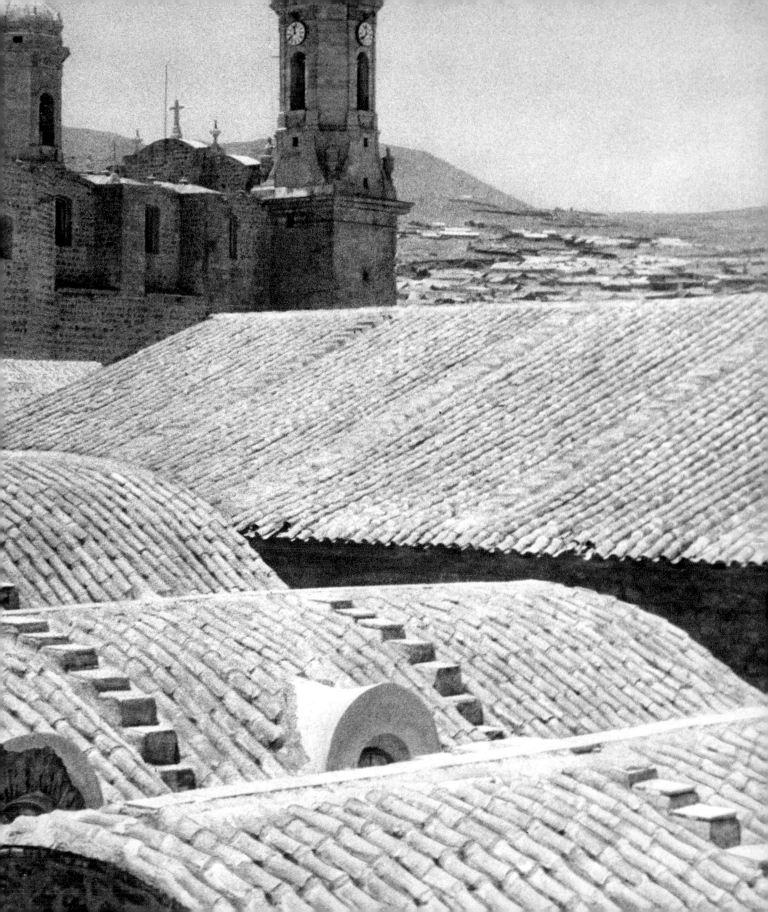

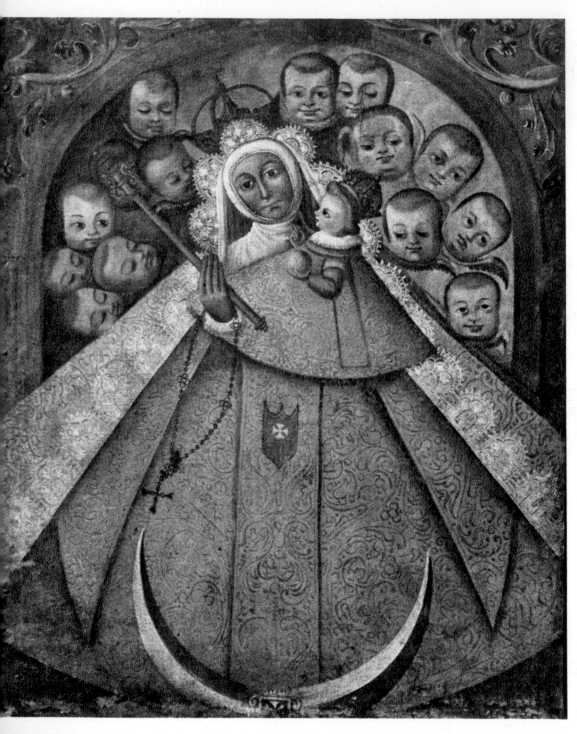

129

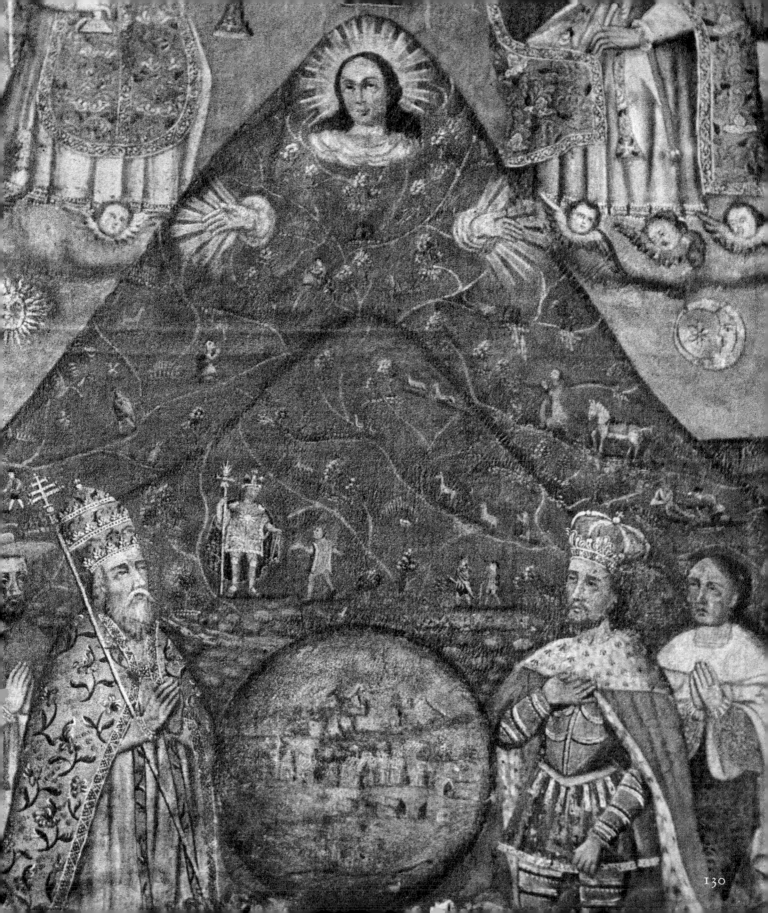

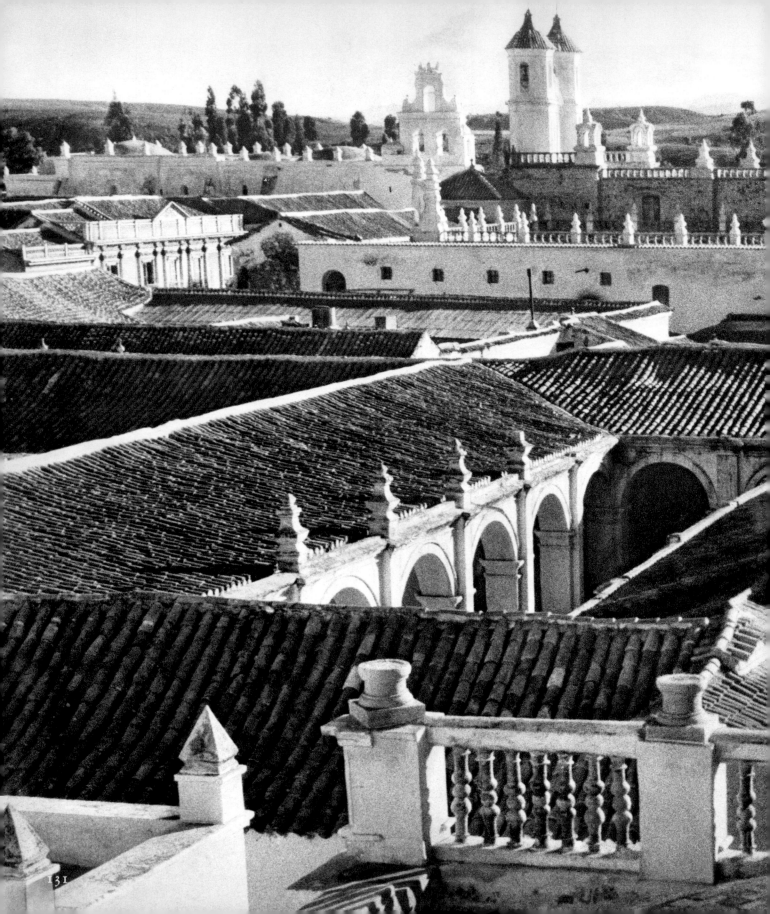

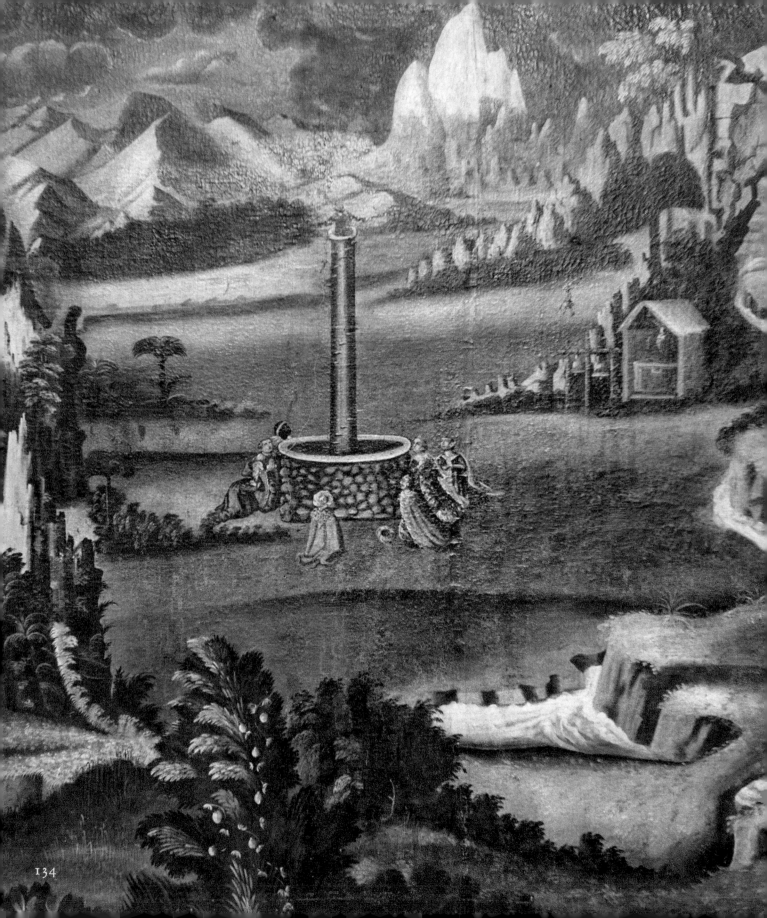

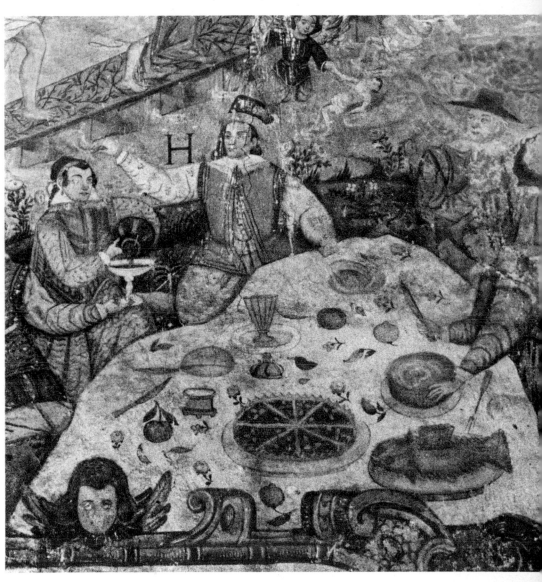

135

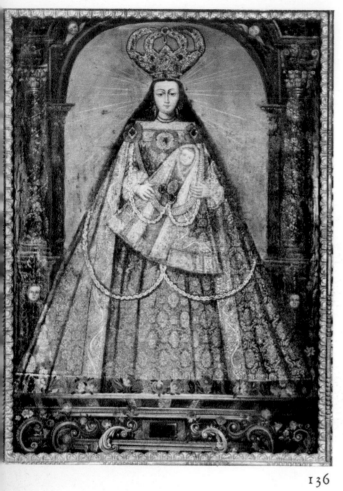

136

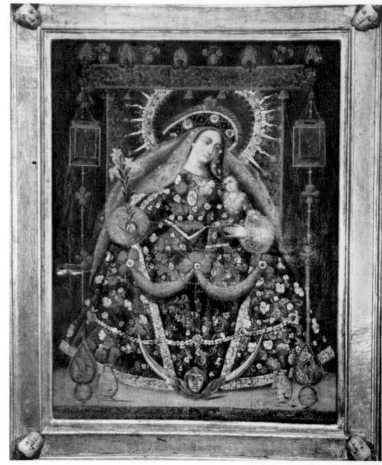

137

139

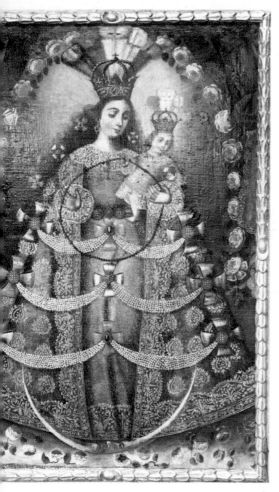

138

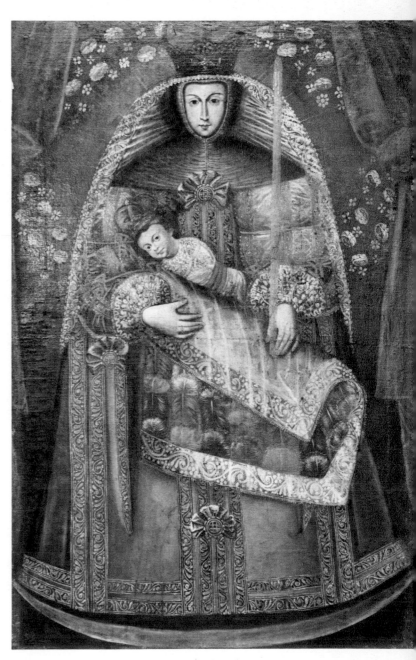

140

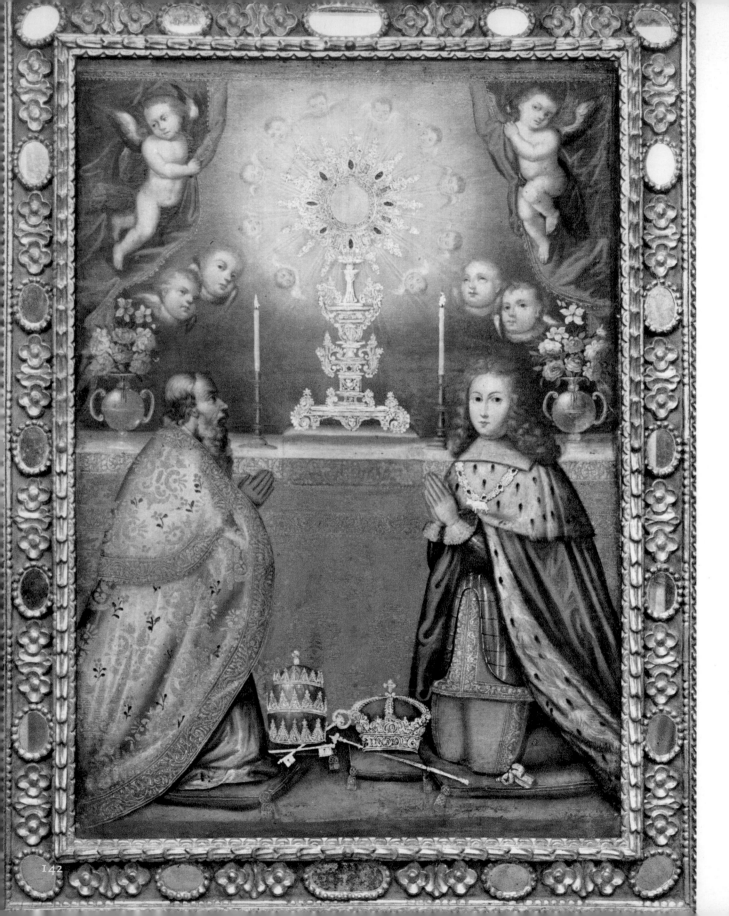

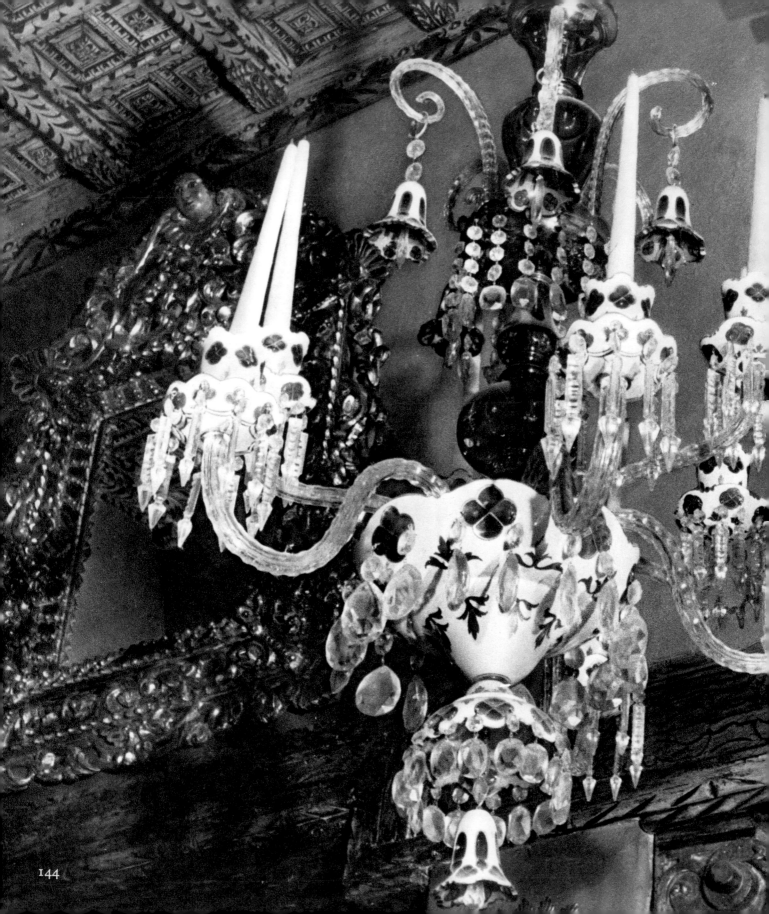

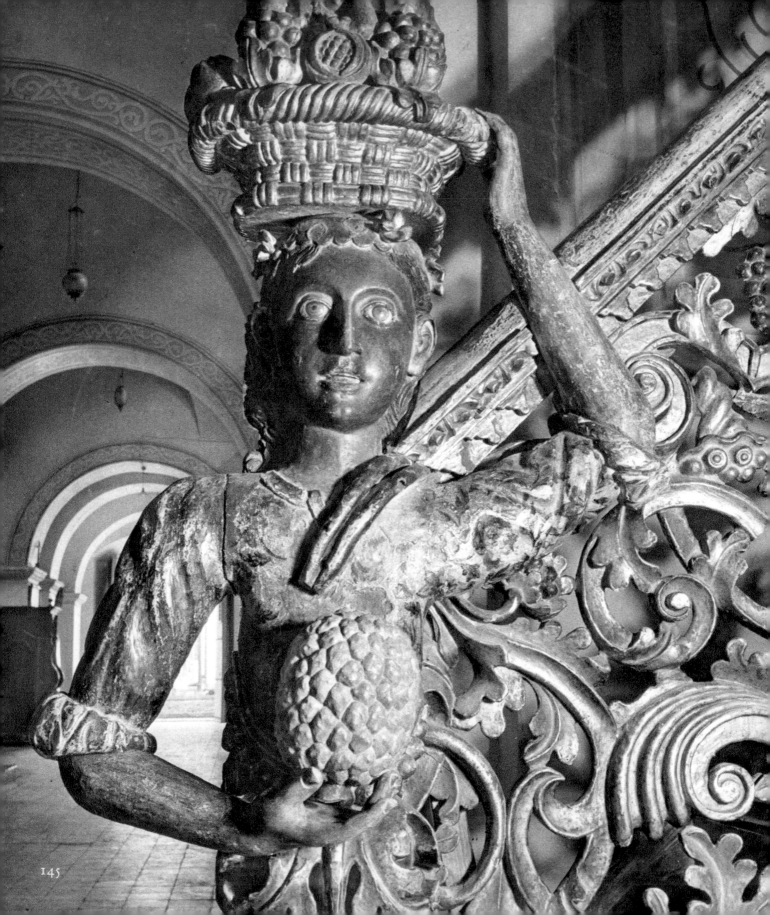

VII The Triumph of a Craftsman

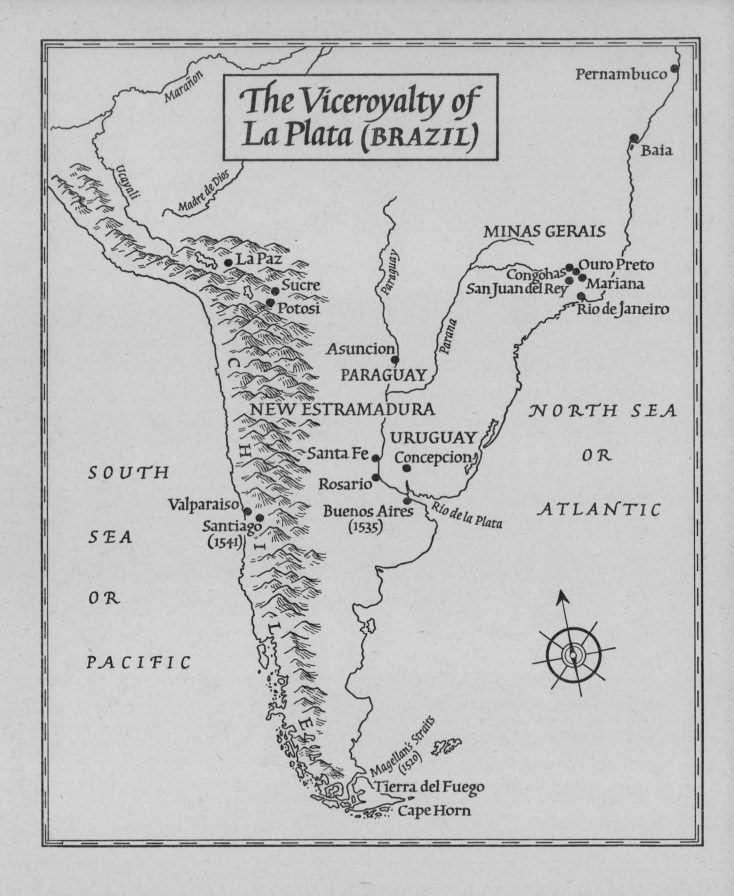

The Viceroyalty of La Plata (BRAZIL)

Marañon

Ucayali

Madre de Dios

Pernambuco

Baia

MINAS GERAIS

La Paz

Sucre

Potosi

Paraguay

Ouro Preto
Congohas
San Juan del Rey
Mariana

Rio de Janeiro

Asuncion

PARAGUAY

Parana

NEW ESTRAMADURA

NORTH SEA

URUGUAY

SOUTH

Santa Fe

Concepcion

OR

Rosario

ATLANTIC

Valparaiso

Buenos Aires
(1535)

Rio de la Plata

SEA

Santiago
(1541)

OR

PACIFIC

*Magellan's Straits
(1520)*

Tierra del Fuego

Cape Horn

ANTONIO FRANCISCO LISBOA was the bastard son of Manuel Francisco de Lisboa, an architect, and Isabella, a Negro slave. He was baptised in the parish church of the Conception in Ouro Preto, which his father had designed, and was to be buried there in 1814, under the name of Aleijadinho, 'the little cripple', having contributed much to the erection and adornment of some fifty sacred buildings, yet without ever achieving the title of master-builder, because he was guilty of *infamia di mulato*.

Aleijadinho embodies the genius of thousands of anonymous craftsmen, mulattos and half-breeds, whose faith breathed life into the altars and façades of the Roman church from New Orleans to Rio de Janeiro. He was said to have learned his trade from books, from an illustrated Bible, or by taking lessons from the engraver Joao Gomez Batista. But in fact it ran in his blood; his father and uncle were *carpentiros*, carvers in wood, and as a child he lived in their workshops and yards, learned to sketch a face or a plan just as a fisherman's son learns how to draw a net and mend it. This is fairly characteristic of colonial art and indeed of any art that comes from the hands not of master theorists but of workmen; by a natural process of evolution a boat-builder or country carpenter becomes a master-builder, because by making roof-trees or church stalls he has acquired a knowledge of design. The craft here makes the artist, the man who, by his natural understanding of the secrets and possibilities of wood, emerges from a carver to an architect. One is astonished to find the façade of a Baroque church repeating the same volutes seen in the curling beard of a Christ by Aleijadinho, the same grace in two different techniques, two different

materials *(plates 156,164)*. It was as a wood-carver that Aleijadinho first made a reputation at the age of twenty; at twenty-five he probably drew the plan for the Church of Moro Grande (1763), and at twenty-eight he created his architectural and sculptural masterpiece, San Francisco of Ouro Preto (1766).

The King of Portugal, having learned from the tribulations of the Spanish king, made sure that there would be no monastic orders to eat away his revenues in Brazil: by an ordonnance of 9th June 1711, renewed in 1715 and 1721, he forbade monks to settle in Minas Geraïs, the great mining town. Consequently the art of the area was not part of the missionary campaign but paradoxically, a parochial and also royal growth.

The architectural dictatorship which characterizes sacred buildings in the Spanish Indies is more marked in Brazil, in so far as the non monastic clergy were less ready to accept innovations than the monks, who recruited their artists in every kingdom and drew on resources in every capital. In Brazil as in Mexico and Peru, the bishop and his vicars were servants of a Catholic potentate, the Grand Master of the Order of Christ, on whom a decree by Alfonso V on 7th June 1454 conferred spiritual powers covering all oversea territories. Into his hands flowed the tithes and it was his Treasury that distributed them to the bishops, whose stipends ranged from three to eight thousand crowns a year. The priests only received three hundred and twenty crowns, but the constitution of Bahia authorised them to collect three pence for each house or land-owner, and three-halfpence for each of their slaves, to charge eighteen pence for every communion, and twenty pence for baptisms, marriages and burials, a sum which was doubled in the district of the mines to compensate for the level of prices. But though provided for comfortably in the values of their day, the priests did not scruple to indulge in trade. Ecclesiastical prosperity encouraged building, but here again the King imposed his authority: a special court was instituted by Joao III in 1532 to decide officially whether any fresh church foundation was needed, and

accepted or rejected the plan, besides selecting the architect. In the second half of the eighteenth century the court's business was brought to a standstill, such was the influx of requests. The Tertiary Order of the Franciscans at Ouro Preto requested authorisation for a church to be built in 1752; Aleijadinho began work on the site in 1765, still without authority; at last in 1760 a provisional licence arrived, but the definite licence dated from 1771. Though not present in person, the friars were represented by the Tertiary Orders of the Carmelites, Franciscans and Dominicans or Brothers of Mercy, each of which had a different Virgin for its banner, different habits for processions, and above all different social standing. Aleijadinho's father was admitted into the Tertiary Order of the Carmelites in 1766, a definite recognition of social success, for this brotherhood was the most exclusive club in Ouro Preto, and membership was limited to the wealthy. His standing as Treasury expert and sworn master of the *carpinteros* must have counterbalanced his unsavoury reputation, for a new enquiry into his morals had been instituted in 1756. But Aleijadinho, as a mulatto, could never expect such distinction; he was only a member of the Brotherhood of Sao José. This brotherhood had a lawsuit in 1761 with its Carmelite rivals on a favourite point of dispute, the order of precedence in processions. As a rule the white brotherhoods won, even if they had to take the case from court to court and finally to Lisbon, but each brotherhood was master in its own church and in 1740 the Negroes of St Iphigeneia made a clean sweep of the Whites of the Rosary brotherhood. These conflicts of vanity and battlings round altars, the general zest for victory of Black over White, of miners over officials, of *nouveaux riches* over nobles, helped greatly to stimulate art in this prosperous part of the world, where the diamond trade had already become a handsome source of revenue for Europe. At Ouro Preto as in Mexico and Peru, to build a church was an act of government, a statement of faith, and a challenge to other parishes: by the splendour of your façades and altars you showed that you were more generous, and

above all had the means to be so, and were ready to acknowledge the hand of Providence (the Christian's name for luck) in all these good things miraculously flowing from the discovery of the diamonds. For here, as in Potosí, the furious zest for life had always acted as a leaven on art, and the story of Aleijadinho really begins with the discovery in 1573 of an emerald mine by the *bandeirante** Sebastian Fernandez Tourinho.

Aleijadinho was the offspring of the black majority and the white minority, the one concealing beneath an overlay of patience a still primitive, natural vitality expressed in dancing, the other with its talent for organisation and feeling for wealth; and perhaps we can find no better human interpretation of colonial Baroque, that adulterous half-breed or mulatto art, than in the painful encounter of these two races on a strange continent. The creative dilemma of Aleijadinho the artist was undoubtedly that he was imprisoned between the two; he could belong neither to the white community nor to the black; both rejected him. By law and custom he was even cut off from the natives. Frézier declares that Negroes were forbidden to have intercourse with Indian women under penalty of castration, and in theory this law also applied to mulattos. Sensuality speaks out in the work of Aleijadinho, and sensual he was by nature, never less so than at the age of forty when he caught the leprosy of these southern climates, which Raynal declares 'urged men strongly towards pleasure.' He was a short, stocky little figure with a low forehead, a close crop of hair, a pointed chin and fiery eyes, and was said to be a drunkard and womaniser like his father; but there it was, his father was white and he but half white, and in the eyes of the world his blood dyed the natural vices of man a deeper black. By such quasi-logical reasoning, sincere but absurd, Negroes were deprived of their natural rights. Though he worked as hard as his father and won more fame, Aleijadinho never became wealthy, and the reason is not far to seek: amongst other deprivations, he was not legally entitled, as a man of colour, to sign

an agreement. Being paid for piece-work, and under the orders of a white master-builder, he often had to wait ten, twenty, even fifty years for what was due to him, patiently accepting meanwhile some marks of favour, gold scapulars or indulgences, unless his client, confident of complete immunity, simply refused payment out-right on the pretext of non-fulfilment of some clause. Even white master-builders were not strangers to such disputes; Aleijadinho's uncle Antonia Francisco Pombal had been declared a bankrupt in 1744, and in 1805 Francisco de Lima had all his property confiscated by the Tertiary Order of Sao Jao d'el Rei and died insane in consequence three years later. He was the builder of the major chapel of the sanctuary of Senhor Bom Jesus de Matozinhos de Congonas do Campo 1772; *(plate 155)*, where Aleijadinho was to spend the dramatic last years of his life. His hands and feet were little more than stumps now, and he worked on his knees with the tools bound to his wrists, carving those twelve prophets on the terraces *(plates 148-158)* and the sixty-six statues of the *passos** *(plates 159-168)*. Two black slaves, Mauricio and Januario, and two colourists, Francisco Xavier Carneiro and Ataïde, helped him in the task, carrying him to his work each day in a litter. His agony – each statue a station in its progress – lasted eighteen years from 1796 to 1814 when he died, blind and paralysed, leaving behind him the statue of a suffering Christ with the eyes of a gazelle surrounded by a company of soldiers and servants with strangely sensual chins and mouths, of apostles with aggressive or sleeping hands, terrifyingly awkward, and arms that twist with misery and amazement, saintly women well rounded in flesh, dazed with grief, and on the wide stairs climbing this hill, where fifty years before Feliciano Mendes had passed a life of solitude as a hermit, the prophets, carved in an airy bluish stone, and gazing out of empty eyes on a sky that is grey with heat and humidity.

NOTES ON THE ILLUSTRATIONS

146 SAO JOAO D'EL REI, MINAS GERAIS Church of the Third Carmelite Order (1733-1857). This town in the mines district of Brazil was so named in 1713 in honour of King Joao V of Portugal (1707-1750). The church façade is the work of Francisco de Lima Cerqueira. Originally designed to be square, the towers became round, then octagonal, with windows set at the angles. The door is said to have been designed by Aleijadinho and made by his workmen. The façade was probably completed between 1808 and 1816 by masons. *See fig. XI*

147 SAO JOAO D'EL REI, MINAS GERAIS Church of San Francisco d'Assisi (1773-1809). Aleijadinho's plan was probably altered by Francisco de Lima Cerqueira, who contracted for the work in 1779 and was declared bankrupt by the Teritary Order of the Franciscans in 1805. His property was confiscated and he died insane in 1808. The church was completed by Aniceto de Sanza Lopez. Only the door is ascribed to Aleijadinho. *See fig. XII*

148- CONGONHAS DO CAMPO, MINAS GERAIS The prophets on the terrace of the Bom Jesus de Mato-
158 sinhos, carved by Aleijadinho (1800-1805), in the local grey-blue stone called soapstone. They include the greater prophets Isaiah, Jeremy, Baruch, Ezekiel, Daniel, Joel (150), and some of the lesser: Hosea (165), Amos (166), Jonas (151). Compare the treatment of these statues in stone with those of the *pasos* in cedar wood *(plates 159-168)*.

155 CONGONHAS DO CAMPO, MINAS GERAIS General view of the Bom Jesus de Matosinhos (1757-1818). Authority to build a chapel here was given in 1757 to the Portuguese hermit Feliciano Mendes, and work began in 1758 on the plan of Antonio Gonzalves Rosa and Antonio Rodriguez Falcate; between 1769 and 1772 a tender by Francisco de Lima Cerqueira was accepted. In 1780 the hill was redesigned to make it a place of pilgrimage like the Bom Jesus at Braga in Portugal and Aleijadinho was entrusted with the terrace design, the twelve statues of the prophets (see above) and the seven rest chapels or *pasos* with carved and coloured statues of the Passion. *See fig. X*

159- CONGONHAS DO CAMPO, MINAS GERAIS The painted statues of cedar for the *pasos* or resting-chapels
165 of the Bom Jesus de Matosinhos, carved by Aleijadinho (1796-1799) and coloured by Carneiro and

253

Altaide. In all there were probably seventy of these statues, inspired by the Last Supper of Francisco Salzillo de Murcia, at the Ermita de Jesus. Illustrated here: a sleeping apostle (159), two servants (160, 161), the Apostles at the Supper (162), Christ at the Last Supper (164), Christ mocked and crowned with thorns (165).

166 SUCRE, BOLIVIA Ironwork in the Cathedral screen (eighteenth century).

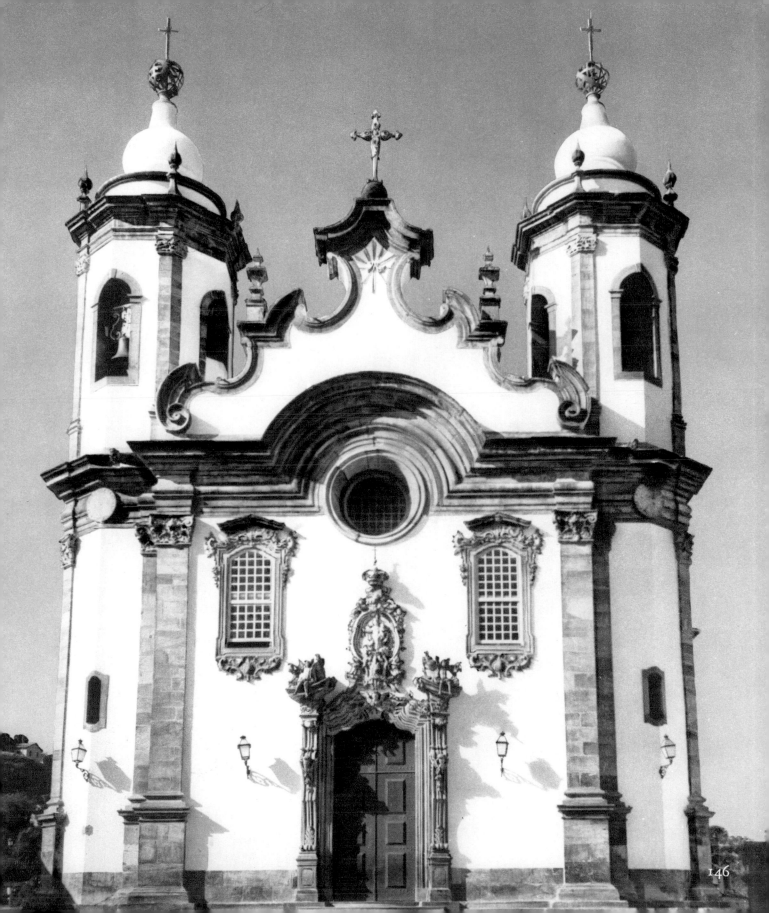

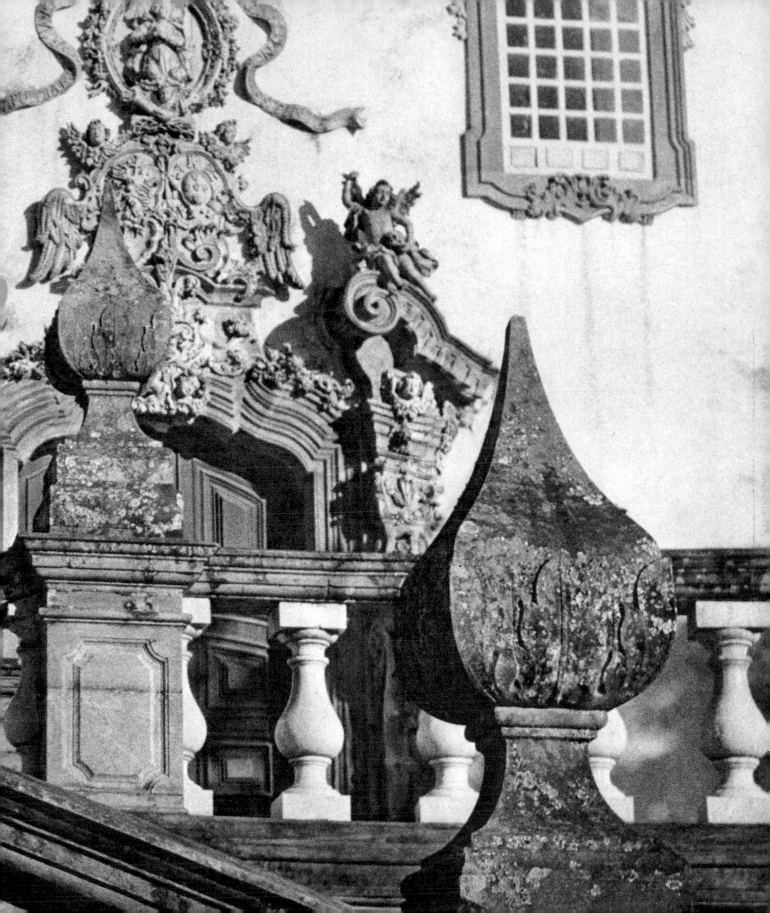

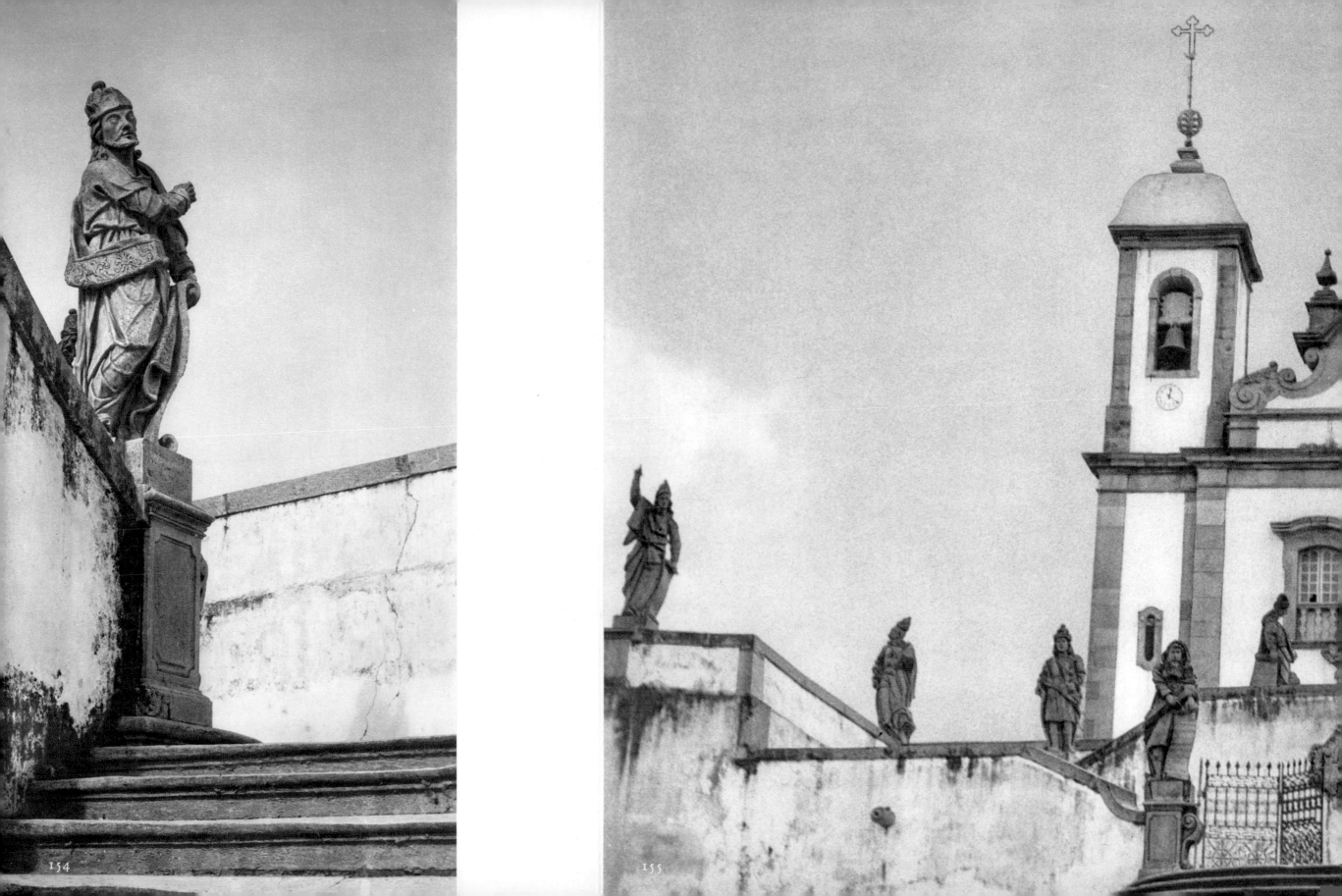

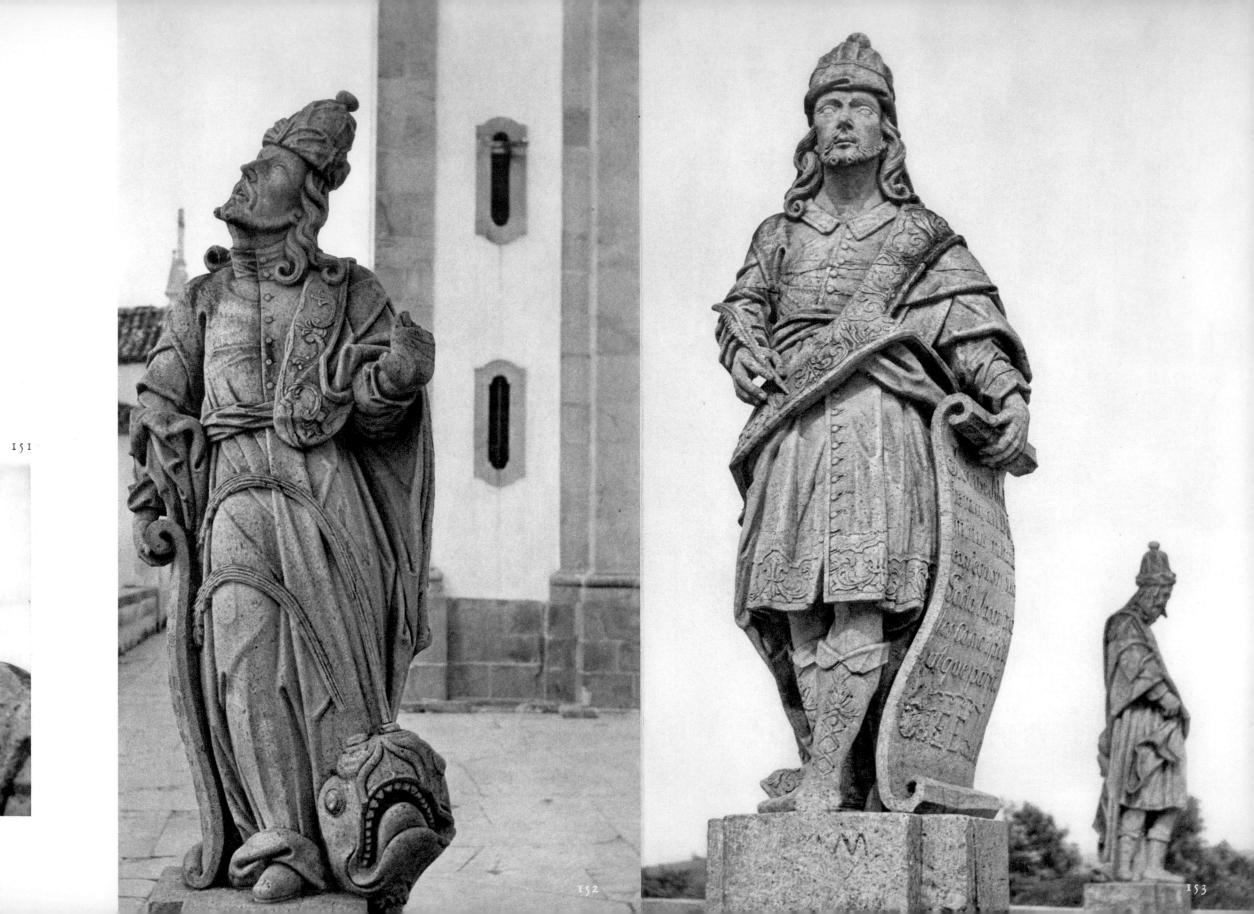

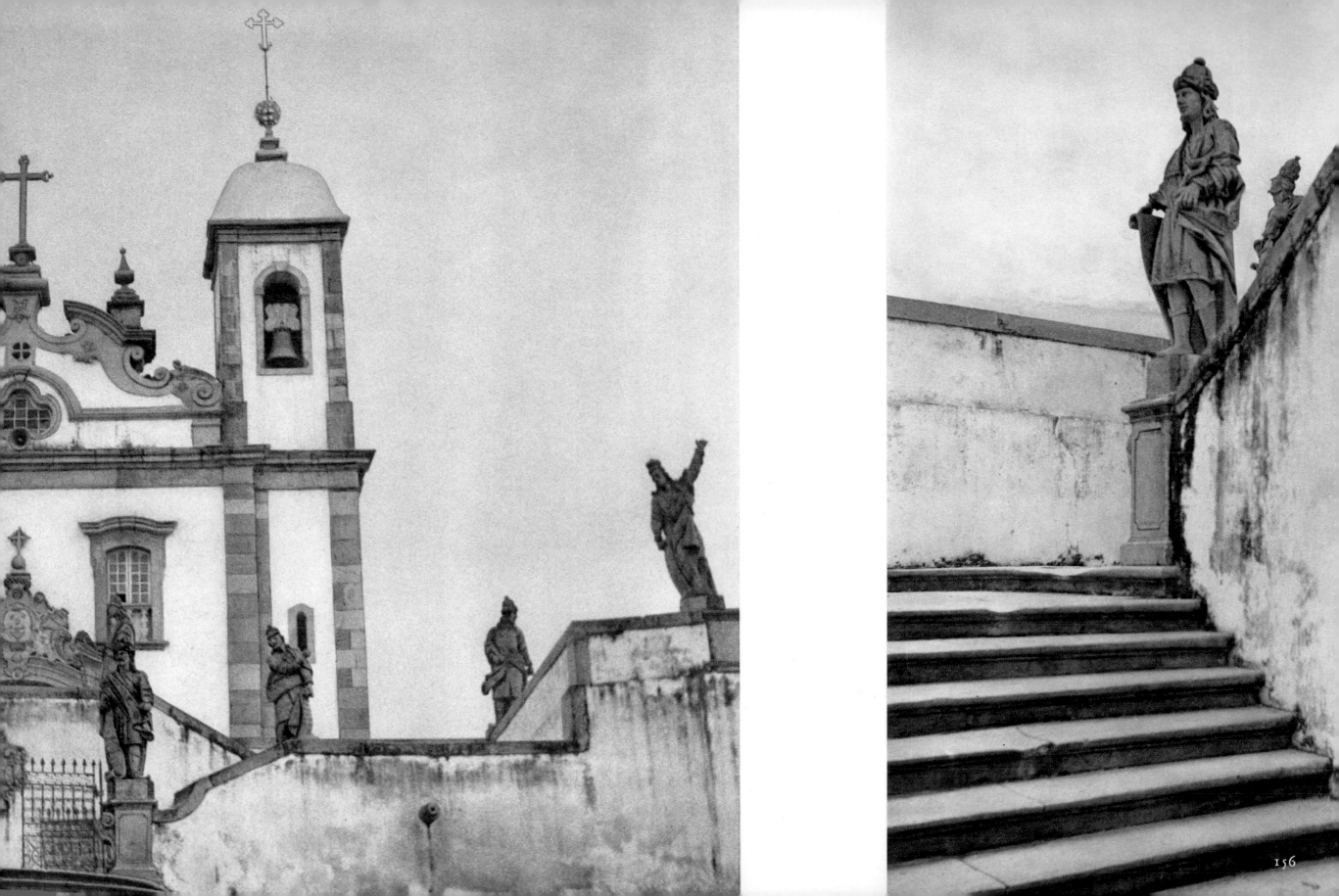

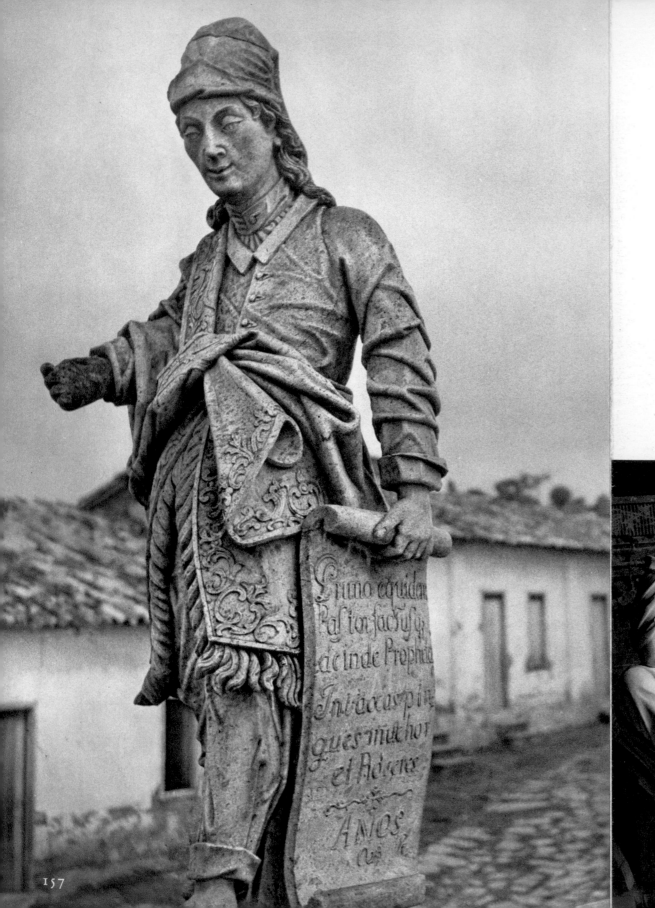

157

158

159

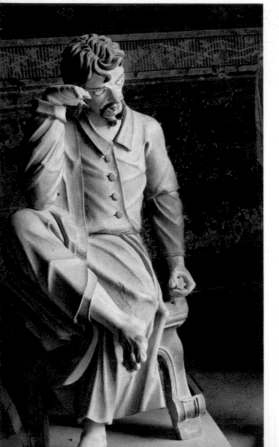

160

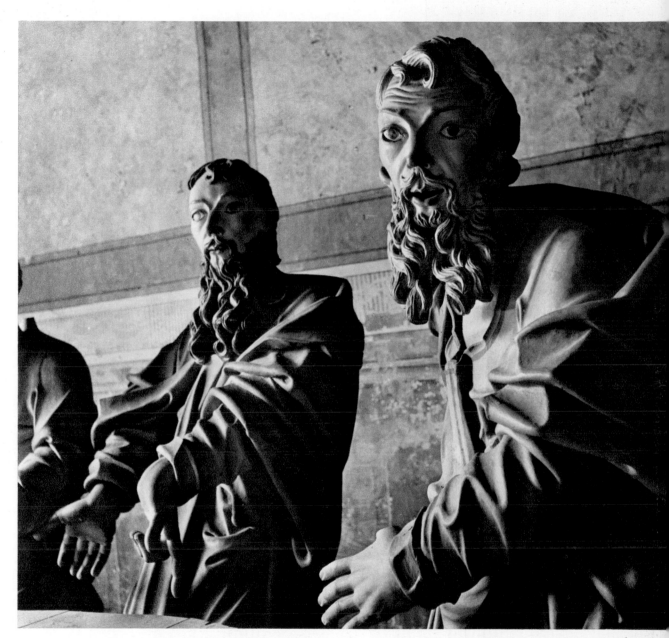

161

162

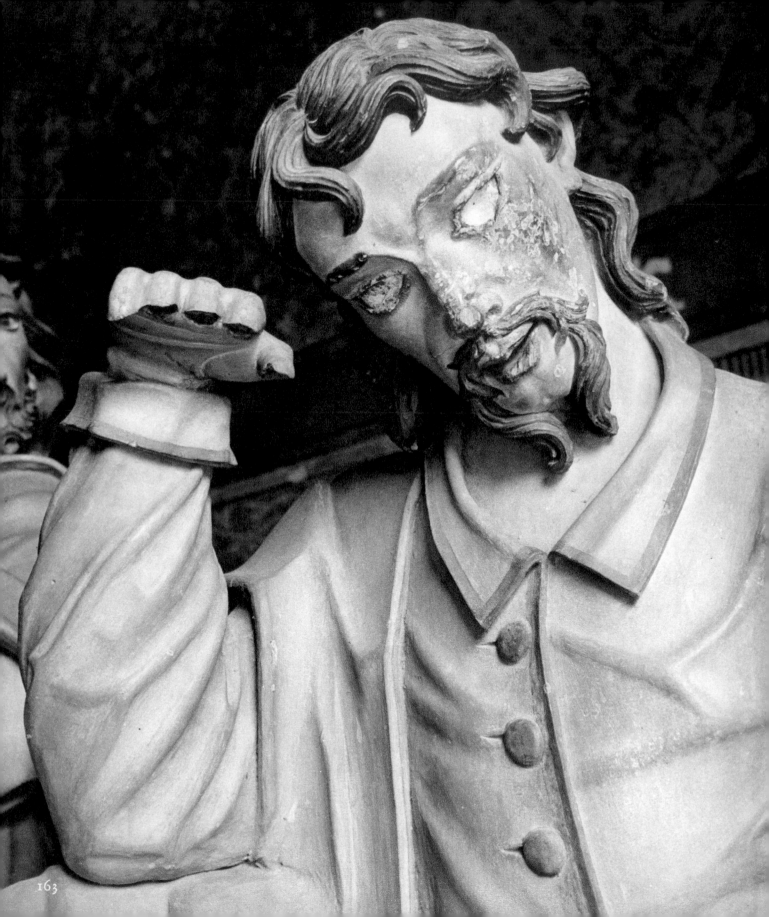

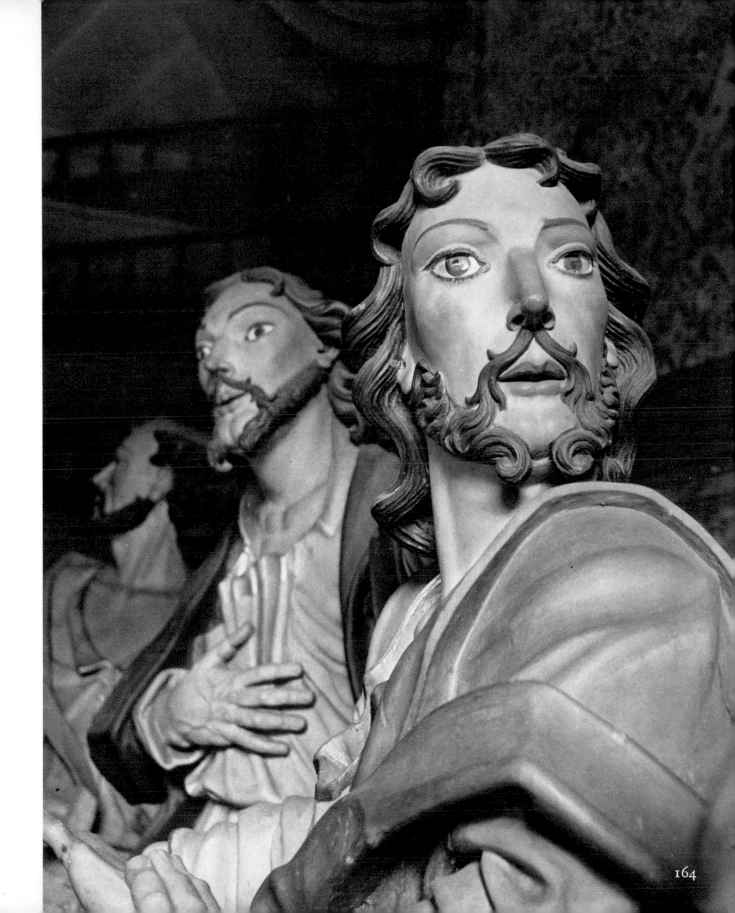

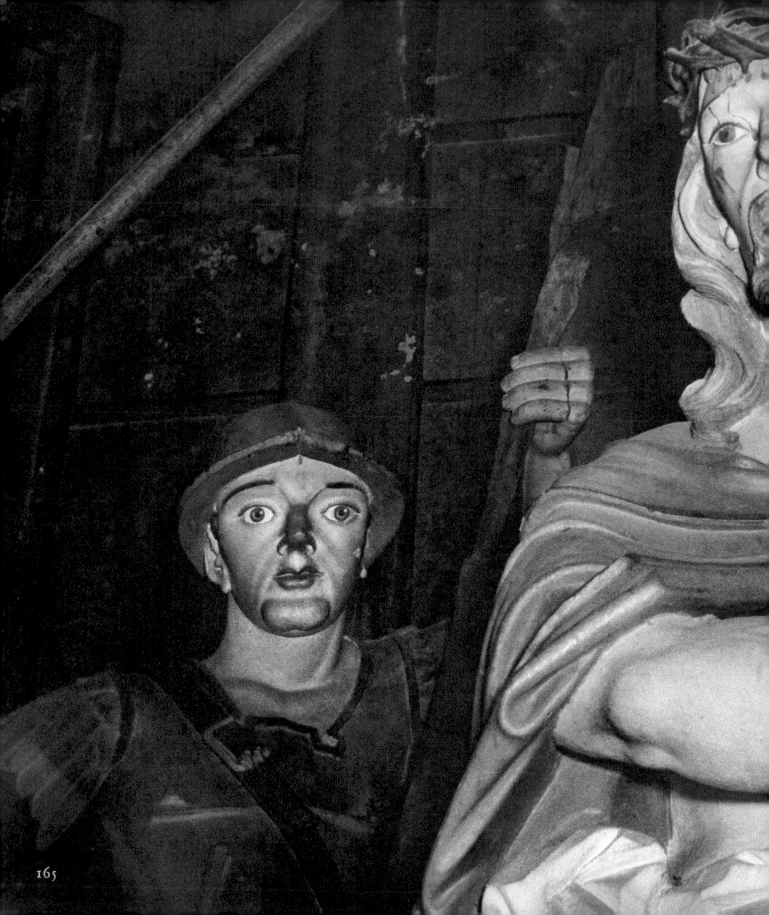

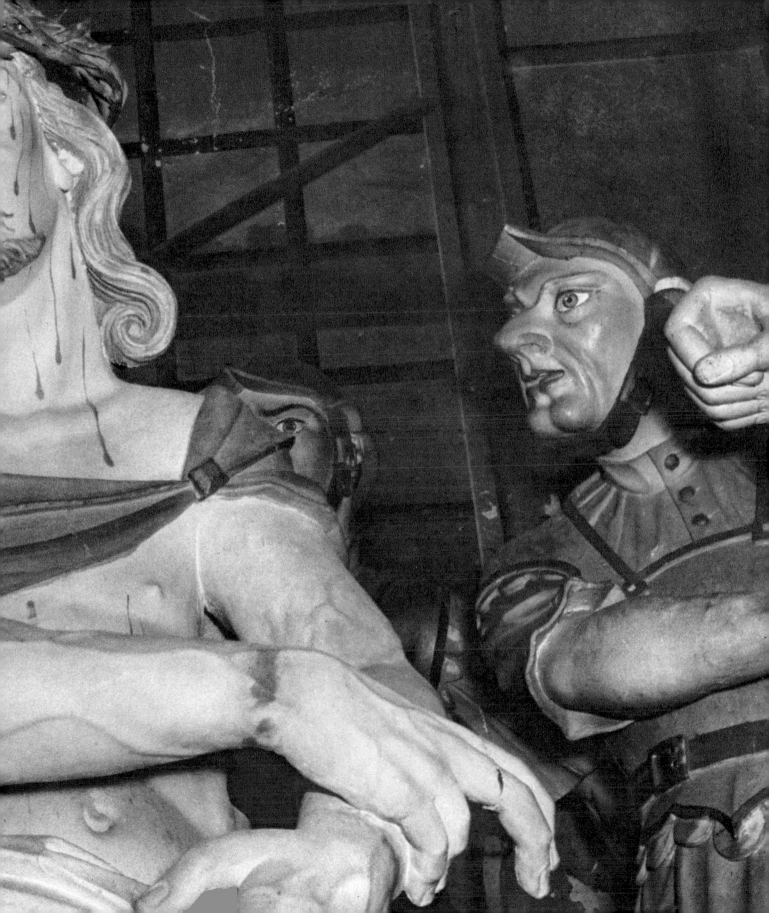

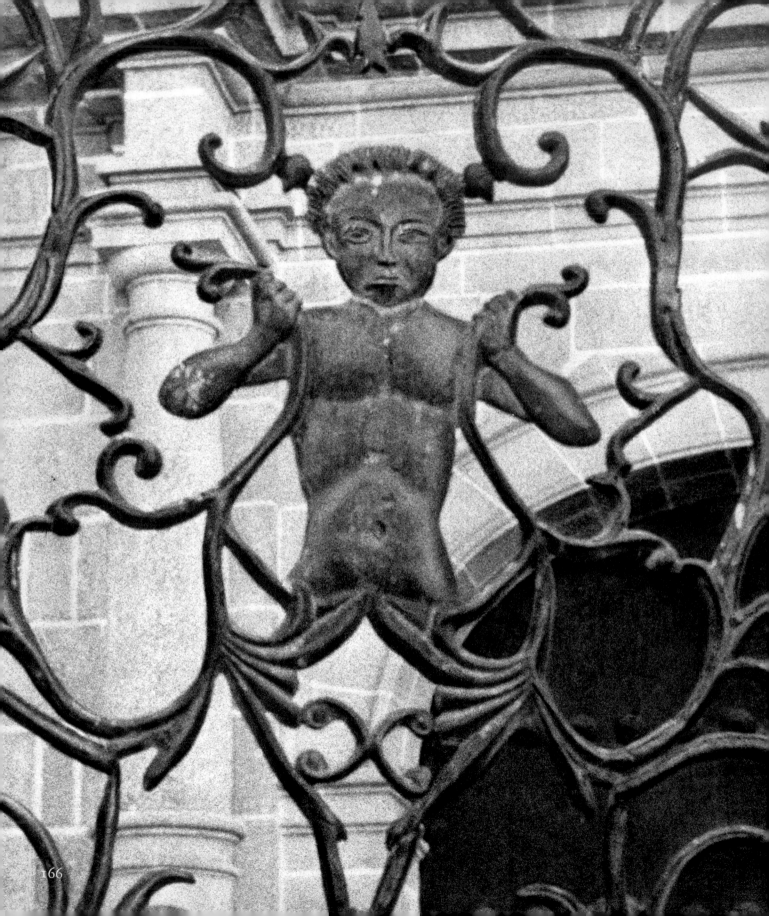

GLOSSARY

AMERICA The continent probably discovered by Eric the Red in the tenth century and certainly by Christopher Columbus in 1492 was so named by the cartographer Waldseemuller in homage to the Florentine Amerigo Vespucci, who claimed to have discovered the mouth of the Amazon in 1499. Latin America includes all the nations conquered by the Spanish or Portuguese from Mexico to the Argentine.

ATAHUALLPA The last independent Inca emperor, the thirteenth after Manco Capac, who founded the dynasty about 1200. Atahuallpa was executed by the Spanish in 1532. *See under* Inca, *also plates 103, 115.*

AYMARA Peoples of the Andes whose language is still spoken in the provinces of Arequipa and Puno in Peru, and La Paz in Bolivia. They may have been connected with the civilisation of Tiahuanaco.

AZTEC Nation related to the Toltecs, from whom (about 1300) they took over the conquest of Mexico, where they founded Tenochtitlán, the present town of Mexico, captured by Cortés in 1520. Their language is Nahuatl. *See also* Montezuma.

BANDEIRANTES Half-breeds of Southern Brazil and the State of Sao Paulo. In the course of slave-hunting they discovered the interior of Brazil and pushed its frontiers to the river heads of Paraguay where they came into collision with the Jesuits.

BAROQUE Derived from the Spanish *barrueco*, a jeweller's word for a pearl of irregular form. It was already used towards the end of the seventeenth century to describe things that were irregular, unequal or strange, and (in painting) for faces that did not conform to the rules of classical proportion. German art critics began to apply it to architecture towards the end of the nineteenth century. Since then the word has been used in a wider sense to denote a conception of art rather than a particular style.

BERNINI (1598-1680) Baroque architect, sculptor and painter, appointed director of works for St. Peter's in 1630, who designed the baldachin *(plate 168)* and the pulpit, also the tombs of Popes Urban VIII and Alexander VII.

BORROMINI (1599-1677) Baroque sculptor and architect, renowned for the originality of his plans, especially for the elliptical nave of San Carlo alle Quattro Fontane (1638-1641) and its façade (1667); also responsible for the decoration of San Giovanne in Laterano in 1650.

BRAZIL Discovered on 22nd April 1500 by Pedro Cabral, again in 1509 by Diego Correa Ramalho and in 1526 by Aleixo Garcia. In the sixteenth century it was divided into thirteen areas governed by captains under the authority of a Captain-General residing at Bahia and later at Rio de Janeiro. Administration was similar to that adopted in Spanish America. Stretching from the mouths of the Amazon at Sao Paulo, the province extended in the seventeenth century to the river heads of Paraguay, and in the eighteenth century to the Andes. In 1880 there were three to four million inhabitants, and nearly two million Negroes in 1818.

BULL The Papal Bull of Alexander VI of 3rd May 1493 divided the new discoveries in the Indies between Spain and Portugal by a line passing through the two poles and a point a hundred leagues west of the Cape Verde Islands. The Treaty of Tordesillas of 7th June 1499 moved this point two hundred and seventy leagues farther west, which endorsed the colonisation of Brazil by the Portuguese. *See page 19.*

CHIBCHAS A people of the savannah of Bogota (Columbia). The Chibcha and Inca civilisations were probably the most important in South America, characterized by their free and frequent use of gold.

CHURRIGUERA (1650-1725) An architect and sculptor, Catalan by birth, who gave his name to the Spanish Baroque style of the eighteenth century. In 1689 his design for a catafalque for the obsequies of Queen Marie-Louise was accepted; in 1693 he was responsible for the reredos of the *alta mayor* of San Estaban of Salamanca, copied in the Mexican altar-pieces of the eighteenth century, and characterised by the use of the *esbipite* or *estipite* column *(plate 19)*. His work was continued by his two sons, grandson, nephew and disciple Pedro Ribera. In 1718 Jeronimo de Balbas of Seville introduced Churrigueresque

into Mexico with The Altar of the Kings, and his son carried the style yet further in Tasco. *See page 32 and plate 100.*

CONQUISTADORS Name given to the soldiers and captains who carried out the conquest of America between 1492 and 1550; their descendants retained the title as a mark of nobility. In 1744 the author of *Gil Blas de Santillane* notes: 'All those who descend in any way whatsoever from these famous soldiers of Cortés modestly assume the title of conquerors and are so jealous of it that they hold it to be well above greatness.'

COUNTER-REFORMATION In accordance with the prescriptions of the Council of Trent (1563), the Church resumed the direction and control of sacred art between the end of the sixteenth and middle of the seventeenth centuries. Greater austerity in architecture was insisted upon *(see* Vignola *and plates 5, 8)*, mythology was banned and representations were recommended of the Virgin and saints whose worship had been questioned during the Reformation.

CREOLE Name given to any Spaniard or Portuguese of white race born in America.

CUZCO SCHOOL OF PAINTING Famous for its painters, Indian or half-breed, who devoted themselves to portrayals of the 'Incas of Castile' in the seventeenth century. *(See plates 101-103, 109, 110, 112, 114, 115 and 122)*. The founder was probably the Franciscan friar Basilio de Santa Cruz, the master of Juan Zapata Inga, who painted in Chile about 1684. Don Alonso Cortés de Monroy probably commissioned in 1650 a picture by him representing the Conquest. The Cuzco School is said to have come under Bolognese influence through Francisco Albani (1578-1660) and Spanish influence through a son of Murillo. Among the best-known artists of the school are: Juan de Espinosa de los Monteros (about 1670), Francisco Juarez, Basilio Pacheco, Ignacio Chacon, Antonio Vilca, Mariano Zapata, Diego Quispe Ttito, and the half-breed Manuel Torres about 1722.

ESCORIAL, *San Lorenzo del* Monastery palace built for Philip II between 1560 and 1584 by Juan de Bautista de Toledo and Juan d'Herrera, in the severe Counter-Reformation style. In Aviler's *Vie de Vignola* it is stated that Philip II requested Baron Bernardino Martirano to consult the ablest Italian architects; twenty-two plans were submitted, one by Palladio among them. These were put in the hands of Vignola, who made from them a combined design so successful that it was difficult to imagine anything more excellent. The

King of Spain was so pleased with it that he made very attractive offers to Vignola...' But the Italian architect declined; he would not give up his work at St Peter's in Rome *See under* Vignola.

GALLEONS Name given to the squadron of vessels that sailed in August for Cartagena while those that sailed in April–May for Vera Cruz were called 'the Fleet'. The two squadrons joined on their return to Havanna. This scheme was evolved between 1543 and 1566. The squadrons consisted of thirty to ninety vessels which sailed out with manufactured goods and brought back gold, silver and spices. The galleons' flag had three bands, red, white and yellow; the middle band bore a black eagle, crowned, and ringed with the Order of the Golden Fleece. The Atlantic war squadron which protected the galleons consisted in 1740 of one vessel of a hundred and fourteen guns, the *Infanta real*, two vessels of seventy-four guns, the *Africa* and *Invincibile*, six of seventy guns, four of sixty-four guns, including the *Conquistador*, and six of sixty guns, with two frigates and two galleasses. *See page 215.*

INCA Peruvian dynasty whose origins before the eleventh century are unknown (see under Atahuallpa), giving its name to a civilisation and empire comprising south Columbia, Peru, west Bolivia, and parts of Chile and the Argentine.

INDIES OF CASTILE The Spanish Empire in America. This comprised, from north to south, New Navarre, New Biscay, New Galicia, New Spain, Golden Castile, Terra-Firma, New Andalusia, New Granada, New Castile, New Toledo, New Estremadura, and, in the Pacific, Manilla, which belonged to New Spain. Under the authority of the Council of Indies, founded in 1511, the Spanish American Empire at the end of the eighteenth century was divided into four viceroyalties: New Spain, Terra-Firma, Peru and La Plata *(see under these names)*; six regions governed by Captains-General: Porto Rico, Havanna, Caracas, Guatemala, Chile and the Philippines; thirteen seats of justice: Mexico (1527), Guadalaxara, Guatemala, Cuba, Lima (1542), Charcas, Chile, Santa Fé, Quito, Buenos Aires (1661), Caracas, Cuzco (1717), and the Philippines. During three centuries a hundred and seventy viceroys took office and five hundred and twenty-eight captains-general; there were two hundred towns of some standing, seventy cathedrals, some seventy thousand churches, five hundred convents, for a population of about ten million inhabitants of whom less than two

million were Spanish. The revenue in 1780 was estimated at ninety million Spanish pounds of which thirty-four million were collected by the Treasury.

INVINCIBLE ARMADA, The Spanish Fleet destroyed by the English in 1588. It was called the 'great wooden town' and had cost Philip II several years' revenue from the Indies. Under the command of Alfonso Perez de Guzman, Duke of Medina-Sidonia, it comprised the squadrons of Biscay, Castile, Andalusia, Guipuscoa, also galleasses, a total of a hundred and thirty-two ships, two thousand seven hundred and sixty-one guns, seven thousand eight hundred and sixty-five sailors, twenty thousand six hundred and seventy-one soldiers. The English had collected a hundred and ninety-seven ships, fifteen thousand seven hundred and eighty men. The Duke returned with eighty-seven ships. In his fury Philip II bit a silver candlestick and cried: 'I did not send them to fight the winds!'

KINGS OF SPAIN, EMPERORS OF THE INDIES 1474, Isabella and Ferdinand V. 1504, Philip I. 1516, Charles V. 1556, Philip II. 1598, Philip III. 1621, Philip IV. 1665, Charles II. 1700, Philip V. 1746, Ferdinand VI. 1759, Charles III. 1788, Charles IV. 1808, Ferdinand VII.

MARQUISES OF OAXACA

I Cortés, by letters patent of 2nd July 1529.

II Don Martín Cortés y Arellano, son of the foregoing and Jeroma de Zuniga.

III Don Hernando Cortés, son of the foregoing and Doña Ana Ramirez y Arellano (his cousin).

IV Don Pedro Cortés, brother of the foregoing, died without issue.

V Doña Jeroma Cortés, sister of the foregoing, wife of Don Pedro Carillo de Mendoza, grand majordomo of Queen Margaret of Austria.

VI Doña Stephania Carillo de Mendoza y Cortés, daughter of the foregoing, wife of Don Diego d'Aragon, Duke of Terre Nova, Prince of Castel Vitrano and of the Holy Empire, Marquis d'Avila and Favora, Admiral of Sicily, Viceroy of Sardinia, Knight of the Golden Fleece.

VII Doña Juana d'Aragon, daughter of the foregoing, wife of Don Hector Pignatelli, Duke of Monteleone, Prince of Noja.

VIII Don Andrea Fabrizio Pignatelli, son of the foregoing.

 IX Doña Jeroma Pignatelli, daughter of the foregoing, wife 'of Don Nicolas Pignatelli, Viceroy of Sardinia and Sicily.

 X Don Diego Pignatelli, son of the foregoing.

 IX Don Fabrizio Pignatelli, son of the foregoing.

 XII Don Hector Pignatelli, son of the foregoing who was living at Naples in 1780 – was it his son who yielded the town to Murat?

MAYAS Indians of Mexico and Guatemala whose ancient empire probably dates back to the fifth century B.C. It consisted of a federation of cities with a well-developed civilisation – Lopan, Yacluclans, Uaxactun and Palenque – which probably moved in the eleventh century into Yucatan *(see under this word)* forming a new empire with Chichen Itzá and Uxmal. One of the Maya tribes, the Lankantons, still exists.

MEXICO SCHOOL OF PAINTING Probably founded in the sixteenth century by Simon Pereyns and his pupils Francisco Morales, Francisco de Zumaya, Andres de la Concha and Juan de Arrue. The earliest works were religions and show the Flemish influence also felt in Spain; van Eyck had been in Aragon since 1428 and the works of Martin de Vos (1536-1693) were imported into Mexico. Portraiture emerged from sacred art at the end of the seventeenth century, much later than in Spain, where it was in evidence by the end of the sixteenth century. Lopez de Herrera, Nicolas Rodrigo Juarez (1667-1734) and Cabrera (1695-1768) did not usually paint portraits. Cabrera, who came from Oaxaca, worked at Santa Prisca de Taxco. The great Mexican Baroque painters are, after Lopez de Artenga, Pedro Ramirez, Baltasar de Echave, Juan Rodriguez Juarez. *(See plates 72-81, 92, 95).*

MICHELANGELO (1475-1564) Poet, painter, sculptor and architect, who said of himself: 'I advance alone along untrodden paths', which might be the remark of a great Baroque artist, if we read into the words a refusal to accept conventions and a systematic search into what is new. Michelangelo also said: 'My style is destined to make great fools', and the sally was often applied to the lesser Baroque artists of the seventeenth and eighteenth centuries.

MONTEZUMA The Aztec emperor who was taken captive by Cortés on the 14th November 1519, and killed fighting beside the Spaniards during the siege of Mexico in 1520. His four

daughters were given dowries and husbands by Cortés, and his son, baptised under the name of Pierre, was given a title.

MULATTO Issue of a black and a white person.

NEW SPAIN (1535-1821) A viceroyalty made up of the present republics of Mexico, Guatemala, Salvador, Honduras, Nicaragua and Costa Rica and the islands of Cuba, Haiti, San Domingo and Porto Rico, together with New Mexico, which extended as far as New Orleans and California. At the end of the eighteenth century its revenue was estimated at fifty-four million pounds and its population at six million five hundred thousand. Its capital was Mexico, once the Aztec city of Tenochtitlán, which was finally captured on 13th August 1521; by 1522 it already had a *cabildo*, or municipal council, by 1535 a mint, by 1548 an archbishop (the Franciscan Zumarragua), by 1553 a royal and pontifical university, and by 1581 the doubtful benefits of the Inquisition. By 1664 religious houses had become so numerous that the *cabildo* asked the king to forbid any further foundations; apparently there had been fifty-five during the course of the eighteenth century. Widely different figures have been given for its population in the seventeenth and eighteenth centuries, ranging from fifty thousand to two hundred thousand inhabitants, but it is known that most of them were natives.

PERU From 1544 to 1817 a viceroyalty, whose territories included those of Terra Firma up to 1718 and those of La Plata from 1776 onwards. In the eighteenth century its revenue was estimated at twenty-seven million pounds, its population at two million. The capital was Lima, or the Town of Kings, founded by Pizarro on 18th January 1535. Jerome de Loaysa became its first archbishop in 1541 and founded its university in 1551; the mint dates from 1565 and the Holy Office (of the Inquisition) from 1569. The whole town, of which the religious orders possessed two-thirds, was destroyed by an earthquake in 1747. Cuzco, the ancient Inca capital, means 'the centre' in the Quechua tongue. It is said to have been founded by Manco Capac and to have had three hundred thousand inhabitants. Pizarro took possession of it on 15th November 1533 and almost immediately the Franciscan, Peter of Portugal, founded a religious house there. It was declared the 'noble and great city of the Indies' by a royal cedula in 1540 and acquired a university in 1592. Its cathedral, built over the ancient temple of Viracocha, is said to have cost sixty-five million gold francs.

In 1850 Cuzco had fifteen churches, four monasteries, three convents and six Beguine convents. On Potosí and Sucre *see plates 128 and 131*.

PIGNATELLI See Marquises of Oaxaca.

LA PLATA Viceroyalty composed of the present states of Bolivia, Paraguay, Uruguay, and the Argentine. The capital, Buenos Aires, to which the Jesuit missions of Paraguay belonged, was founded by Mendoza in 1536. Apparently its population did not exceed one million.

PLATERESQUE One of the styles of the Spanish Renaissance, characterised by extremely rich ornament lavishly applied to basically simply forms. It was much used in the Spanish Americas.

QUECHUAS The people of southern Peru whose language was used in the Inca empire They were much influenced by the Spanish missionaries and administration.

QUITO SCHOOL OF PAINTING It is said to have sprung from the college of Indian art founded by the Franciscan Jodoque Rurke de Mansalaer (died 1574) and the Brotherhood of the Rosary, founded in 1590 by the Dominican Pedro Bedon. In the eighteenth century this last was under the control of the Franciscans. Miguel de Santiago (1655-1706) rose to the unusual heights, for a colonial artist, of sending his works to Rome; one of his pupils was Manuel Samaniego y Jaramillo, author of a treatise on painting which is mainly a re-hash of Pacheco and Carel von Mander. Between 1779 and 1788 two hundred and fifty paintings by the Quito school were despatched from Guayaquil to Mexico. *See plates 132-134, 142-143.*

ROCOCO Term describing a style of architecture, furniture and gardens much in favour under Louis XV which made use (sometimes excessive) of lavish ornamentation. It has since acquired a much wider significance.

SERLIO Architect born at Bologna in 1475. In 1541 he was at Fountainebleau where he dedicated his *Books of Architecture* to François I; they were translated into Spanish at Toledo in 1552. He was a theoretician rather than a practising architect.

TEOCALLI Aztec word for temple, meaning 'house of god'. The Indians of Mexico applied it also to Catholic churches.

TERRA FIRMA (1718-1810) Viceroyalty composed of the present states of Panama

Colombia, Ecuador, Venezuela, the Guianas and the northern part of Amazonas. In the eighteenth century its population was numbered at two million. The capital was Santa Fe of Bogota, built by Gonzalo Ximenes de Quesada between 1538 and 1541. In 1774 it is said to have had six thousand inhabitants and in 1820 thirty-five thousand, two thirds of the town being the property of religious houses. The first pan-American congress was held by Bolivar in the Dominicans' church in 1827. Papayan, discovered by Diego de Nicusa in 1509 and founded by Benalcazar in 1536, was the capital of a mining area said to have possessed four hundred churches in 1571. A Dominican inventory of the seventeenth century lists sixty-six different tribes or peoples living in the city. Papayan had fifty thousand inhabitants at the time of the Conquest; by 1585 these had dwindled to ten thousand. The first bishop, an Augustine called Caronio, made a vain effort to protect the Indians, but the governor ordered his return to Spain in 1560. The town was destroyed by an earthquake in 1736. By 1820 its population was reduced to seven thousand, its gold mines abandoned, and most of its religious houses became barracks and stables, but the bishop's revenue still reached forty thousand dollars. The town of Quito, taken in 1534 by Sebastiano Benalcazar who re-named it San Francisco, had as its first bishop a Dominican, Pedro de la Penna. In 1725 it had eight parishes, four religious houses, an important Jesuit college, three thousand Spaniards and ten thousand inhabitants of mixed blood. By 1820 the population numbered seventy thousand but there were still only four paved roads.

VIGNOLA (1507-1573) Began his career in Rome in 1530 and acquired fame chiefly through his Villa Farnese (1547-1554) and Gesù Church (1568). *See plates 180 and 181.* In 1570 he published his *Treatise on the Five Orders of Architecture. See* Escorial.

VITRUVIUS Roman architect of the first century B.C. whose treatise was discovered in 1414 at Monte Cassino. It was translated and thoroughly examined by the great masters of the Renaissance, and for three centuries remained the Bible of classical architecture.

YUCATAN (Mexico) An example of the unceasing conquests of the Spanish Empire in America. It was discovered by Solis in 1507 and then again by Valvidea who was ship-wrecked there in 1511 and eaten, along with his companions, by the natives. The only survivors were Aguilan and Guerrero, whom Cortés found in 1519 after the defeats of Cordoba and Grijalva in 1517 and 1518. A new expedition of 1527, commanded by the two

Montejos, father and son, led to the founding of Merida in 1542 on the site of the Maya city of Ti-hoo. Diego de Larda, a Franciscan, became its bishop in 1578 and boasted of having destroyed six thousand idols and twenty-seven codexes. A large number of the natives withdrew into the interior, to Chichen Itzá, where a Dominican mission was completely wiped out in 1555. The Franciscan mission of 1618 found there a statue of a horse which was worshipped like a god. It was a portrait of the horse Cortés had left with the Itzas during his expedition to Honduras. In 1669 Merida had to fortify itself against the revolt of Chichen Itzá; the punitive expedition of 1674 was not successful, but in 1693 Martin Ursua captured the town. More revolts followed in 1713, 1761 and 1847, after which last the Mexican government was forced to sign a treaty in Maya and Spanish creating an independent Indian State. This State continued in existence until 4th May 1901 when it finally lost its independence at the end of war begun in 1871.

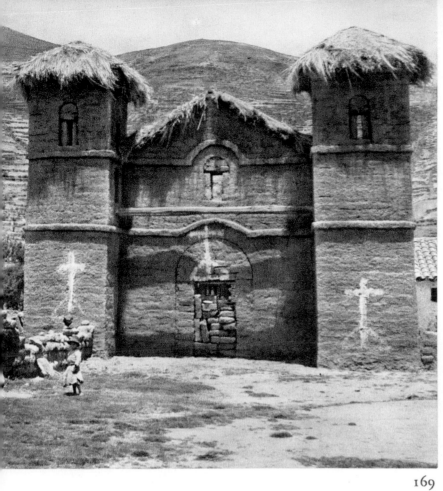

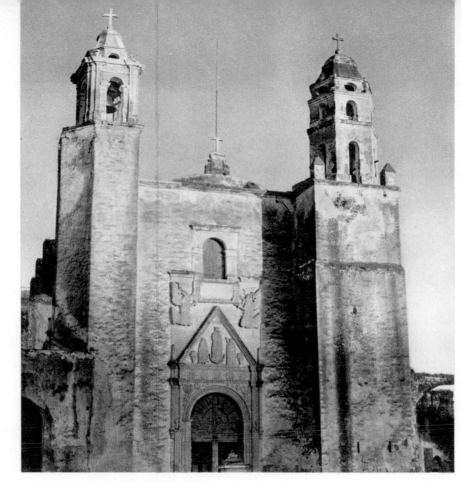

169

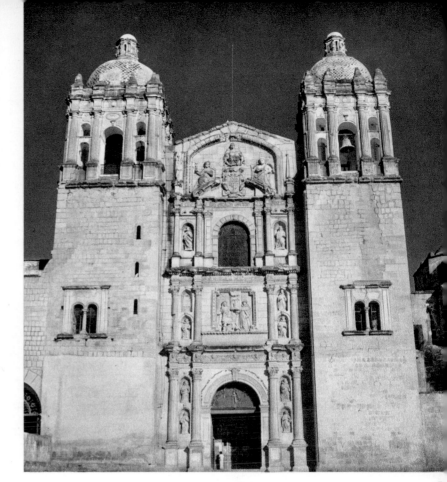

I

170

175

176

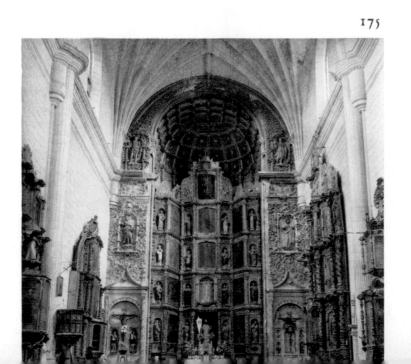

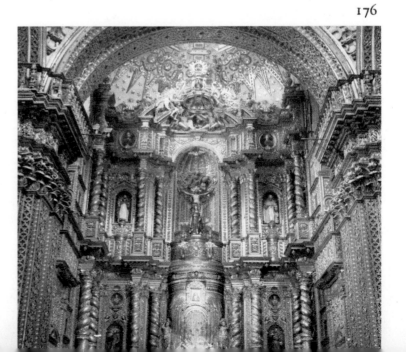

169 Ecuador

170 Tepoztlan (1560-1570)

171 Oaxaca (1570-1600)

172 Oaxaca (1682-1695)

173 Ocotlan (1745-1760)

174 Sao Joao del Rei (1773-1809)

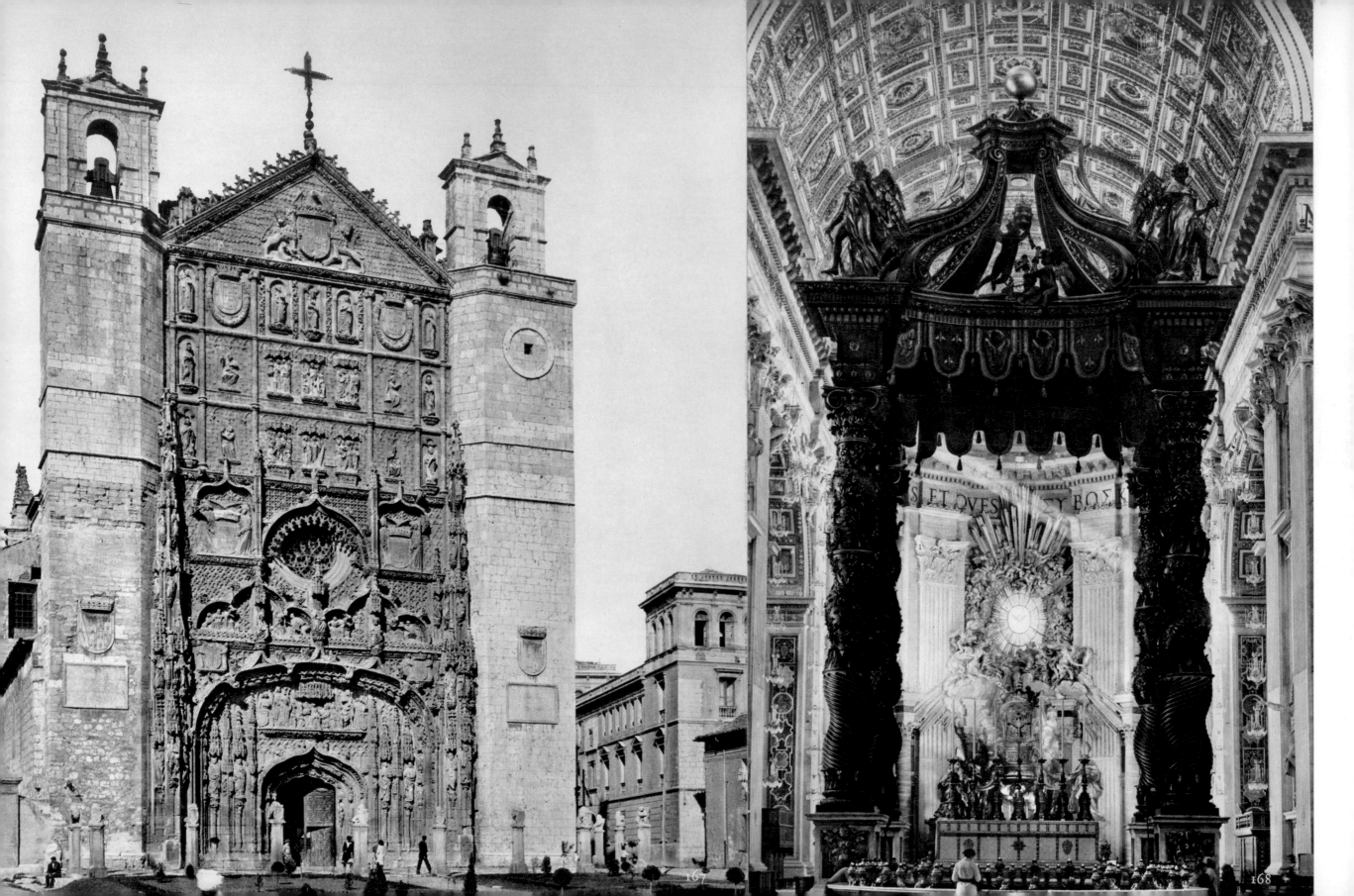

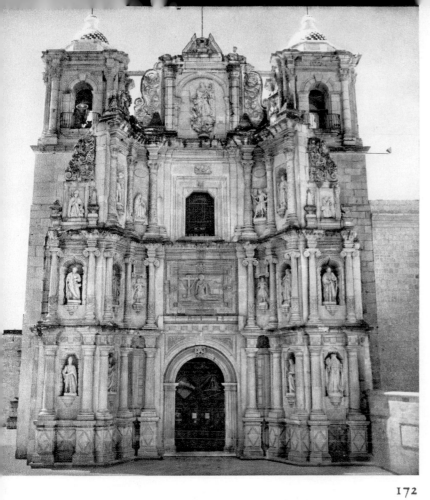

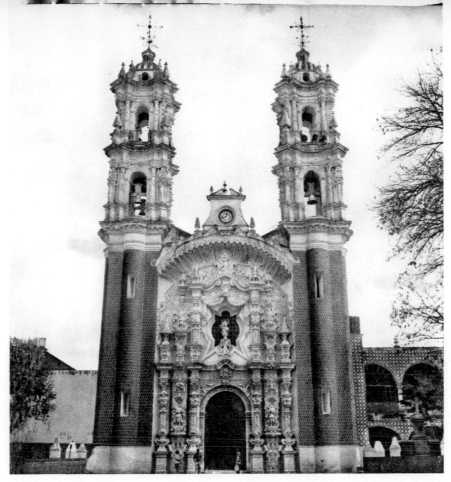

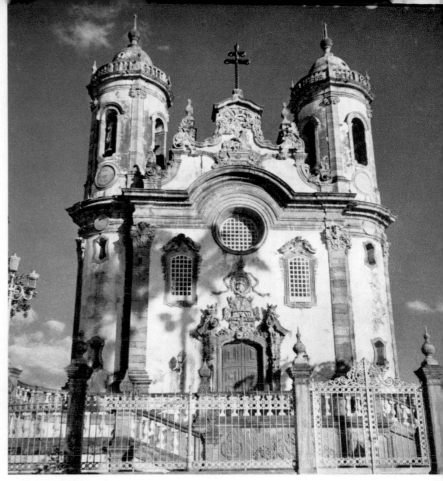

172

173

174

177

178

179

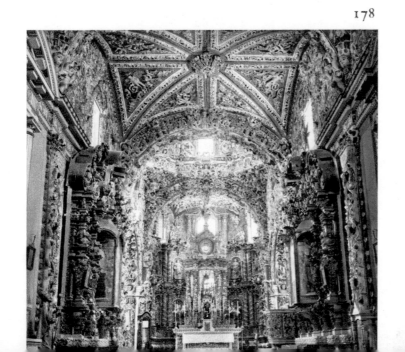

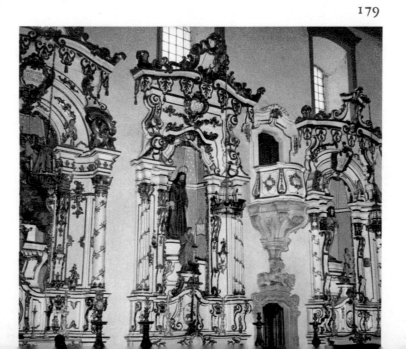

175 Yannuitlan (1541-1575)

176 Quito (1605-1754)

177 Oaxaca (XVIIIᵉ s.)

178 Tonantzintlan (XVIIIᵉ s.)

179 Ouro-Preto (XVIIIᵉ s.)

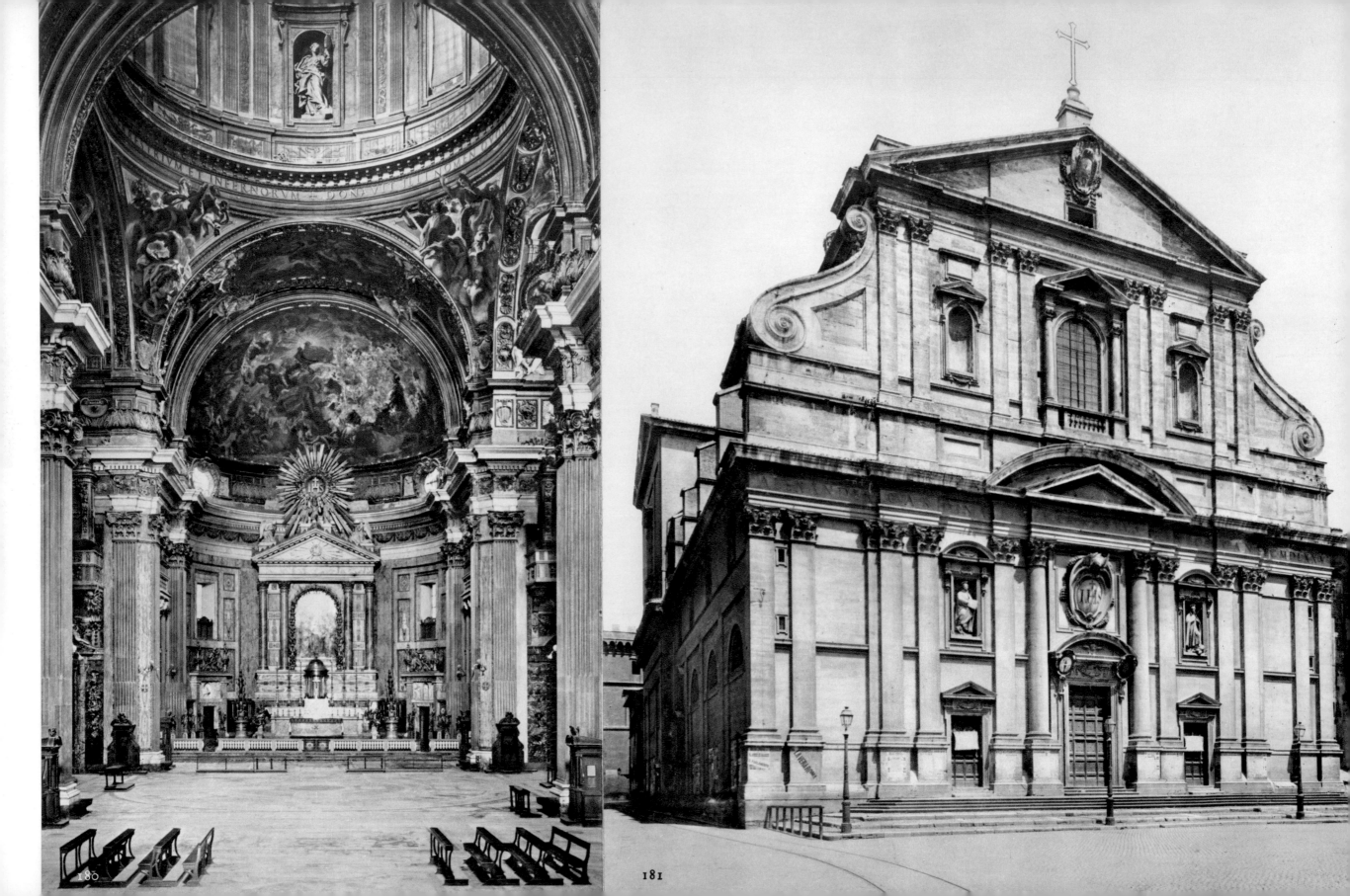

180

181

NOTES ON THE ILLUSTRATIONS

167 VALLADOLID, SPAIN Façade of San Pablo church in the Plateresque style; example of cross-influence in style in the times of the Catholic kings. Gothic tradition is here influenced by the flamboyant style of Flanders and the *Mudéjar* of Arab origin. The church of the Spanish Conquest was to be a compromise between this type of Spanish church with two towers and the Counter-Reformation design symbolised in the Gesù Church in Rome *(plate 181)*. For carvings in the Isabelline and Plateresque style, see the *posa* at Huetjotzingo *(plate 3)*, the Casa de Montejo at Merida *(plates 7, 8)*, the interior of the church at Yannuitlán *(plate 18)* and the façade of the church at Tepotzotlán *(plate 170)*. *Photograph by Bertault.*

168 ST PETER'S, ROME The baldaquin by Bernini (1624-1633). Decoration in cloth and wood transposed into bronze – a great triumph in monumental architecture, a veritable monument inside a monument; the seventeenth century called it 'a machine'. The four twisted columns with their composite capitals which form the supports are fluted to one-third of their height, the other two-thirds being decorated with vine-stems, leaves and cherubs designed by Francis the Fleming. Vignola was probably the first to lay down rules for this type of column, but it was due to Bernini that it became an essential element in ornamental architecture, especially in altar-pieces *(plates 141, 176)*. The formula was given in every manual of architecture. *Photograph by Boudet-Lamotte.*

169 ECUADOR Façade of a deserted church on the Andean plateau. Built of adobe or large rough clay bricks, and covered with thatch, in its simplicity it recalls the earliest mission churches.

170 TEPOTZOTLAN Façade of the Dominican convent church (1560-1570); an example of the architecture of the Conquest. *See page 22 and plate 57.*

171 OAXACA Façade of the church of the Dominican convent (1570-1600?). An example of interpretation of the Classical style, using the five orders. *See page 23.* The interior is Baroque; *see plates 99, 177.*

172 OAXACA Façade of the Church of Santa Monica (1682-1695). An example of *barrocorico* or overcharging of the Classical style with sculpture. *See page 25.*

173 OCOTLAN Façade of the Church of Santa Maria (1745-1760). An example of *barroco exuberante*, work of a native craftsman, with pre-Columbian influence. *See plate 17 and page 27 ff.*

174 SAO JOAO D'EL REI Façade of the Church of San Francisco (1773-1809). An example of Brazilian Baroque with Lusitano-Austrian influence, sometimes called Rococo. *See plate 147.*

175 YANNUITLAN Altar-piece of the Dominican convent (1541-1575). In their Gothic and Plateresque setting, the pictures are grouped in tiers and set in the classic orders. *See plate 18.*

176 QUITO High altar of the Compaña (1605-1754). An example of the Jesuit style, to be compared with the interior of the Gesù Church *(plate 180)*. In a setting of arabesques, complicated perhaps by pre-Columbian influence, with intervals of Composite order, the high altar is adorned with Bernini's twisted columns *(plate 168)*. *See also plates 119, 120.*

177 OAXACA Interior of the Church of the Dominican convent. An example of *barrocorico* of the early eighteenth century. *See plate 99 and page 145* for the vaulting decoration.

178 TONANTZINTLAN Interior of the Church of Santa Maria. An example of *barroco exuberante* of the mid-eighteenth century, and of *poblano* or native Mexican art. *See also plates 11, 30.*

179 OURO PRETO Interior of the Church of Our Lord of Carmo. An example of Rococo ornamentation in Brazil at the end of the eighteenth and opening of the nineteenth century.

180-181 THE GESU CHURCH, ROME Cardinal Alessandro Farnese gave the Jesuits forty thousand crowns towards the building, as arranged with the church architect Vignola and the Jesuits' architect, Giovanni Tristano, who directed the work, begun in 1568 and completed in 1584. The façade (181) which is austere and very typical of the spirit of the Counter-Reformation, is by Giacomo della Porta (1541-1606). In the form of a Latin cross, with the east end rounded in a half-circle, the interior *(plate 180 and fig. VI on page 24)*, includes six side chapels, and four more in the corner of the crossing. The nave has galleries above arcades of Composite pilasters. The inside of the dome is embellished with niches alternating with windows and adorned with stucco figures. The great cradle-vault of the nave, the pendentives and the cupola of the dome were painted in the seventeenth century by Baciccia with a *gloria* sky. The high altar is by Father Pozzo. On the influence of the Gesù Church on colonial architecture, *see pages 24 ff. Photograph by Anderson.*

BIBLIOGRAPHICAL NOTES

The bibliography dealing with Latin America is vast and in a book of this size it is impossible to cover it fully. On the history of the subject, the following were consulted: Jean Descola, *Les Conquistadors*, Paris, 1954; Jean Babelon, *L'Amérique des Conquistadores*, Paris, 1947; F. A. Kirkpatrick, *The Spanish Conquistadors*, London, 1934; W. H. Prescott, *History of the Conquest of Mexico*, New York, 1843 and *History of the Conquest of Peru*, New York, 1847. Special mention must be made of Salvador de Madariaga's two books *The Rise of the Spanish Empire of America* and *The Fall of the Spanish Empire of America*, London, 1947, the first comprehensive treatments of the period between the sixteenth and nineteenth centuries; without them this book could not have been written.

On the art-history of the area: Germain Bazin, *L'Architecture Baroque Religieuse au Brésil*, 2 vols., Paris, 1956 and 1959; Pal Kelemen, *Baroque and Rococo in Latin America*, New York, 1951; Manuel Toussaint, *Arte Colonial in Mexico*, Mexico, 1948; 'L'Art Baroque' in *La Documentation Photographique*, Paris, 1958; G. Charles, *L'Art Baroque au Brésil*, Paris, 1956 and *L'Art Baroque en Amérique Latine*, Paris, 1954; Cossio del Pomar, *Pintura colonial, escuela cuzquena*, Cuzco, 1928; Emile Mâle, *Religious Art from the Twelfth to the Eighteenth Century*, London, 1949; Musée National d'Art Moderne, Paris, *Catalogue d'Art Mexicain*, 1952; Léon Rochnitzky and Mathilde Pomès, 'Le Baroque Americain' in a special number of *La Renaissance*, Nov.-Dec. 1936; V. L. Tapié, *Baroque et Classicisme*, Paris, 1957; Hector Velarde, *Arquitectura Peruana*, Mexico, 1946; *Fanal*, Vol. X, No. 43, Lima, 1955.

Other books are listed here under the page for which they were principally used: page 11: Bolivar, quoted by Gavino Pacheco Zegarra in *Ollantai*, a play in Quechua verse from the Inca period, Paris, 1898; page 17: Bernal Diaz del Castillo, *La Conquista de Nueva España*, translated as *The Conquest of New Spain* and published in London, up to 1916; page 17: Machiavelli, *Il Principe*, 1513; page 19: on the Alexandrine Bull see M. le Baron Henrion, *Histoire des Missions Catholiques*, Paris, 1846; page 26-7: Mollien, *Voyage dans la République de Colombia*, Paris, 1824; page 28: Vignola, quoted in d'Aviler, *Cours d'Architecture*, Paris, 1760;

page 29: Las Casas, *Histoire de la Destruction des Indes*; page 30: Bullock, *Six Months' Residence and Travels in Mexico*, London, 1824; page 63: Easter Monday at Cuzco after Paul Marquoy, *Voyage à travers l'Amérique du Sud*, Paris, 1869; page 67: Vétancourt, quoted by Salvador de Madariaga in *The Rise of the Spanish Empire in America*, op. cit; page 67: Juan de Grivalja, *Chronique de l'Ordre des Augustins au Mexique*; page 69: on imitation gold see Félibien, *Traité d'Architecture*, Paris, 1690; page 111: Thomas Raynal, *Histoire Philosophique et Politique des Etablissements et du Commerce des Européens dans les deux Indes*, Geneva, 1780; page 114: Francisco de Toledo, quoted in Salvador de Madariaga, *The Rise of the Spanish Empire in America*, op. cit; page 117 and ff: *Histoire générale des Missions catholiques*, op. cit. and *Lettres des Augustins du Perou sur la religion des indigènes*, 1550-1555. *Annales de Philosophie Chrétienne*, XXI; page 119: *Deuteronomy*, XII, 1-3, *Acts*, XVII, 22; page 121: Palafox, quoted in *Histoire des Missions*, op. cit; page 119 and ff: on the Jesuits of Paraguay see *Lettres édifiantes et curieuses concernant l'Asie, l'Afrique et l'Amérique*, Paris, 1840; page 148: Alcide d'Orbigny, *Voyage pittoresque dans les deux Amériques*, Paris, 1836; page 148: Thomas Raynal, op. cit; page 148: on wigs see J. B. Thiers, Doctor of Theology, Incumbent of Champrond, *Histoire des Perruques, où l'on fait voir leur origine, leur usage, l'abus et l'irrégularité de celles des ecclésiastiques*, Avignon, 1777; page 148: Gabriel Henao, S.J., *Traité du Paradis*, 1652; page 188: François Depons, *Voyage à la partie orientale de la Terre-Ferme*, Paris, 1806; page 190: 'We, who...' quoted in A. de Beauchamps, *Histoire de la Conquête et des Révolutions du Pérou*, Paris, 1808; page 190: Bishop of Santa Marta quoted by Salvador de Madariaga; page 216: on Quito, *Voyageurs Anciens et Modernes*, Paris, 1855.

COLOUR PLATES, MAPS AND FIGURES

INDEX

Arabic numerals refer to page-numbers, arabic numerals in italics to notes on the plates,
and roman numerals to figures or colour-plates

Date Due